# Virginia CURIOSITIES

**Help Us Keep This Guide Up to Date**

Every effort has been made by the author and editors to make this guide as accurate and useful as possible. However, many things can change after a guide is published—establishments close, phone numbers change, hiking trails are rerouted, facilities come under new management, etc.

We would love to hear from you concerning your experiences with this guide and how you feel it could be made better and be kept up to date. While we may not be able to respond to all comments and suggestions, we'll take them to heart and we'll also make certain to share them with the author. Please send your comments and suggestions to the following address:

The Globe Pequot Press
Reader Response/Editorial Department
P.O. Box 480
Guilford, CT 06437

Or you may e-mail us at:

editorial@GlobePequot.com

Thanks for your input, and happy travels!

CURIOSITIES SERIES

# Virginia
# CURIOSITIES

## QUIRKY CHARACTERS, ROADSIDE ODDITIES & OTHER OFFBEAT STUFF

### SHARON CAVILEER

## SECOND EDITION

**INSIDERS'** GUIDE®

GUILFORD, CONNECTICUT
AN IMPRINT OF THE GLOBE PEQUOT PRESS

**INSIDERS'** GUIDE®

Text design by Nancy Freeborn
Maps by Rusty Nelson © Morris Book Publishing, LLC
Photo credits: See page 309.

ISSN 1932-734X
ISBN-13: 978-0-7627-4140-3

Manufactured in the United States of America
Second Edition/Second Printing

To my beautiful daughters Jessica and Rachel who
represent the best labor of my life.

## Acknowledgments

Thanks to those who have made this book possible: Lynnette Brugeman, City of Suffolk; Dave Bodle, *Virginia Explorer*; David DeCecco, Pepsi; Bill Stoddard, author and Mountain Dew historian; Robie Marsh, Virginia's Eastern Shore Tourist Commission; Ross Weeks, Historic Crab Orchard Museum; Hester Waterfield, Virginia Beach; Rebecca Cutchins, Portsmouth; Mary Fugere, Hampton; Patty Long, Northern Neck Tourist Commission; Cindy Hines, Shenandoah County; Laura Overstreet, Alexandria; Debbie Geiger, Geiger & Associates; Sergeii Troubetzkoy, Staunton; Bob Parrish, Connie Coling; Kitty Ward Barker, Southwest Virginia; Betty Scott, Grayson County; Bill Hartley, Birthplace of Country Music Alliance; Rosa Lee Jude, Wytheville; Janene Charbeneau, Richmond; Dr. Stuart McGehee, Craft Memorial Library; Augusta Thompson, Lynchburg; Martha Steger, Virginia Tourism Corporation; Frank McNally, National Air and Space Museum, Steven Udvar–Hazy Center; and Gillian Belnap, Mimi Egan, and Mary Luders Norris, editors extraordinaire at the Globe Pequot Press. Thanks also to the countless others who answered my dumb questions and pointed me in the right direction, and especially to my parents, who made me do my homework.

# VIRGINIA

THE NORTHERN
NECK AND
MIDDLE
PENINSULA

TIDEWATER
AND THE
EASTERN
SHORE

NORTHERN
VIRGINIA

RICHMOND
AND ITS
ENVIRONS

THE
SHENANDOAH
VALLEY

CENTRAL
VIRGINIA

SOUTHWESTERN
VIRGINIA AND
THE BLUE RIDGE
HIGHLANDS

# Contents

Virginia Is for Horse Lovers.

# Introduction

Virginia is a mighty big state: The Old Dominion encompasses 40,000 square miles. It can take the better part of nine hours to drive from Alexandria to the Cumberland Gap. Traveling south from the capital, it will take you four hours or more to cover the territory between the Potomac River and the Roanoke River on the North Carolina state line. Add in the jolly traffic tie-ups that Northern Virginia has grown famous for, and you'll know why the Yankee rallying cry was "On to Richmond." It's still a struggle to get there.

Virginia used to be even bigger. Much bigger. The earliest land grant gave the two original colonizing companies all the land between 34 and 41 degrees north latitude. That's roughly from Wilmington, North Carolina, to New York City. Nobody knew how far west the country went. Wouldn't old King James I have been surprised if he knew the strip of land was nearly 3,000 miles wide?! It's a gift worthy of the *Guinness Book of World Records*.

From its beginnings as the equivalent of a small country, the Old Dominion was carved up into more pieces than the Waltons' Christmas turkey. What was once Virginia became Wisconsin, Michigan, Illinois, Indiana, Ohio, West Virginia, and Kentucky. Defined by the old borders, there are a bunch more Virginians than the state claims. Listen up, Buckeyes and Cheeseheads: There's grits in the grain of your state history.

Although more battles were fought in Virginia during the Civil War than in any other state, it's also chock-full of colonial and Revolutionary sites, with more military museums than you can shake a saber at. Virginia is home to the Pentagon, the world's largest office building, and Naval Station Norfolk, the world's largest military installation. Here is where you'll find the headquarters of the National Rifle Association and Fort Monroe, America's largest stone fort, which guards the gate to the Chesapeake.

Each region can state unequivocally that it's the best place to live. There are mountains, rolling hills, and flatland, river valleys and beaches, swamps and rocky bluffs, saltwater and freshwater, and a good part of the world's largest estuary, the Chesapeake Bay. Summers in the Virginia flatlands can get pretty hot, but the mountains stay serene and naturally chilled. In the Bluefields, it so rarely reaches 90 degrees that the chamber of commerce serves free lemonade when it does.

Virginia is America's chameleon, changing before your eyes. If you take a picture anywhere in Virginia, folks will swear the photo was taken someplace else. A snapshot of the Eiffel Tower at King's Dominion is a cheapskate's European vacation—admission is less expensive than one meager meal in Paris.

The seven million people who live in the Old Dominion are as varied as the topography, but they all have one thing in common: They passionately love the place. A blessing that adorns most houses reads: "To be a Virginian either by birth, marriage, adoption, or even on one's mother's side, is an introduction to any state in the union, a passport to any foreign country and a benediction from above." That pretty much sums it up.

Aside from their love of the land, Virginians are an independent sort. They tend to do what they please, sometimes with amusing results. And they're hardier than most. Comes with the territory, I guess. This was the first place where a European settlement stuck, and a whole wonderful country grew up around it. From Jamestown to Williamsburg to Charlottesville and Alexandria, Virginia produced patriots who had some darned good ideas about government, including Patrick Henry, George Washington, George Mason, Thomas Jefferson, James Madison, and a host of others. And it was in Yorktown, Virginia, that we bid byebye to the British and were left to our own devices.

Life has been pretty good ever since. Beyond the lovely plantations and scenery, you can eat your way through the state and drink yourself tipsy on Virginia wine. You owe it to yourself to sample the specialties: crab cakes and barbecue, rockfish, peanut soup, Smithfield hams, peanut butter, Route 11 potato chips, wine jelly, homemade ice cream, apple pie, hoecakes, and planked shad. What you don't want to ingest is the ramp, a wild lily that springs up early and stinks to high heaven. Of course, we have a festival for it. Taste it if you must, but the stink will ooze from your pores for days. Consider yourself warned.

Virginians love the state for its foibles as much as its assets. We still celebrate Lee-Jackson Day (that's Robert E. and Stonewall). We can tell you which Confederate general was in command at what battle, but we pretend not to know how to get into D.C. John Rolfe might be remembered most for marrying Pocahontas, but it was he who brought the cash crop that built many family fortunes. Fine Virginia tobacco is still coveted worldwide, despite the political incorrectness of saying so. Most of us have seen ghosts; they're a dime a dozen around here. What we don't do is admit it to strangers. Instead, we tell these tales in the third person, attributing them to our neighbors.

Folks know when their families arrived here, and the earlier the better. Being a "first family of Virginia" still carries some weight, even though Jamestown is old news. Some of the best names in Virginia—Byrd, Pateson, Carter, Lee, Custis, Mason, Washington, and Shirley—are so good, we'll make them into first names and middle names. I know a lot of Carter Lees. (You can trace the Lee family history through the centuries at Stratford Hall.)

If you're coming to Virginia, don't try to do it in a day. Whether you're visiting virtually on the pages of this book or planning on passing through, don't miss the marvels that dot the map. Take your time and

wander from Arlington National Cemetery to Appomattox, from the waters of the Chesapeake Bay to the majesty of the Blue Ridge Mountains. These are stirring sites that will stick with you for life, but don't overlook the magic of the miniature—from the world's oldest pet ham in Smithfield to the wing walkers at the Bealeton Flying Circus. Dream a little in John Boy's bedroom on "Walton's Mountain" in Schuyler or at the Steven Udvar–Hazy Center of the National Air and Space Museum in Chantilly. Have a laugh floating on Butts Tubes on the Potomac, clog up a storm at the Carter Family Fold in Hiltons, or watch the privy races in Grayson County. You can even check out your past lives at the Association for Spiritual Enlightenment; its founder, Edgar Cayce, had more incarnations than cats have lives.

In spite of the oddities, Virginia is as upscale as it is down-home. We are a sophisticated sort, with opera and symphonies, a score of fine-art museums, and a slew of consumer castles (think Nordstrom, Saks, and Neiman Marcus). But it's still just fine to whistle "Dixie" while you eat your goober peas.

Find your own curiosities, or be one. Looking under a rock or following a country road, you can sometimes find something wonderfully strange. I hear there's a place called Yogaville that hands out inner peace quicker than business cards. It's time to be on my way. Om.

# WHY THERE ARE TWO VIRGINIAS

Once upon a time, there was only one Virginia. The original land grant included all the lands between Maryland and the Carolinas, all the way west. Of course, the grantors didn't know that the colonies were actually attached to a huge continent more than 3,000 miles across. So when Washington surveyed west, he traveled into country that we now know as West Virginia. In Washington's day it was all just plain Virginia. The laws that originated in the east with wealthy and well-educated plantation owners were imposed on freethinking frontier folks just scratching out a living in rugged mountain country. The landed gentry of the Tidewater and the mountaineers didn't see eye to eye on much of anything.

Then came the Civil War, and Virginia seceded from the Union. Some Virginians disagreed with that decision, particularly those in the western part of the state who had closer ties to the railroads and the burgeoning markets of the west, such as Pittsburgh, Cleveland, and Cincinnati. Because the only railroad that linked the Ohio Valley with the East Coast, the B&O, passed through Virginia, it was in Confederate hands. The creation of West Virginia solved that little problem. West Virginia's panhandle just happened to contain the B&O rail lines.

The secession of West Virginia from Virginia was just ducky in Washington circles. The spin to the story was that West Virginians arose in an antislavery movement, but West Virginia's constitutional convention was drafted to allow slaveholders to continue the practice after statehood. The convention also prohibited the settlement of any additional slaves or free blacks in the state. When Republicans in Congress squawked, West Virginia adopted the Willey Amendment, calling for a slow and gradual emancipation of slaves.

CONTINUED

No one had elected the West Virginia senators who arrived in Washington. They called themselves the "Loyal" or "Restored" Virginia Government. West Virginia was admitted to the Union on June 20, 1863. A case later brought before the Supreme Court challenged the legal shenanigans that created the state, but the judges upheld the process. West Virginia would stay West Virginia with its ties to the North.

According to journalist Tom D. Miller of the Hunting, West Virginia, *Herald-Advertiser & Herald Dispatch,* in 1974, absentee owners still owned or controlled at least two-thirds of the privately owned land in West Virginia. About a third of it is owned by large corporations in the North, from Baltimore to Boston. To this day, the Virginias still don't have much in common.

## Virginia Singalong, or
## Why Virginia Still Doesn't Have a State Song

When African-American composer James Bland penned the notes and lyrics of "Carry Me Back to Ole Virginny," he had no idea that the simple tune would become the state song.

But the lyrics by the old minstrel singer didn't age well. Picture a bunch of elected officials hosting international trade guests and bursting into song:

> *Carry me back to ole Virginny,*
> *There's where the cotton and the corn and 'tatoes grow,*
> *There's where the birds warble sweet in the springtime,*
> *There's where the old darke'ys heart am long'd to go,*
> *There's where I labored so hard for old massa,*
> *Day after day in the field of yellow corn,*
> *No place on earth do I love more sincerely*
> *Than old Virginny, the state where I was born.*

After endless discussion as traditionalists butted heads with more politically correct contemporaries, the Virginia Senate came up with a compromise. Why not declare "Carry Me Back" the state song emeritus and appoint a committee to select a new state song? Sponsors thought it was a perfect solution. The plan didn't dislodge Virginia's deep roots, nor would traditionalists be forced to select something new to serve in place of the original. The matter could languish in committee for years! It was pure political genius.

The bill passed, but not by a landslide. On January 28, 1997, the vote was 24–15 to declare the old song "Emeritus" and send a study commission into inaction. Although the intent was to update the state's image and put the ghosts of the plantation era to a peaceful rest, legislators opened a Pandora's (music) box.

The study committee thought it would be splendid to hold a song contest, and entries flew in. Deciding who would win became unmanageable as some of the more wealthy and powerful contestants lobbied hard in Richmond. A State Song Subcommittee finally came up with eight finalists. Among them are entries by country music legend A. P. Carter and Jimmy Dean, the sausage king. The eight finalists were posted on a Web site, www.vipnet.org/song.

In January 2000 the Advisory Commission on Intergovernmental Relations (ACIR) accepted the State Song Subcommittee's recommendation to postpone the selection of a winner. Six years later, silence was still the state song. So Charles D. Colgan, the longest-serving state senator in Virginia, proposed the adoption of "Shenandoah." Nevermind that the lyrics refer to the Missouri River, hundreds of miles west of the Virginia border.

Carry me back to ole Virginny, please!

# NORTHERN VIRGINIA

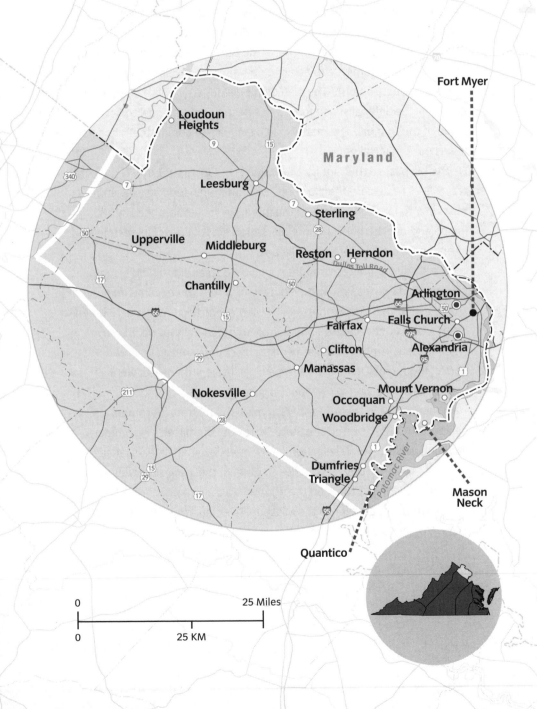

Fort Myer

Loudoun
Heights

Maryland

Leesburg

Sterling

Upperville

Middleburg

Reston    Herndon

Dulles Toll Road

Chantilly

Arlington

Fairfax    Falls Church

Clifton

Alexandria

Manassas

Nokesville

Mount Vernon

Occoquan

Woodbridge

Mason
Neck

Dumfries
Triangle

Potomac River

Quantico

0                          25 Miles

0              25 KM

# NORTHERN VIRGINIA

## For Crying Out Loud!
### Alexandria

For centuries, news was shouted from the street corners by a man with a big bell and a bigger mouth. "Hear ye, hear ye!" he'd cry, and the neighborhood would be all ears for the broadcast news. One of Alexandria's early town criers, a freed slave named Peter Logan, put out the first "Amber Alert" about a missing child. Happily, the child was found, safe and sound.

After the death of town crier John Yagerline, in 2005, Alexandria was silent. A hue and cry went up, and the city's elected officials posted the eighteenth-century job on the twenty-first-century Internet. When five applicants responded, the mayor and council held a "Cry-Off" in City Council Chambers. The winner was William North-Rudin, a twenty-year resident of the city.

The unpaid volunteer position is for life.

The fact that the last two criers died in office made North-Rudin a little queasy, but he's ecstatic about the job. "You don't know how much fun it is to be the town crier," he said. "It's twenty minutes to get dressed, ten minutes to get there, and one minute to cry."

Since there's a high mortality rate and no payday, there better be an upside. What North-Rudin loves most is the public response. People often confuse him with characters from the contemporary world of

advertising. During the Washington's Birthday Parade, a teen onlooker shouted out, "Dude, you got any oatmeal?" The kids at T. C. Williams High School also tease him. "They think I'm the Colonel," said North-Rudin. "Then they try and order chicken . . . extra crispy."

Alexandria's town crier volunteers to lead the city's parades and sound off at official functions. He's also "for hire." North-Rudin makes a little pocket change by "crying" at weddings, bar mitzvahs, engagement parties and political party gatherings. It really is a "penny for your thoughts." Of course, North-Rudin is a member of the American Guild of Town Criers, where he learns the tricks of the trade (such as turning off your cell phone during events). He and his wife, Patrice, write all the material for his "cries." In one, composed to solicit more community volunteerism, he rang his bell and yelled:

> If service to others
> Be as a healing balm,
> Get thee hither to
> Alexandriavolunteers.com.

Ringing in the ears is one hazard of the job.

## Spot Gives New Meaning to "Dog Days"

Alexandria

In the elegant port city of Alexandria, man's best friends have higher status than India's sacred cows.

The coveted canines and their people mingle over bowls of bones and martinis at Doggie Happy Hour, held every Tuesday and Thursday from 5:00 to 8:00 P.M. at the Holiday Inn Select on King Street. Created in 1999 to entertain Alexandria's dog-loving population, this doggie-do has become a big to-do. It draws as many as seventy-five dogs of all breeds, from mastiffs to Chihuahuas, for socializing and congenial tail-wagging in the courtyard. Costume contests for the Fourth of July, Halloween, and Jimmy Buffett concerts are popular diversions from the regularly weekly palling around with the pooches.

And despite the barks, there's less bite here than would be found in your average biker bar. Tom Ruth, former food and beverage manager, explained that it is a very social event: "Most of the dogs are well behaved. The worst thing that happened is that a dog got spooked and dragged his leash and the chair it was tied to several blocks before we caught up with him."

The cavorting canines have created a stream of publicity on MTV and in newspapers from Tokyo to Atlanta, and the event has its own Web site, www.doggiehappyhour.com. Phone (703) 549–6080.

Then there's the Olde Towne School for Dogs (703–836–7643), where puppies are enrolled before they're born. The waiting list for doggie day school is at least three months long, about the time it takes from breeding to litter. The school is located at 529 Oronoco Street in an elegant brick building that was formerly the property of actor Robert Duvall and his brother Jack. Carlos Mejias and his wife, Sandy, bought the building and opened the school in 1975. It limped along for years until a car crashed through the front entrance. The photo on the front

page of the paper drew dozens of new customers, and the business is a now a "bowsing" success, with eighteen human employees serving dozens of dogs daily.

Two weeks of doggie day school cost more than $1,000, and that's a far sight more cash than for some kid camps. The school bus adds another $30 a day. Mejias's customers are well able to afford the tuition. They are authors, politicians, actors, and broadcasters. The dogs' faces are less familiar, their privacy protected. In nine to twelve workouts a day, led by strolling trainers in polo shirts and caps, the dogs learn to heel, sit, stay, lie down, and respect the rights of others. The owner receives an evaluation and three private lessons with his or her newly polite and politically correct pet.

Mejias's school was so successful that he opened a satellite facility in nearby Springfield that's really the cat's meow. The Old Towne Pet Resort (703–455–9000; www.oldtownpetresort.com) is a day spa and hotel for coddled canines, top dogs, pampered Persians, and alley cats with airs. Owners can select a $70-per-hour massage, a swim in the indoor pool, or a luxury suite with a television, window, and cybercam to view their precious pets from afar. Limousine service is also available for the pets.

Who wouldn't mind being treated like a dog?

## George and Martha's Medicine Man:
## The Stabler-Leadbeater Apothecary Shop
Alexandria

In 1792 a young Quaker merchant opened a small apothecary business in Alexandria. If he'd known it would still be open 214 years later, he might have been neater.

Today the shop is the Stabler-Leadbeater Apothecary Museum, a treasure trove of dusty herbs and archives, and of lotions and potions still in their original glass bottles. Under the eaves of the old curiosity shop on South Fairfax Street are drawers full of foxglove and witch hazel, bloodroot and ginseng, and a little plant named cannabis.

No, you can't buy it by the ounce, but George or Martha Washington's doctors might have. Mount Vernon is located just 7 miles south of Alexandria along the Potomac River, and President George would stop in to buy supplies and replenish his medicine chest. Pharmacist Stabler filled an order for the medicine used to treat Washington's final illness, quinsy, an inflammation of the throat. His doctors actually disagreed on how best to treat the ailing president; a younger doctor wanted to perform a tracheotomy, but it was considered too radical. The procedure might have saved his life. After Washington's death, his wife continued to shop at the apothecary, ordering quart bottles of Stabler's best castor oil.

Stabler gave the shop to one of his seven sons, William, who passed it on to a brother-in-law, John Leadbeater. Alexandria grew into a thriving port city with plenty of war, pestilence, and death to address. Folks like Robert E. Lee, J. E. B. Stuart, Daniel Webster, John C. Calhoun, and other notables would stop and shop at the apothecary.

And there was the little matter of the Civil War. Alexandria was the longest-occupied city in the Confederacy, and before being allowed to do business with the Union troops, the Leadbeaters had to sign a loyalty oath. Interestingly, John's wife, Mary, was the one who signed.

The apothecary supplied medicine to soldiers, citizens, and travelers alike, along with paint, cleaning supplies, seeds, and sundries. In July of 1861, after the first major battle of the Civil War, thousands of Union soldiers stood outside the shop for a dose of Hot Drops to cure colds and flu. The mixture of myrrh and casicum cost a penny, and Leadbeater racked up $100 a day in sales.

After the war there were epidemics of yellow fever and influenza, and lots of ships carrying passengers with exotic illnesses that needed treatment. By 1865 the shop was supplying goods to 500 pharmacies in metropolitan Washington. The apothecary also shipped up to five wagonloads of medicine a day to ferries going south and trains going west.

The good times rolled on even during Prohibition, when the apothecary was allowed to continue to purchase alcohol for its "pharmaceutical tinctures, elixirs, extracts, colognes and bay rums in doctors' prescriptions." Codeine, morphine, and many other controlled substances were dispensed on doctors' orders.

Chlorobutanol, tradename Chloretone, was popularized as the active ingredient in Mothersill's Seasick Remedy which Leadbeater made

And you thought your prescription drug plan was bad!

The Great Depression meant the death of the business, which had thrived for more than a century. The owners locked the doors and walked away, leaving the dusty contents intact. Today the apothecary shop is a nifty museum with a practical application. Its contents give visitors a little pinch of history—and that's nothing to sneeze at.

The Stabler-Leadbeater Apothecary Shop Museum is located at 105–107 South Fairfax Street in Alexandria. Visit www.apothecary museum.org for information.

## Just for Spite
Alexandria

If your neighbors are encroaching on your property, driving down your driveway, or strolling through your side yard, take a cue from the colonials: Build another house on your property just for spite!  That'll show 'em.

Don't think you have enough room? No matter—"spite houses" can be built to fit. One at 523 Queen Street in Alexandria is a mere 7 feet wide. Inside, it's a spacious 350 square feet. Featured in *Ripley's Believe It or Not,* the 1830s-era building is now owned by a collector of small houses who uses it as his pied-à-terre while visiting Washington, D.C.

Tourists gravitate to the adult "dollhouse," with most snapping the same shot. The visitor faces the cheery bright blue house, raises both arms, and stretches to touch both sides of the facade. Tenant Linda Cole initially enjoyed living in the house with her cocker spaniel. But after a while the necessity for neatness and the constant stream of tourists at her one front window got old. "It was like living in a glass house," she said.

To make matters worse, the house is featured in a new Architectural Walking Tour brochure available at the Alexandria Visitors Center at 221 King Street (703–838–4200; www.thefunsideofthepotomac.com) and is a stop on regular walking tours offered by Alexandria Colonial Tours (703–519–1749; www.alexcolonialtours.com).

While privacy is a precious rarity at the spite house, its construction sure stopped that annoying neighbor from using the alley. There hasn't been a carriage through there for more than 175 years. That's a long time to hold a grudge.

Not much room to stretch out . . . but not much to clean either.

## D.C. West Cornerstone

Arlington

Although the District of Columbia was designed to be a pristine dia-
mond shape, the northern Virginia border looks as if it has been pecked
to death by ducks. This raggedy edge, formed by the Potomac River,
was the result of chronic controversy that lasted through the better
part of the nineteenth century.

Virginia and Maryland vied for the honor of donating land for the
new nation's capital. Of course, it was nasty swampland, and folks were
really glad to be rid of it. Andrew Elliot laid out the 10-mile square capi-
tal city in a compromise that let both Virginia and Maryland donate
some land. The boundary was marked by four great cornerstones, with
smaller stones at 1-mile increments.

The Alexandria land was ceded to the District of Columbia in 1789.
The Arlington land was ceded to the District of Columbia in 1801. The
colonials in Alexandria and Arlington thought that being a part of the
capital would bring wealth and power, but like generations of politi-
cians, secretaries, and interns who followed, they were sorely disap-
pointed. They fussed, moaned, and lobbied. Finally, in March of 1847,
the land was ceded to Virginia as Alexandria County.

Keep in mind that in 1862, when Virginia decided not to continue as
a part of the good old U.S.A., it seceded. So in the course of fifty years,
the same land was seeded, ceded, retroceded, and seceded.

In 1865 the Union was preserved, but the capital boundaries stayed
the same, with the Potomac River marking the line.

You can see the surviving cornerstone on North Meridian Street in
Arlington. It doesn't mark anything except time, and the Daughters of
the American Revolution built a fence around it to preserve it. The
stone's inscription wraps around two sides and reads JURISDICTION OF THE
UNITED STATES 1791.

## High Art

Arlington

Ronald Reagan Washington National Airport isn't in Washington at all. It's in Arlington, across the Potomac River, in Virginia.

The art deco terminal has been restored and refurbished to reflect the life and times of Roosevelt's New Deal era. Built on the old Abingdon Plantation site, the terminal reveals nothing of its origins except for a display of artifacts from an archaeological dig completed before construction began in the fall of 1938.

The new terminal—all light, air, and steel—complements the old. It is so arty, you can take a tour of works by thirty artists, led by volunteer docents from the Corcoran and the Smithsonian's National American Art Museum. The works, including floor medallions, glass sculptures, and canvas, represent a variety of media.

Tours of the airport's art and architecture last about an hour and are available to groups of three or more. Reservations are required two weeks in advance (703–417–0895). The tour can be a great way to pass the time between connecting flights. If you haven't made reservations and your plane is late, you can download a virtual tour to your laptop from www.mwaa.com and absorb the ambience. If you do the actual tour, you'll be strolling around more than a million square feet of space, so wear those comfortable shoes.

## The Plane Truth

Arlington

If you're looking for a little tranquillity, Gravelly Point Park is not the place to be. In fact, one of its key attractions is the deafening traffic above.

Built on a landfill just north of Ronald Reagan Washington National Airport, this little park has a lot going on. Planes scream about 100 feet overhead at speeds exceeding 150 miles per hour. Aircraft arrive and depart with alarming regularity, every other minute during peak periods.

Inexplicably, the park is always crowded.

You can reach the park from the northbound lanes of the George Washington Parkway. Pack a picnic, spread out a blanket, and scream a little louder than the engines overhead.

Tucked on the banks of the Potomac River, Gravelly Point is also a great place to see the capital skyline. And the Mount Vernon bicycle trail runs through the park; the 8 miles to George Washington's home can easily be reached from here. The park, open during daylight hours, is a popular spot for picnickers, Jet Skiers, fishermen, bicyclists, tourists, and airplane aficionados, despite its location on a creek with the unfortunate name of Roaches Run. Don't worry though: There aren't any roaches, just rats the size of cats down by the water!

## The Longest Miniature Golf Hole in the World
Arlington

If putting is your strong suit, tee off at the world's longest miniature golf hole at Upton Hill Regional Park on Wilson Boulevard in Arlington. The great greens are a welcome respite from the urban setting that surrounds them. When you reach the tenth hole, the hill falls away—a long way—to the hole. You might even want to trade that putter for a five iron. From tee to green, it's 140 feet and a challenge for everybody but Tiger Woods.

Thank goodness for gravity.

The deluxe course was designed by Jim Bryant of Park Projects Inc. After a lifetime of designing courses with jungle and cartoon themes, Bryant saw this natural setting as a big challenge; he wanted to preserve the landscape and make the course interesting without using the usual windmills and clowns.

Upton Hill is open daily from Memorial Day to Labor Day and on weekends in spring and fall. It is part of the Northern Virginia Regional Parks system (www.nvrpa.org), which includes far more than woodsy trails. If the golf course gets you a little hot under the collar, cool off in the swimming pool or swat away aggression at the batting cages. If you still can't chill out, throw a few horseshoes or have the oldsters teach you bocce ball.

Golfers tend to be diehards though, and you might just want to play again. Greens fees are an affordable $5.50. Playing the longest hole is worth much more. Phone (703) 534–3437.

## The Flying Flea

Chantilly

Visitors to the impressive Steven Udvar–Hazy Center of the National Air and Space Museum in Chantilly might overlook the tiniest aircraft on display. The HM.14 is dwarfed by the space shuttle *Enterprise,* the *Enola Gay,* and 200 other aircraft and 135 pieces of space equipment.

Despite its name, the HM.14 was a mighty mite. The aircraft weighed only 250 pounds, had a wingspan of 17 feet, and was just a smidge less than 12 feet long. It was designed by Frenchman Henri Mignet, a notoriously poor pilot, to be built and flown by almost anyone with an itch to take to the skies. The design was well outside the box. The flea was to fly without ailerons, elevator, and rudder pedals. It had two wings, a stick, and a front-mounted 35-horsepower engine. The flyer could turn by moving the stick to the left or right.

Mignet called it "Pou de Ciel" (sky louse). The inventor claimed that anyone could build his plane if they could wield a hammer and nail. The concept caught on, but the name didn't. The Brits preferred to call it the "Flying Flea."

By 1935 it looked like the flea would infect the skies. Hundreds of them were being assembled in France and Britain, and many were in the air. The president of the U.S.–based Crosley Radio Corporation wanted his own and had one built for himself in Sharonville, Ohio. When it was done, Mrs. Page Crosley proudly christened it "La Cucaracha" (the cockroach), continuing the insect effect.

Then, the aircraft started falling from the skies. As it turned out, the Flying Flea HM.14 had a design flaw that made recovering from a dive under certain conditions nearly impossible.

That little fact exterminated the interest in the Flying Flea. Few survive, but you can catch "La Cucaracha," Crosley's Flying Flea, at the Steven Udvar–Hazy Center, 14390 Air and Space Museum Parkway, Chantilly (202–633–1000; www.nasm.edu).

## Clifton General Store
Clifton

The Clifton General Store is the place to shop in the tiny town of Clifton, located in the southwestern corner of Fairfax County, about 25 miles west of Washington, D.C. It's also the only place to shop.

Clifton doesn't have a gas station, mini-mart, grocery store, or anything else that smacks of twenty-first-century commerce. There's no home delivery for mail either; you have to walk to the post office to pick it up.

There are two fine restaurants, a post office, and a few gift and antiques shops for the tourists, but for the locals, there's the Clifton General Store. Beyond the butter, eggs, milk, and grocery items, the grill keeps its owner, Tom McNamara, hopping. Just like the good old days, this is the place to get the news. The nosy-neighbor bulletin board posts who's moved in or out, had a baby or published a book, starred in a movie or lost a dog. By the door, used novels are sold for a dollar, while the *New York Post,* the *Washington Post,* and other papers from Baltimore to Richmond provide the news of the day.

It's not uncommon to see a horse tied up out front. In fact, it's not uncommon to see almost anything. As an example, Christmas caroling is done on four hooves . . . the equestrian way. Horses and riders are decked out for the season in red and green, creatively costumed as holiday trees, reindeer, elves, angels, and ornaments.

Despite its folksy feel, Clifton has both a silly and a sophisticated side. Bert and Ernie from *Sesame Street* sit atop the shelves inside the General Store, smiling down at the customers. Former First Lady Nancy Reagan used to stop by after lunch at the Heart and Hand. Theater great Helen Hayes summered here to get away from the Washington heat. Today diplomatic license plates are as common as the BMWs and Porsches that traffic Clifton's country roads.

The freed slaves who founded the town would be amazed at its current exclusivity. During the Civil War, Clifton resident William Beckwith died, bequeathing to his slaves the 1771 homestead, 200 acres of land, and freedom. In gratitude, the freed men built a Baptist church in 1869. The simple structure, with its hand-hewn pews and altar, is still used for worship.

Today's residents of Clifton like it just the way it is—about a century behind the times. They've turned down a commuter rail station, road improvements, and dozens of other "modern" ideas. Outside of town, lots must be five to ten acres to assure that the countryside survives. In 1984 the U.S. Department of the Interior declared the entire town a National Historic District. The town's hundred voters must have a lot of political pull. Visit online at www.clifton.org.

Deck your horse with boughs of holly!

## Virginia's Oldest Town
Dumfries

When you're driving south on U.S. Highway 1 between Woodbridge and Quantico, you pass one of America's most important colonial ports. Dumfries, on the Quantico Creek estuary, was one of the few deepwater ports on the Potomac that could accommodate sailing ships. Starting in 1690 with a gristmill, the town grew quickly as a tobacco port. The English couldn't get enough of Virginia's finest tobaccos.

Dumfries beat out Alexandria by one day as the first chartered town in Virginia. Dumfries's charter is dated May 11, 1749.

Thanks to Scottish merchants, Dumfries mushroomed into a center of commerce, with a customs house, tobacco warehouses, and artisans of all kinds. In 1763 Dumfries was the second-leading port in the colonies, rivaling Boston in gross tonnage.

The social scene followed the money, and Dumfries became a cultural capital. It had an opera house, theaters, a racetrack, and "ordinaries"—the colonial equivalent of a hotel and restaurant. Washington's first biographer, Parson Weems, led the town's literati.

When you think of thriving cities that launched their success on the seafaring trade, New York, Boston, Charleston, Savannah, and Alexandria come to mind. Dumfries doesn't, and the reason is understandable. In the nineteenth century, the port silted, preventing ships from entering. If you look for the port on US 1, you're pretty much on target. The roadbed runs right over it. Learn more about the town at www.dumfriesva.com.

## On Guard

Fairfax

Doug Wickland is keeper of the key for the National Firearms Museum at the National Rifle Association (NRA) headquarters in Fairfax. The curator, who has a degree in anthropology as well as museum studies, is also a fourth-generation NRA member.

"I can't remember a time there weren't guns around. I've been around guns all my life," says Wickland. "I'm a collector, shooter, and hunter." His sons, Jeremiah and James Marshall, are the NRA's only fifth-generation members.

The museum contains a cache of historic weapons, America's arsenal to the citizen soldier. Each year, more than 40,000 people visit the museum, which is located off U.S. Highway 50 and Interstate 66. There's also a shooting range and a spot to snack, the NRA Cafe.

Kilroy was here, and here he'll stay.

Exhibits trace America's history through its firearms, with more than 2,000 guns on display. The oldest is a 1380 hand-forged firearm from Salzburg Castle. Your ancestors might not have come over on the *Mayflower,* but there's a gun here that did. There are displays depicting everything from European exploration and colonization to the American Revolution, the War of 1812, the Civil War, the Wild West, and on into the twentieth century.

You can see three guns owned and used by Annie Oakley and guns from dozens of law enforcement units, including the famed Texas Rangers. There are displays of some of America's most respected firearms manufacturers: Colt, Remington, Eli Whitney (who didn't just invent the gin cotton), Sam Walker, Ethan Allen, and Smith and Wesson. Presidential firepower, from Theodore Roosevelt, Grover Cleveland, Dwight Eisenhower, Lyndon Johnson, Ronald Reagan, and George H. W. Bush is on display.

Donations account for 98 percent of the collection. Calls and e-mails come in daily with extraordinary claims to fame. "I've got this old gun that my grandfather said was at Gettysburg." Usually it wasn't—it just

*Counting saddles can be just as effective as counting sheep.*

spent the war in grandfather's barn. Staff members help you capture accurate information. The galleries are all computerized to make it easy to glean firearm facts to win any argument.

The Second Amendment is omnipresent. A display quotes James Madison's original, the revised versions adopted in the Bill of Rights, and commentary by our founding fathers. Wrote James Madison: "Notwithstanding the military establishments in the several kingdoms of Europe, the governments are afraid to trust the people with arms."

That statement holds true in the museum, too. Armed guards guard the guns.

The National Firearms Museum is located at 11250 Waples Mill Road in Fairfax. Admission is free. Phone (703) 267–1600 or visit www.nrahq.org/museum for more information.

## 007 Sightings
Fairfax

Although you can't visit CIA headquarters, which is tucked behind guarded gates in Langley, you can get your spy fix with spooks aplenty on the Spies of Washington Tour. It's offered by son-of-a-spy Francis Gary Powers Jr. and the Cold War Museum scheduled to open in Lorton in 2007. Tour guides Carol and John Bessette aren't just any run-of-the-mill tour guides. They're bona fide intelligence officers who were looking for something different to do after they retired. With a spy's-eye view, parks, strip malls, and mailboxes are full of intrigue once you've heard the inside story. It just goes to show how sneaky this business of spying can be.

The most unlikely sites have spy stories. Students at Georgetown University would hang signals from their dormitory windows to alert Confederate forces in Arlington of Union troop movements. Master spy

Aldrich Ames was captured just a block from his suburban home in Arlington. Ames had paid for the house with more than a half million dollars in cash, which should have been a dead giveaway. Government employees tend not to be at the top of the food chain when it comes to compensation.

Says Carol Bessette: "His was probably the worst case. The cost of his actions was not only the loss of important information and compromising his country, his actions resulted in a direct loss of life. At least ten Soviet citizens working for American intelligence were killed."

What motivated Aldrich Ames was a plain old all-American divorce. When his marriage went south, Ames said he found himself with about $13,000 in debts, although government investigators say it was more like $46,000. Compounding his mistakes, he remarried in haste. Although he's currently serving a life sentence, giving him plenty of time to repent at leisure, prison officials say he has no remorse.

When notorious super-spy Robert Hanssen wanted a stash of cash, he'd wander over to the little footbridges at Foxstone and Nottoway Parks in Vienna, where the Soviets would leave a bag of diamonds or cash in exchange for America's most valuable trade secrets. Ironically, the loot was tucked into a garbage bag.

Hanssen appeared to be a normal guy with the FBI. He had a wife and kids and a house in Vienna. He attended church every day. He also bought a car for his favorite stripper and sent $10,000 in cash to Mother Teresa. Go figure. He's now serving a life sentence for fifteen counts of spying for Moscow. Hanssen avoided the death penalty with a plea bargain, but some of the double agents he exposed weren't so lucky.

For more information on the tours and for reservations, call (703) 273–2381 or visit www.spiesofwashingtontours.com. The Cold War Museum's Web site is at www.coldwar.org.

# NOTHING CIVIL ABOUT THIS WAR

The Civil War is still part of the fabric of life in Virginia. The Old Dominion saw more action than any other state in the C.S.A., and families lost ancestral homes, land, and fortunes. The economic devastation of the war lasted a century.

So when you're in Virginia, you might want to refer to things Civil War–related by their proper names. In the North, the "recent unpleasantness" is called the "War between the States"; in the South, it's the "War of Northern Aggression."

When it comes to battlefield names, there's still discord between the South and the North. Northerners named their battles after bodies of water, Southerners after the nearest town. That's why those who went to school in New England look for Bull Run and end up at the regional park with its pool and campground. Here, we call it Manassas.

## If It Ain't Eggs, It Ain't Breakfast

Fairfax

If your mother told you not to play with your food, you'll be horrified at Fair Oaks Mall, where the kids play in their food. Giant waffles, bowls of cereal, and strips of bacon are the playground for the pint-sized at this shopping center just off I–66 in Fairfax.

The sculptures were manufactured in New Braunfels, Texas, where everything is BIG. At Fair Oaks, they were a family favorite for years. When mall management removed them, parents had a temper tantrum over toast and begged to have their bacon back.

The breakfast foods are back in the mall and crawling with children, like ants at a picnic. For information on Fair Oaks Mall, call (703) 359–8300 or visit www.shopfairoaksmall.com.

## The Blue and Gray Dating Game

Fairfax

During the War of Northern Aggression (aka Civil War), a girl couldn't be too careful. Between 1861 and 1864, the Northern Virginia dividing line between North and South shifted faster than you could whistle "Dixie."

Union forces enjoyed the best of Southern hospitality, whether they were invited or not. In August 1862, on the way to Manassas (called Bull Run in Yankee-speak), a group of Union officers spent the night at the comfortable home of the Fords of Fairfax City. Daughter Antonia Ford, age twenty-two, listened intently at the keyhole.

The next morning, the young lovely asked for a pass to visit a sick aunt and rode off into the Virginia countryside. It might have been coincidence, but the Union troops suffered a second stinging defeat at Manassas that month.

Many Confederates were neighbors in Fairfax and adjoining counties. They relied heavily on "intelligence" gathered in the parlors, fields, and farms of Northern Virginia. Antonia and Laura Radcliffe, also of Fairfax, were both suspected of spying. A raven-haired beauty, Antonia charmed both Union and Confederate officers alike. She was particularly fond of Union Maj. Joseph Willard, some years her senior, who courted her amid the competitive field of Blue and Gray. Although Radcliffe was never caught, young Antonia was not so lucky. Her home was searched in March 1863, and she was caught with a commission from J. E. B. Stuart as a Confederate aide-de-camp.

Antonia was caught with the goods. On March 17 Maj. Willard had the unlucky duty of riding into Fairfax and arresting his young paramour. She was jailed at the Old Capital Prison, where she eventually suffered from malnutrition.

Willard lobbied for her release, and the couple's courtship continued. The Ford family approved of Willard enough to smuggle him back through Confederate lines by wagon so Antonia and Willard could "court."

They married in March 1864 and had one son in their seven years together. Willard founded the hotel that still bears his name on Pennsylvania Avenue in Washington, D.C. Antonia died in 1871 of complications resulting from her time in prison. Her home on Main Street in Fairfax, now an office building, contains a small exhibit in her honor.

The Ford House is located on Route 123 (3977 Old Chain Bridge Road) in Old Town Fairfax. For more information on Antonia Ford and Civil War History in Old Town Fairfax, log on to www.visitfairfax.com or call (800) 572–8666.

# BEWARE THE BLACK WIDOW

If you've ever wolfed a whole pepperoni pizza and chased it with a gallon of ice cream and a bag of Oreos, you're just a rank amateur. How about chowing down 250 tater tots in 5 minutes, 57 Krystal burgers in 8 minutes, 65 boiled eggs in under 7 minutes, or 44 soft-shell lobsters in 12 minutes?

This isn't gluttony but a sport sanctioned by the IFOCE (International Federation of Competitive Eating). How about turning that manic munching into money and fame?

Fairfax County is the home of one of the most fearsome competitors in the world. Competitive eating phenomenon Sonya Thomas's professional name is the Black Widow (www.sonyathe blackwidow.com). She chose it "to eliminate the males."

In reality, Sonya is a slip of a thing, 5 feet 5 inches tall and weighing just a smidge over 100 pounds soaked in butter. Although she only entered the sport in 2002, she's eating up the competition across the country, winning titles and setting new records. Thomas was named "Rookie of the Year" in 2003 and was nearly unbeaten in 2004. Today she holds some 27 world titles, including 4 pounds 3 ounces of roast turkey in 12 minutes. Don't you dare ask this girl to Thanksgiving! Sonya also managed to chow down 8.31 pounds of Armour Vienna sausage in 10 minutes and 25 grilled cheese sandwiches in 10 minutes.

The 37-year-old began her career after seeing a competitive eating event on cable television. She felt that she had a "burning desire" to win, as well as a good appetite and active metabolism. The phenomenon who can eat 11 pounds of cheesecake in 9 minutes hasn't gained an ounce in her years of competition. Her daily diet is healthy food with an occasional sweet.

Taylor's training regimen is minimal. She occasionally practices her speed eating for a minute or two at home and then relaxes. According to Sonya, the sport requires focus and great eye-hand coordination, as well as the ability to chew and swallow fast. To stretch her stomach, Taylor will often top off a regular meal at home with a gallon or so of diet soda or water.

In the world of competitive eating, there is the legend of the "One Eater," a small woman who will appear on the scene and conquer the world like a manic, munching Joan of Arc. According to the IFOCE publicist George Shea, "In recent months, the prophesy has been mentioned more and more frequently as the eaters have seen Sonya Thomas excel in nearly every contest she enters." Coincidentally, the Black Widow aspires to become the world's No. 1 competitive eater.

Eat 'em up, Sonya!

## The South (Vietnam) Shall Rise Again

Falls Church

Got a feeling for pho? Want to put some spring rolls in your step? Have some tien to spend? Then head over to Saigon Boulevard for some Southeast Asian civilization. While the name Saigon disappeared from most maps and globes for thirty years after the city fell to communist invaders in April of 1975, the spirit of the South (Vietnam) has risen again in Falls Church, Virginia.

As the North Vietnamese marched into the capital, they renamed it Ho Chi Minh City. Thousands of Vietnamese escaped the invading armies by any means possible: by aircraft, on foot, and in small boats. In the first year, the U.S. government assisted 130,000 refugees into the United States. By the year 2000, the Vietnamese community was 1.2 million strong.

Secretary of State Cyrus Vance said: "We're a nation of refugees. Most of us can trace our presence here to the turmoil or oppression of another time and another place. We will not turn our backs on traditions." That sentiment proved an omen. In a ceremony on January 29, 2006, as a part of the celebration of Tet, the Vietnamese New Year, part of Wilson Boulevard was redesignated Saigon Boulevard. Right outside the red gates leading to the Eden Shopping Center, government officials and Vietnamese Americans celebrated with dragons, drummers, music, and applause. Saigon was back!

The mayor of the city of Falls Church, a Vietnam veteran, welcomed the change. Tan Nguyen, the chairman of the Vietnamese community of Washington, D.C., was all smiles as he cheered into the microphone: "The Vietnamese community of Washington, D.C., Maryland, and Virginia and the Vietnamese overseas will be very happy to see the appearance of Saigon Boulevard."

On the boulevard, join hundreds of Vietnamese Americans as they stroll the shopping districts like Eden Center and relax in Vietnamese cafes. Stores cater to more petite frames (like a size 0 wedding dress), and the grocery stores carry fishes and fresh vegetables that are foreign to Occidentals. Have something that ails you? Try a remedy at the herbalist. Buy a movie or CD that's the latest thing in Southeast Asia, or book a luxury vacation beachfront on the South China Sea.

Don't be shy! In the new Saigon, everybody speaks English.

*Luckily, English is also spoken here!*

## A Place Worthy of Attention

Fort Myer

The first military division in the United States is even older than our Constitution. The third U.S. Infantry Division was founded in June 1784 to protect the western boundaries of the new nation. The unit now guards the capital city and the Tomb of the Unknown Soldier, and it is responsible for Arlington National Cemetery.

Within the urban fort property overlooking Arlington National Cemetery and the skyline of Washington, D.C., the Old Guard Museum reveals the long and distinguished history of the unit. The Old Guard fought in most of the nation's major conflicts, including the Battle of Gettysburg, during its two centuries of service.

The Old Guard Museum is free and open to the public. Located in Building 249 on Sheridan Avenue, inside Fort Myer, it is within view of the parade grounds where the first two army aviation test flights began. On September 9, 1908, Orville Wright took the controls for a flight endurance test, circling the field fifty-seven times. Later that day he took the first passenger, Lt. Frank Lahm, who flew for an hour and twelve minutes. Just eight days later, the aircraft experienced mechanical failure and crashed to the ground, killing Lt. Thomas E. Selfridge, a field artillery officer. Selfridge is buried at Arlington National Cemetery, where one of the gates is dedicated to his memory.

Near the parade grounds and the Old Guard Museum are the army's last horses. The stables contain the ceremonial horses and caissons that carry American veterans to their final resting place in Arlington. Visitors are welcome if the animals are not in use for a ceremony. One of the stables has been dedicated to the memory of Black Jack, the riderless horse that became a profound symbol of sorrow and loss in 1963 during the funeral of President John F. Kennedy.

Black Jack ably performed his duties. During his career, he participated in two presidents' funerals and 150 others, including ceremonies for Gen. John J. Pershing.

After his death, the beloved Black Jack was buried beneath the museum's parade grounds. The horse's grave is marked with a plaque and flowering bushes.

The Old Guard Museum can be reached at (703) 696–6670.

## Pardon My Turkey
Herndon

Although presidential pardons may be controversial, nobody cries fowl over the turkey pardon.

Whether you vote Democrat, Republican, or Vegan, you'll be glad to know that there's consensus in the White House to pardon the Thanksgiving turkey. It's been a holiday tradition since Truman was in office.

Each year, two fowl candidates are flown to D.C. via commercial airline, courtesy of the National Turkey Federation. Just as the nation's vice president waits in the wings as a possible stand-in for the commander in chief, so does a vice tom. Turkeys, it seems, have a habit of dying suddenly, so to make sure no Thanksgiving goes without a pardonable turkey, there are two feathered candidates.

Unlike other White House guests who get to bed down in the Lincoln room, once the traditional photo with the president is taken, these guys are either escorted back to their home state or to Frying Pan Park in Fairfax County. Don't let the park's name mislead you, though. These turkeys won't wind up in any skillet.

Park staff holds a ceremonial "roast" to welcome the celebrated birds on the day before Thanksgiving. There's no heat here, just some turkey wannabes—schoolchildren, guests, and turkey lovers who've

practiced their gobbling to help the turkeys feel at home. Then the birds are shown to their new home at the park, a nice shady spot, with an 8-by-l0-foot shelter and a 20-by-30-foot yard. The toms are joined by a pair of handsome hens so they don't get lonely.

Unfortunately, the presidential turkeys are often a bit too big for their barnyard. Being "plumped to perfection" doesn't aid in longevity.

Sometimes, there's not a presidential turkey to see. Andy Rooney came out with a *60 Minutes* crew in search of a pardoned bird. "Where's Tom?" asked Rooney.

"He's where all the old turkeys go," quipped the park manager.

Although they're well fed, well cared for, and well treated, the birds don't live long. You can cast the conspiracy theories aside. "They're not bred for longevity. They come here to live out their golden months," the manager explains.

There is no cemetery to visit and no marker to lay flowers beside, although there is a special spot set aside in the park. Its location is a state secret.

The Tomb of the Unknown Turkeys, perhaps.

Kidwell Farm is at Frying Pan Park, 2709 West Ox Road, Herndon. Phone (703) 437–9101.

*Pardon me, Mr. President.*

# MOSBY'S MISCHIEF

Col. John Mosby and his band of Confederates rode into Fairfax one night and rousted Union Gen. Edwin Stoughton right out of his bed. Another Union officer, Lieutenant Colonel Johnstone of the Fifth New York Cavalry, opened a bedroom window on hearing the commotion of the troops leaving town and asked what cavalry was passing by. When the Confederates laughed, Johnstone knew he was in trouble. Springing undressed from the bedroom he shared with his wife, he ran out of the house into the night. The Confederates went after him but were stopped by Mrs. Johnstone. Mosby described her behavior as "like a lioness." The Confederates grabbed Johnstone's uniform from the bedroom and rode off with it and the captive Gen. Stoughton. They traveled south behind Confederate lines to Culpeper, where they turned Stoughton over to Lee.

Meanwhile, the escaped Union officer, Johnstone, had hidden in the backyard privy, spending a cold, stinking night in the South. Even though his "lioness" wife was relieved to find him alive, she refused to give him a hug or a kiss until she had brushed him down with a horse brush and given him a bath.

The food here is out of this world.

## For a Ferry Fine Time

Leesburg

Always shy on bridges, the Potomac River has been as much of an obstacle as an asset. In the past a hundred ferries carried passengers and products from Virginia to Maryland and D.C. Today only one ferry-boat, the *General Jubal A. Early,* continues to ply the Potomac River.

Four miles northeast of Leesburg, from a landing site now called White's Ferry, people have been crossing over into Maryland by ferry-boat since the early 1800s. Originally begun by the Conrad family, the ferry business was bought by Confederate officer Col. Elijah Veirs White, who was casting about for something new to do after the war ended. His ferryboat proved to be quite a workhorse, staying on the job through Reconstruction and the days of horse and wagon. After the turn of the twentieth century, it carried automobiles, six at a time.

The ferry business changed hands a couple of times in the early part of the twentieth century, and in 1946 a new boat, a recycled wooden army barge, came to work on the river. Owner Edwin Brown named it the *General Jubal A. Early* after the Confederate hero. Since then, although the boat itself has changed, the name has remained the same. Today the ferry carries pedestrians, sightseers, bicycles, and up to twenty-four cars at a time. On a weekday, as many as 200 commuters avoid the dreaded Capital Beltway by taking the ferry. It's a pleasure cruise compared to the usual commute.

White's Ferry is on Route 655 off U.S. Highway 15 northeast of Lees-burg. Phone (703) 777–1589. On the Maryland side, it's at 24810 White's Ferry Road, Dickerson; (301) 349–5200. The one-way fare is $8.00 for trucks, $3.00 for cars, and 50 cents for bicyclists and pedestrians.

The ferry runs from 5:00 A.M. to 11:00 P.M. 365 days a year, except during extreme high water or when the Potomac freezes over, a rare event indeed. It's still a pretty ride.

## Hoof on Over Here

Leesburg

Although foxhunting has fallen from favor in many parts of the world, it's still a big to-do in the Old Dominion. Folks belong to hunt clubs and dress up for the occasion in their hunting coats. Only the hunt staff may wear the red jacket, which are called "pinks" after the tailor who made them, and woe to the wag who buys one from a thrift shop and wears it to the hunt club ball. After a sip of liquid courage from the hunting cup, members mount their steeds and fly over fences, creeks, and logs. The tradition is ingrained.

The Museum of Hounds and Hunting is tucked away in a rarely used wing of Morven Park Estate, formerly the home of Governor and Mrs. Westmoreland Davis. Born to wealth and privilege, Davis was a riches-to-rags-to-riches story, due to the nasty repercussions of the South losing the war. He had to earn back the family fortune with real estate and his law practice. It didn't hurt that he married Marguerite Inman, heir to the Red Star shipping line. It also helped that his wife had childless sisters; when they died, the fortune boomeranged back to the surviving sibling, Mrs. Westmoreland Davis.

The Davises moved to Virginia to enjoy the sporting life, and they joined the Loudoun Hunt. Morley, as Governor Davis was called by his friends, wrote an early public relations piece to describe the hunt's economic benefits to the community. Cash was the reward for local farmers who allowed folk to fly through their fields on horseback, over their fences and crops in pursuit of br'er fox.

As it is with those who have too much time and money on their hands, heated conflict arose about which hunting dogs were better, English or American. Of course, out of the conflict came competition, along with the requisite cheating. One English hounds fan tried to rig the contest by purchasing a tame fox for $4.50. The ruse was discovered and the Americans were top dog.

In time, Governor Davis was named Master of the Fox Hounds, but his wife wasn't pleased. "The business of being Master of the Fox Hounds quickly became time-consuming and worrisome," she wrote. Westmoreland later helped organize the Masters of Foxhounds Association of America and the Huntsman's Room, the foxhunters' own Hall of Fame.

The museum contains saddles, trophies, jackets, buttons, silver horns, and saddle cups. Maps of the favored meeting places of different hunt clubs feature some of the finest estates in the country. Equestrian and canine art decks the walls. In the commissioned paintings of hounds and horses on a hunt, the socially prominent would always be placed at the front; those not worth mentioning were placed at the back and so small as to be unrecognizable. Not surprisingly, Governor Westmoreland usually appeared up front.

The Museum of Hounds and Hunting is located at Morven Park, 17263 Southern Planter Lane, Leesburg. Phone (703) 777–2414 or visit www.morvenpark.org.

Hunting for horse history? Well, trot on over to Morven Park.

## No Butts about It

Loudoun Heights

The Potomac would be just another river if it weren't for the fine fun at Butts Tubes, tucked along the riverfront at the far northwestern corner of Northern Virginia.

Here the Butts family has been making fun for a generation by putting butts in inner tubes. The place is a little off the beaten path on Harper's Ferry Road, just 5 miles from Harper's Ferry, West Virginia, so the Buttses make sure the price is right to make it worth the trip.

They'll take your $20 bill and give you a life vest, your choice of tubes, and a ride upriver. After that, you can float the day away.

Just remember that rocks can be hazardous. Be sure to lift your butt.

Butts Tubes also rents duckies, rafts, and canoes in case you want to keep your butt dry. Call (800) 836–9911 or visit www.buttstubes.com.

## A Bad Day to Stay in Bed

Manassas

The Henry family had farmed the land 5 miles north of Manassas Junction since 1826. Judith Henry was widowed in 1829 when her husband, Dr. Issac Henry, a U.S. Navy surgeon aboard the USS *Constellation,* died of pneumonia. Mrs. Henry went on about her business, raising her children and keeping the farm operating with the help of her daughter Ellen, slaves, and nearby neighbors.

In 1861 Judith was eighty-five years old, ailing, and bedridden when Confederate troops began fortifying the area around Manassas. Her grown children worried. Son Hugh wrote to his sister Ellen: "Should troops be passing about the neighborhood, you and mother need not fear them, as your entire helplessness, I should think, would make you safe." Hugh was sadly mistaken.

On July 21, 1861, green recruits from Lincoln's new army, who had signed up for ninety days of service to "whip the rebels," met equally untrained Confederate forces at Mrs. Henry's farm. Despite the desperate pleas of her family and the soldiers, Judith Henry refused to leave. Her slave, Lucy Griffith, stayed by her side while the first fierce battle of the Civil War raged outside.

When Union Capt. James B. Rickett's artillery battery fell under fire from the direction of the Henry home, he suspected snipers. Rickett's men returned fire, and Judith Henry, still lying in her bed, was seriously wounded. Lucy Griffith took cover in the fireplace and heard the cannon fire and bullets ricocheting off the stone.

Judith Henry died of her wounds that evening, becoming the first civilian casualty of the Civil War. Buried just a few yards from her home, her headstone reads: "The Grave of Our Dear Mother, Judith Henry. Killed near this spot by the explosion of shells in her dwelling during the battle of the 21st of July 1861. When killed she was in her 85th year and confined to her bed by the infirmities of age . . . "

Lucy Griffith survived and was reportedly hard of hearing for the rest of her life. Interestingly enough, she was freed four years after the July 21 battle by the same forces that shot her mistress dead.

The Manassas National Battlefield Park, which contains the Henry home, is located at Route 234 and U.S. Highway 29 in Manassas. The Henry Hill Visitors Center is open year-round. Phone (703) 361–1399 or visit www.nps.gov/mana.

## Mr. Mom Had Rights

Mason Neck

Who would have thought that one of the world's most important documents was written by a Mr. Mom?

George Mason lived downriver from Mount Vernon in one of the most beautiful plantations on the Potomac. A wealthy planter born with an English sterling silver spoon in his mouth, Mason lived well at Gunston Hall with his wife, Ann, and their twelve children.

Although Mason played a vital role in the formation of the new country and made a remarkable contribution as the author of the Virginia Declaration of Rights, after Ann's death in March 1773, he rarely journeyed from the plantation and declined a larger political role, choosing instead to be an active parent.

Like most of his Virginia neighbors, Mason was a slave owner, but he presented the radical idea that man was born with "certain inalienable rights." James Madison lobbied for the inclusion of Mason's ideas in the U.S. Constitution's Bill of Rights. The same ideas reappeared in the French Declaration of Rights of Man and Citizen, and the United Nations' Universal Declaration of Rights. Generations later, Mason's ideas were repeated in Birmingham and Selma, in Cuban prisons, and in Tiananmen Square.

In 1776 at the Virginia Convention, Mason wrote: "That all men are by nature equally free and independent and have certain inherent rights . . . among which are the enjoyment of life and liberty with the means of acquiring and possessing property, and pursuing and obtaining happiness and safety."

Mason also asserted that the power of government "is derived from the people" who retain "an indubitable, inalienable and indefeasible Right to reform, alter, or abolish" any government at will.

In a rare foray away from home, Mason attended the 1787 Constitutional Convention in Philadelphia. He hotly debated the content of the new draft constitution, arguing that too much power was being put in the hands of the government and too little in those of the people. He also insisted that the Constitution abolish the slave trade. When these items were not included, he executed his right not to sign.

Mason left Philadelphia, his signature nowhere to be found on the new Constitution. His refusal to sign not only made him an unpopular figure, it ended a lifelong close relationship with neighbor George Washington.

Although James Madison took up Mason's cause and introduced a Bill of Rights at the First Congress in 1789, Mason is one of the least-known of our founding fathers. That changed in 2002, when a memorial to George Mason opened on the Mall in Washington, D.C.

Gunston Hall Plantation is located at 10709 Gunston Road, Mason Neck. Phone (800) 811–6966 or visit www.gunstonhall.org. Open daily for tours.

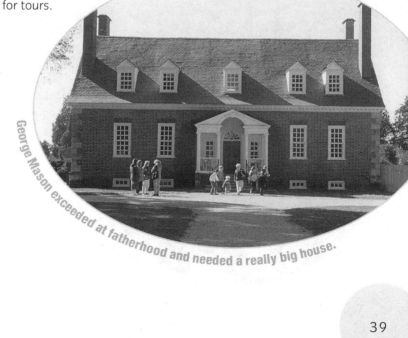

George Mason exceeded at fatherhood and needed a really big house.

## Aquatic Equines
Middleburg

Roger Collins swims not with the fishes but with the horses. He makes a healthy if watery living swimming horses at the Northern Virginia Animal Swim Center in Middleburg.

The indoor pool is nobody's backyard discard. It was designed especially for equines, although canines can take a dog paddle there too. Concrete ramps ease the horses into the deep water one hoof at a time. When they're neck deep, they instinctively begin to swim, with only the top half of their heads above water. Every few strokes, they'll blow like a whale, and the sound reverberates throughout the enclosed space.

The exercise is not horseplay. No pony pool parties are these. "We swim the horses for conditioning," says Collins. "It gives them an extreme cardiovascular workout." When training horses for racing and other events, about 60 percent of the training is groundwork. The laps in the pool are just as effective as running on hard ground, and much more gentle on the horses' legs. "It also boosts their confidence," Collins says.

The horsey hose-down precedes a dip for Dobbin.

The pool is kept cool and comfy at 66 to 72 degrees. Workouts are specifically designed for training, therapy, or conditioning and can include as many as thirty laps around the pool. As the horses swim, a trainer holds the harness and strolls the pool deck. Each horse is hosed down before and after its swim.

"This isn't new," says Collins. "The Egyptians and the English have swum their horses for centuries." And it isn't as expensive as you might think. The solo swim is a bargain at $15 a dip.

The Northern Virginia Animal Swim Center is at 35469 Millville Road in Middleburg. Phone (540) 687–6816 or visit www.nvasc.com for more information.

## Still the Father of Our Country
Mount Vernon

When experts were restoring George Washington's gristmill at Mount Vernon, they came upon another use for the grain: whiskey. Yes, the father of our country was also a distiller, and it wasn't just a batch of moonshine for his own use. George's five stills used the grain from the gristmill to make whiskey with corn, rye, and barley malt.

George hired Scotsman James Anderson to be his plantation manager. Anderson promised that the stills would be productive, making more profit for the plantation. Washington agreed to give it a try and began in 1797 with two stills.

Anderson proved to be right on. Virginia had a taste for whiskey. Washington sold the spirits by the gallon for 50 cents or so, and by the barrel to merchants in Alexandria who lapped it up. In its first year of operation, George Washington's whiskey factory made 11,000 gallons of the stuff and $7,500 cash profit. The distillery, one of the largest in

the Mid-Atlantic, was so successful that Washington added a cooperage to make barrels for his beverage.

The Distilled Spirits Council of the United States has underwritten the restoration of Washington's distillery, which is located 2 miles from Mount Vernon. When it's completed in 2007, visitors will be able to see how the whiskey was made; they just won't be able to taste it. Phone (703) 780–2000 or visit www.mountvernon.org.

## The Tank Farm
Nokesville

If you've had a hankering for a Sherman, you'll understand Allan Cors. The Virginian collects tanks, and they aren't miniature versions; they're the real deal.

"Since I was about ten years old, I've been fascinated by military history," says Cors. Over the years, he's read everything he could about the subject. "I'm interested in the documents, the uniforms, the firearms, the armor. In fact, I'd always thought it would be fun to be a museum curator," he muses.

The childhood fantasy was fulfilled in 1988 when Allan Cors founded the Virginia Museum of Military Vehicles. He had really begun in 1982, when he found a World War II Ford jeep that he said he just had to have. He brought it home to his upscale neighborhood in McLean. A year later, he added a three-quarter-ton WWII Dodge command car, and in 1985 he brought home a Sherman tank.

Displaying his collection was a lot harder than putting a trophy fish up on the wall. "First my car left the garage, then my wife's car left the garage, and then we stored the jeep under the deck. My wife, Darleen, was a good sport about it, but there have been some understandable questions along the way."

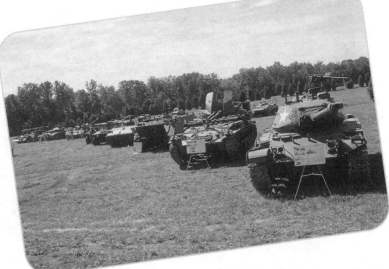

An extraordinary crop of tanks.

To solve the storage problem, Cors rented warehouse space in Alexandria and Warrenton. As any collector knows, the more space you have, the more you need. When his tank collection outgrew the warehouses, he bought sixty acres with a grass airstrip in Nokesville, and the Tank Farm was born. Today about 140 tanks, armored vehicles, and motorcycles are stored there.

And they all run. A staff of four and a host of volunteers have restored the armor to working condition. Cors has a license from the Bureau of Alcohol, Tobacco and Firearms and buys vehicles worldwide. His reputation has spread wider than tank treads. Calls come in from around the world for assistance.

The Air Ground Museum in Quantico asked for help in finding a 1917 Liberty truck. Cors located two being used for farm chores in Montana and re-created one good truck for the Marine Corps. Cors has com-

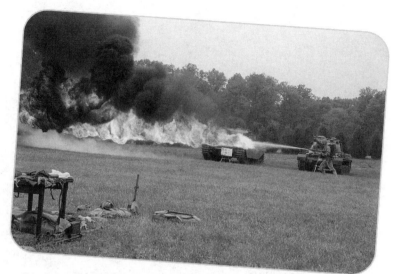

**Don't try this at home.**

pleted twenty other restoration jobs for the Marine Corps and the Army Museum System, with vehicles on display in Virginia, Georgia, Kansas, and Kentucky.

The military armor has also engaged in quite a different theater. Cors's collection has appeared in Hollywood productions, including *Godzilla, Species II, Mars Attacks, Rules of Engagement, The Sum of All Fears,* and *Flags of Our Fathers.*

Since there has been such a clamor to clamber about the Nokesville collection, Cors holds open houses annually at the Tank Farm, a few miles off Routes 28 and 234 on Aden Road. If you absolutely can't wait for the public events and have to rent one today, visit Cors's Web site. It's www.tanks2go.com, of course.

Cors is donating numerous vehicles to the National Museum of Americans at War, which is scheduled to open 2009 adjacent to the Manassas Regional Airport.

## She Dropped, but She Still Shops
Occoquan

Northern Virginia has cornered the shopping market. There's Tysons Corner, Dulles Corner, Galleria, Pentagon City, Fair Oaks, and Potomac Mills, and that's not all. Macy's, Bloomingdale's, Nordstrom, Neiman Marcus, Saks, Lord & Taylor, and Tiffany & Co. arrived in Northern Virginia about the same time as the Internet, and telecommunications money bubbled up like Texas crude. If you've got it, you can spend it in the New Dominion.

It's part of the reason the rest of Virginia hates the north, even Northern Virginia. All the money is there.

Shoppers fly in from such far-flung places as the United Arab Emirates, shipping stuff home by the boxful. Buses arrive at Christmastime for shopping excursions from all over, even from New York City, the capital of consumerism.

Many shoppers return to the quaint town of Occoquan again and again. Others, like Charlotte, remain, even when they've passed on into the next world. Charlotte is dead—quite dead—but her shopping habit reaches beyond the grave.

The port of Occoquan once received sailing ships laden with silver, silks, brocades, and jewelry from the far reaches of the British empire. As the wife of a sea captain, Charlotte was accustomed to the finer things in life. Today she haunts the pink house where she was once mistress. The house is now a series of shops, many selling vintage clothing and antiques. Charlotte must feel right at home because she still likes to try things on. Gloves, scarves, and hats are her favorites. Shopkeepers who tidy things up at night find disorder in the morning.

Charlotte is no shoplifter; she pays for her pleasure, stacking neat little piles of coins by the cash register. And, on occasion, she leaves a single red rose.

Charlotte is just one of the ghosts in this tiny mill town founded in 1763 on the banks of the river called Occoquan, an Indian word that means "land at the end of the water." One of the original Dogue Indians is said to haunt a restaurant mirror, scaring the daylights out of diners. Shops now located in an old funeral home have residents long passed who overstay their welcome. The merchants lead "Our Spirited History" ghost tours, so you can walk the walk with Charlotte and her other-worldly pals. Phone (571) 334–7357 or (703) 491–0635 or visit www .occoquan.com. The village of Occoquan is located off Interstate 95, exit 156 and go north on Route 123.

## Talk about an Identity Crisis

Quantico

Mitchell Raftelis is the mayor of the town of Quantico, the only town in America to be completely enveloped by a military base.

Sure, it has a little Potomac riverfront, but the shore is owned by the Marine Corps, and the water belongs to the state of Maryland, at least until the Supreme Court decides differently. But that's another story.

To get into Quantico and visit with any of its 561 residents, you pass by the statue of Iwo Jima, under a sign that reads Crossroads of the Corps, and stop at the guarded gate. Just tell the stone-faced sentries you're going to the town of Quantico and they'll let you pass. Finding the town is a little like finding a needle in a haystack. It comprises 30 square acres in the midst of the 57,000-acre military base.

Potomac Avenue is like any tiny American town's main street, only with more barbershops. There are ten different spots to get your hair cut on seven compact streets. There's one mailman and one full-time policeman, who has an entire squad of MPs at his beck and call.

Being surrounded by 15,000 Marines has some advantages. "We're more like a college town than a military base," says Raftelis. "We have people who live here for nine months out of the year. Some are geographical bachelors, and they don't move their families here for the short time they're in school. So they rent an apartment in town, eat in the restaurants, and get on the Internet at Java Junction to stay in touch with their families, just like a college town."

Raftelis grew up in Quantico, seeing movies at the base theater, playing baseball on the base fields, and swimming at the recreation center. The town hasn't grown any since he was a kid. It can't.

"We have an excellent relationship with the Marine Corps now," says Raftelis, "but that hasn't always been the case." When the Marines arrived in 1916, he explains, there were mud streets, board sidewalks, and the occasional milk or egg borrowing. Townsfolk got more sophisticated during Prohibition, bringing in a commodity more popular with the Marines. The men might tuck their bottles of shine into their boots, but the women could sew quite a few more bottles into their skirts.

The general grew tired of his Marines being drunk, says Raftelis, so he made the town off-limits until he found the ringleader. It turned out to be his sergeant major.

Quantico's mayor can call on assistance from one cop and 15,000 Marines.

Quantico is located off I–95 (exit 150) in Prince William County. Stop at the gate at the intersection of US 1 and Route 619, and tell the Marine guard you're going to town. Follow Fuller Road for 3 miles to the first traffic light and turn left on Potomac Avenue.

## One House to Go, Please
Quantico

It seems you can buy almost anything on the Internet these days. How about an antique metal house from Marine Base Quantico, the Crossroads of the Corps?

Dubbed the "Easter Egg Houses," the bright yellow, pink, and powder blue prefabricated Lustron homes were used in the 1950s to house military families on the base. They were mass-produced in a Midwest factory, and the parts that would become a house were shipped to lucky buyers who assembled them. And, if they didn't like the neighborhood, the house could be disassembled and moved again. The original cost was $10,000 apiece for 1,000 feet of living space—a real, real estate bargain.

The entire house is made of steel, except for the windows and the floor. To hang pictures, housewives would use giant magnets. Almost indestructible, the steel walls could take what any kid or Marine could dish out.

According to preservationists, of the original 2,500 Lustron houses produced, about 1,500 are still serving their original purpose. They're being given away for free to anyone with the means and know-how to take them apart and move them away. The developer hopes they'll be used by people who have lost their homes to hurricanes, people with severe allergies, or preservationists who want a unique home.

If you're a man (or woman) of steel who wants to live in a free steel house, look online at www.lustronsatquantico.com. No word on what your wi-fi or cell phone reception will be!

## A New Twist on Tobacco
Sterling

While smoking cigarettes is about as politically correct as wearing fur coats, the young and hip in Loudoun County take their tobacco with a twist at a hookah bar in Sterling. The entire state's economy once revolved around "the dirty weed," and now this cash crop has become the salvation for the brothers Ahmed, a trio of transplants from Bangladesh.

When the tech bust came to Virginia, network engineer Shuman Ahmed went in search of a better way to support his family. Given the immense immigrant population in metropolitan Washington, Ahmed thought a hookah bar might be popular with Middle Eastern men and light up his own economy. So in 2004 Ahmed refinanced the family homestead and opened the Shisha Cafe and Lounge in Sterling. Although the name seems creative and cute, it actually is the translation of a word meaning "smoking tobacco through a water pipe."

One brother, Palash, an internationally known deejay, thought that world music might add to the élan. Another brother, Shimul, who is a trained chef, created an eclectic menu of kabobs and sandwiches. They added a belly dancer to attract additional patrons on Thursday nights and hoped for the best.

Their success came with a surprise! Middle Eastern men didn't much like the music, but the college crowd did. Students gravitate from Virginia colleges like nearby George Mason and Northern Virginia Community College, but also sneak in from very cosmopolitan corners like the

District of Columbia and Richmond. There's even a site on MySpace.com for Shisha'ites, as they call themselves, to share their cafe exploits.

Tiny by modern restaurant standards, the 760-square-foot restaurant at 20921 Davenport Drive, #130, has twelve tables. Customers can order a kabob, a sake bomb, and a choice of flavored tobaccos to be smoked in an ornate brass hookah. You can order up apple, coconut, mango, peach, strawberry, or lemon drop tobaccos or any number of other flavors of the fruity, candy-coated carcinogen until 2:00 A.M. on weekends.

Although hookahs are an ancient way to get hooked, the cafe is as modern as the moment. For more information, call (703) 444–8848 or visit www.shishalounge.net.

## What National Park?

Triangle

Within the suburban jungle of Northern Virginia is a strange oasis: a 17,000-acre forest, covering 27 square miles, that is among the least-visited national parks on the East Coast.

It was the brainchild of FDR, planned as a Recreation Demonstration Area to get kids out of the city. The Office of Strategic Services used the park for intelligence training during World War II. Today the park boasts 37 miles of hiking trails, bicycle paths, camping areas, and historic sites. Cabins, originally built by the Works Progress Administration during the Depression, cost $40 a night for a family of six.

It's the cheapest sleep in the region. And the most peaceful.

Prince William Forest Park is located in Prince William County, off I–95, exit 150. Follow Route 619 to the park entrance. Call (703) 221–7181 or visit www.nps.gov/prwi for details.

## Food for Thought

Triangle

Along US 1 just a few miles from the Crossroads of the Corps is one of the Marine Corps' most beloved secrets, the Globe & Laurel Restaurant. Opened in 1975 by Maj. Richard Spooner (Ret.) and his wife, Gloria, the Globe & Laurel provides an all-corps pub atmosphere and fine food. During the day there's more brass in the restaurant than you'd find in most bands. Medals and spit and polish are the order of the day. Between courses of onion soup, prime rib, and tasty desserts, diners can view Marine memorabilia, which covers the walls and ceiling of the place. There's plenty to feast on.

Spooner has allowed guests to leave their beer steins and patches behind, and the rest is history. Patches and insignias give an informal lesson in the Marine Corps' century of distinguished service. One family donated a late relative's Medal of Honor. They knew it would be displayed as a treasure. It is.

The Globe & Laurel Restaurant is located on US 1 (northbound) in Triangle. Phone (703) 221–5763. The restaurant is open for lunch and dinner Monday through Friday, with dinner served on Saturday evenings.

## Pray Tell, a French Church in Virginia?

Upperville

Driving along US 50, tourists are often surprised by what appears to be a medieval stone church. One of the most beautiful structures in Northern Virginia, this adaptation of twelfth-century French architecture contains a twenty-first-century Episcopalian congregation. The stone courtyard, sanctuary, and bell tower comprise a surprisingly spiritual spot in wealthy hunt country.

The building sprang from one of the most primordial elements: fire. And funds. Lots of funds.

The first church was built on this site in 1842. When fire destroyed it, it was rebuilt on the same foundation in 1895. The foundation eventually failed, and the church building was declared unsalvageable. Fortunately for the tiny congregation, members were able to help. In the 1950s Mr. and Mrs. Paul Mellon stepped up with an offer to build a new sanctuary. The philanthropists pulled out all the stops on the new church. Begun in 1955, construction on the new Trinity church was completed six years later. It was a good investment for Mr. Mellon. The churchyard is his final resting place.

*Thoroughly modern Mellon money kept the faith in Upperville.*

New York architect H. Page Cross adapted the style of the French country churches of the twelfth and thirteenth centuries. The limestone and sandstone for the new church were quarried locally and carved by local craftsmen. In the medieval tradition, they forged their own tools on-site.

Mellon cast a much wider net for the ornamental aspects of the church. Heinz Warneke was hired to hand carve the adornments on the pews, pulpit, and columns. His work also adorns the National Cathedral, and he served as the head of the Department of Sculpture of the Corcoran Gallery of Art. The ironwork was executed by P. A. Fiebiger of New York City. A medieval church near Dresden, Germany, donated the tower angels. The organ, famous in musical circles, was designed by Joseph S. Whiteford, president of the Aeolian-Skinner Organ Company of Boston. It has three manuals and forty-three ranks of pipes. The flags, designed by the Heritage Flag Company, depict the history of the church, the gospels, and various secular themes. Also displayed are the kings' colors, the Great Seal of the Commonwealth of Virginia, the Stars and Bars, and Old Glory—all on the same wall.

The bells in the tower were cast in England. In a gentle gesture, they were dedicated to "the men of this countryside, who by the skill of their hands, have built this church."

Visitors are welcome at Trinity during regular church office hours and for Sunday worship, but they are not welcome to climb the tower. The church brochure warns: "Anyone present on the upper stages when the greater bells ring may find his hearing seriously impaired."

The church is located on US 50 in Upperville. Phone (540) 592–3343.

# RUNS, RACES, BRANCHES, AND SPRINGS

Outside the Old Dominion, there are brooks, creeks, streams, and rivers. In Virginia, we have different appellations.

A spring is where freshwater bubbles out of the ground. A run is a rapidly flowing body of freshwater without any tidal influence (think Bull Run). With so much of Virginia on the Chesapeake Bay watershed or the Atlantic itself, lots of rivers have tides. In fact, 3-foot tides are water under the bridge in Alexandria.

A trace is a gully with a little bit of water in it, and a race is a gully with a lot of rapid-running water.

A branch is a bit of heaven. It's clear, cold freshwater on its way to join a bigger body of water, maybe a race or a run. The best thing about a branch is bourbon and branch, what you drink when you're not having a mint julep.

## Hey, Big Spenders, This Is Virginia's Most Visited Attraction
Woodbridge

Take a guess at what is Virginia's most visited attraction. Monticello? Mount Vernon? Arlington? Williamsburg? Here are a few hints before you guess again.

The site preserves two family cemeteries and isn't far from the old wood bridge that took George Washington's crops to market. The attraction was featured on a Virginia lottery ticket as the historic site crossed by the first telegraph line from New York to New Orleans in 1847.

Give up?

Most folks don't even notice the headstones or the historical marker. They've got other things on their minds: Virginia's most visited attraction is Potomac Mills. That's right, a mall!

More than twenty-two million visitors soak up contemporary culture each year at this value outlet mall located on I–95, just 32 miles south of the nation's capital. That's exponentially more folks than visit Manassas National Battlefield Park, which draws just under a million every year.

*The mall of all malls.*

What makes Potomac Mills an attraction is its size. Bigger than a lot of Virginia towns, it's divided the same way, into cute little neighborhoods. Giant scissors, Lego blocks, and gargantuan shoes help show the way through the maze of storefronts. The mall has twenty eateries and eighteen movie theaters. IKEA, the Swedish furniture giant, expanded its Potomac Mills store from a paltry 155,745 square feet to 300,000 square feet of household "necessities."

Potomac Mills is the size of a downtown. With 1.7 million square feet of retail space, that amounts to nearly a mile under roof. You can walk its boardwalks—designed to comfort the tootsies—for the better part of a day and still not see it all. It even has its own exit off I–95.

Close to Washington's three international airports, Potomac Mills is a hangout for a very global group. Saris and dashikis are as common as baggy jeans. People nosh on Japanese stir-fry, pitas, tacos, and Cajun red beans and rice. There are sweets aplenty to keep folks sugared up and spending.

And there's plenty of spending to be done. Potomac Mills discounts everything, from baubles to Bibles to bras. There's a custom tailor, a flag shop, Off-Fifth Saks, Brooks Brothers, and Polo Ralph Lauren. There are two-dozen shoe stores and six jewelry stores dripping with diamonds and gold.

There's no language barrier here—everybody speaks bargain. To be a tenant, merchants must offer 20 to 70 percent off the retail price of their merchandise.

Potomac Mills is 32 miles south of Washington, D.C., at exit 156 off I–95. For more details, call (703) 496–9301 or visit www.potomac mills.com.

# CENTRAL VIRGINIA

Crozet

Charlottesville

Madison

Amelia County

Reva

Viewtown

Bealeton

Spotsylvania

Fredericksburg

West Virginia

Culpeper

Barboursville

Schuyler

Lynchburg
Forest

Bedford

Farmville

Richmond

Petersburg

Boydton

North Carolina

0        50 Miles

0    50 KM

# CENTRAL VIRGINIA

## Buckets o' Bling

Amelia County

Before the California gold rush, Virginia was a gold mine.

In fact, in the mid-nineteenth century, the state was the third-leading producer of the magical Midas ore. There are plenty of places to keep you searching for your heart of gold in the Commonwealth, including the Goodwin Mine at Lake Anna State Park (540–854–5503) and Virginia City (276–223–1873) outside of Wytheville. But if what you covet is a bucket of baubles and bling, head out to the Morefield Gem Mine in Amelia.

The mine was opened in 1929 to extract gems and commercial-grade minerals from a massive pegmatite vein. The vein runs some 2,000 feet and is approximately 300 feet wide. It's chock-full of eighty or more minerals and is a world-renowned site for the gemstone amazonite. Morefield is also known for yielding amethysts, garnets, topaz, quartz, and plenty of pyrite (fool's gold). Some of the stones found on-site are on display at the Gem Hall of the Smithsonian Institute National Museum of Natural History.

The Morefield Mine was purchased by Sam and Sharon Dunaway, who run the whole hole as a commercial tourist mine. Sam fell in love with the place as a kid, and when it came up for sale, he rushed from Alaska to strike it rich with a gem mine. Although generous to a fault,

the couple keeps a miserly schedule. It's only open to the public on Saturdays during the spring and fall.

If you're feeling lucky and don't mind getting dirty, bring a few buckets from home, pay your $10 admission fee, and start digging around the piles of mine rubble. Once your bucket is full, head out to the sluice, where you can separate the sparkles from the muck. Leave the high heels at home—sturdy shoes and old clothes are recommended. You might want to sparkle like Paris Hilton after midnight, but by day, it is dirty work digging up your gems!

The Morefield Gem Mine is located at 13400 Butlers Road. Call (804) 561–3399 or visit www.toteshows.com/morefield for details.

Gold rushers hurry to a new pile of rock from the underground motherlode.

## Wine amid the Ruins

Barboursville

Thomas Jefferson had a lot of good ideas. One of the best was growing wine in his native Virginia. Considered the father of American wine, he was a real beverage booster, encouraging Americans to drink wine with their meals and grow grapes as an industry. He even served as sommelier to the White House.

While in France, this bon vivant studied the wine industry and brought back vines he thought would grow in the southern climate. They didn't.

The Civil War and Prohibition reversed any progress made in viticulture. Carry Nation and her crowd of teetotalers took their toll. In 1950 there were only fifteen acres of grapes in the entire state.

It took a couple hundred years, but eventually Jefferson's idea took root. American appetite for wine reached amazing levels in the 1960s, and the Farm Winery Law made it possible for small farmers to get into the act. Today Virginia has more than sixty wineries, each marked by a little purple sign with a cluster of grapes. It's possible to spend a two-week vacation sipping, sampling, and enjoying Jefferson's idea.

**Old Dominion winemaking comes into its own at Barboursville Vineyards.**

The house Jefferson designed for Governor James Barbour was much more impressive before it burned down.

Nowhere is the spirit of Jefferson more evident than at Barboursville Vineyards and Historic Ruins. Governor James Barbour, a buddy of the president, admired Jefferson's architectural skills. Jefferson designed Barbour's home, which burned on Christmas Day in 1884. Today the ruins are surrounded by a thriving enterprise with an elegant restaurant, winery, and tasting room. Buy a bottle, pop the cork, and toast Tom's contributions amid the ruins.

Barboursville Vineyards and Historic Ruins is located at 17655 Winery Road in Barboursville. Tastings are offered daily, winery tours on weekends. On summer nights the winery offers Shakespeare as you sip. Phone (540) 832–3824. Visit online at www.barboursvillewine.com.

## Le Cirque du Ciel: The Flying Circus Aerodrome
Bealeton

Those amazing young men in their flying machines still amaze and amuse the crowd at the Flying Circus Aerodrome and Air Show in Bealeton.

This grassy airfield off U.S. Highway 17, where the days of barnstorming never ended, seems frozen in time. Legendary biplanes, like the Stearman, the Waco, and the Ryan, have taken to the air every summer Sunday for thirty years.

The audience sits on wooden benches, craning their necks skyward to catch a glimpse of aerobatic maneuvers. The Flying Circus preserves the barnstorming tradition with all its swagger and glamour.

In the years between WWI and WWII, in the days before television and Ipods, flying circuses were a primary form of entertainment. Pilots would buzz family farms to "advertise" the upcoming events. Locals would come by the hundreds. They'd ooh and aah as "those daring young men in their flying machines" performed amazing aerobatic moves, spins, and loops. Heroes like Charles Lindbergh and Wiley Post first flew as barnstormers before making history.

Barnstorming, wing walking, and biplane acrobatics draw crowds to the Flying Circus Aerodrome in Bealeton every summer Sunday.

After the show, locals would plunk down a hard-earned dollar to take a ride in one of the flying machines. The cost for today's joyride ranges from $50 to $100 at the Flying Circus Aerodrome, but if you prefer to stay planted on terra firma, there are still plenty of thrills.

Families arrive hours before the 2:30 P.M. showtime toting picnic baskets and binoculars. Kids can ride in a small plane powered by a garden hose or ride aboard a hay wagon. The world's smallest mall sells low-tech balsa wood airplanes, metal replicas, and model kits.

Twelve privately owned aircraft perform every Sunday from May through October to cheering crowds. When the vintage planes bump along the grassy runway toward takeoff, it seems improbable that they'll fly—but they do. Show highlights include a skydiver unrolling an American flag, aerobatic maneuvers, airborne ribbon cutting with propellers, and great bombing runs with sacks of flour from the Food Lion. And wing walkers, of course.

A beloved favorite is Charlie Kulp, born in 1926. One of the founders of the Flying Circus, this performer is still flying high at age eighty. Charlie takes to the air in his 1946 Piper J-3 Cub. His character is the Flying Farmer, a pilot novice on his first flight, with terrifying banks, stalls, and near-misses with the ground and treetops. Fortunately, his act is just an act! Kulp is one of the best pilots of any age, with more than a half century of cockpit experience.

You can catch Charlie's act and others (barnstormers, parachute jumpers, etc.) at the Flying Circus, located off US 17, 14 miles south of Warrenton; turn left on Route 644. Phone (540) 439–8661 or visit www.flyingcircusairshow.com. Admission is charged.

## Holy Cow!
Bedford

Who would have thought that you could cross the River Jordan so near the James?

Those who paid attention in Sunday school will appreciate the Holy Land USA nature sanctuary. This larger-than-life walking Bible is a 3-mile journey through the best-loved tales of the Old and New Testaments. Covering 250 acres, this free attraction at 1060 Jericho Road near Bedford is a popular spot for groups and families.

A host of animals populates the Holy Land. Sheep, goats, and donkeys graze in Shepherd's Field. Your travels will take you through Jericho to Nazareth, where Joseph's carpenter shop is open for business and you can refresh yourself with a cool drink at Mary's well. The Dead Sea Scrolls are found daily at Qumran.

The pilgrimage concludes at a bookstore with an assortment of devotional items. If you're not into making the journey by foot, Holy Land offers a twenty-first-century riding tour, not on donkeys but in vans or school buses.

The Holy Land has proven so popular, it's miraculously being renovated and expanded for 2007. Pilgrims can check the progress on the Web site at www.holyland.pleasevisit.com or by calling (540) 586–2823.

## Beale Treasure
Bedford

Nothing attracts attention faster than buried treasure—especially when the booty includes more than one and a half tons of gold, two and a half tons of silver, and a king's ransom in jewels. For more than a century, people have been shoveling, picking, and poking around Bedford County looking for the Beale Treasure.

In 1817 Thomas Jefferson Beale and twenty-nine of his Virginia neighbors headed west to seek their fortunes. Legend has it that Beale needed a change of scenery because of a woman. Not just any woman, mind you, but his neighbor's wife. Whether he coveted her or caught her, we don't know. What we do know is that the neighbor was shot dead, and Beale got out of town to avoid a hanging.

Beale and his buddies headed toward the Rocky Mountains to trap and hunt furry creatures and make bundles of money with bundles of fur. Instead, luck found them as they stumbled upon an exposed gold vein. They stopped, and the trappers became miners in an instant.

After a year's hard work, half the party headed back east with two wagonloads of gold and silver nuggets. They ended up making several trips back to Bedford County and secreted the stash 6 feet under. The party created a complex code to guide them back to the site.

The first code described the location of the treasure, the second outlined the contents of the vault, and the third listed the names of the thirty men who would equally divide the treasure. The codes were then placed in a locked strongbox and left in the safekeeping of a Lynchburg innkeeper named Morris. Beale told Morris to keep the box secure for ten years, then if no one claimed it, Morris could open it.

Several months later Beale wrote Morris that he had given the keys to the code to a friend with precise instructions to mail them to the innkeeper in June of 1832. Morris would never hear from Beale or any member of his party again. The fate of the thirty men remains a mystery.

Morris kept the strongbox for twenty-three years before opening it and trying to decipher the code. A friend of his, James Ward, claimed to have broken Beale's Code #1, which was based on Thomas Jefferson's Declaration of Independence. Deciphered, it reads: "I have deposited in the county of Bedford about 4 miles from Buford's in an excavation or vault 6 feet below the surface of the ground."

Although treasure hunters have been digging themselves to distraction, not a single gob of gold has been unearthed. The current owners of the property, Danny and Nancy Johnson, make their living growing apples and grapes, making wine, and tolerating the treasure hunters.

The Johnson's did find a treasure in their orchard: a new variety of golden apple. In a natural ironic twist, the couple named the fruit "Gold Nugget."

## Buggs Island Lake
Boydton

If it bugs you that politicians get their names plastered all over all sorts of public projects, take heart: You can still call the Kerr Reservoir by its original name. Although it was renamed in honor of North Carolina congressman John H. Kerr more than forty years ago, locals still call the reservoir Buggs Island Lake. Buggs Island, a spot of land in the middle of the Roanoke River, got its name not from a politician but from early settler Samuel Bugg.

Straddling the Virginia–North Carolina border, the man-made lake was created when the Army Corps of Engineers built a dam to control flooding on the Roanoke. The river had a habit of wreaking havoc along its banks, spilling out an incredible fifty floods between 1899 and 1940. The floods had become an annual event unworthy of any celebration.

Containing the river was a mighty undertaking. The dam was to do more than just hold water; it was to provide electricity for the region as well. Workers dug down to bedrock and filled any natural crevices with concrete. They built the dam with 624,244 cubic yards of concrete, 1,317,786 pounds of structural steel, 578,440 barrels of cement, and tons of crushed stone, reinforcing steel, and sand.

The project was successful in more ways than one. It not only controlled the raging Roanoke River and provided electricity for the power-hungry region, it became a tourist attraction in its own right. More than four million people visit every year. The 50,000-acre lake is a popular spot for boating, swimming, fishing, and camping at thirty recreation areas on the shoreline. Make a splash! Phone (804) 738–6371 or visit www.kerrlakechamber.com or www.boydton.org.

## The Place to Pig Out
Charlottesville

Everything about the Boar's Head Inn, a five-star restaurant, hotel, and spa, is about as upscale as you can get. But the lowly pig has a high place in its history, as evidenced by the boar's head that is displayed in the lobby of this elegant inn in Charlottesville.

During medieval times, the sport of hunting boar was reserved for royalty. So when the king shared his catch with his underlings, it was party time. The head of a pig on a platter became a symbol of hospitality.

For a number of years, the Boar's Head Inn held its own piggy party at Christmastime, taking guests back to sixteenth-century England. The Feast Before Forks was a seven-course meal that guests ate with their fingers. The menu included Blamanger of Fysshe with Gillyflower, Brave Salette Dross'd with Vyoletts, and Grand Boyld Pudding of Plumme. (Yes, that's English!)

After eating, the crowd helped light the Yule log and tossed in a sprig of greenery to ward off evil spirits. There were other curious holiday customs too, such as pouring drinks on the roots of pear trees. Medieval farmers did this to assure bountiful crops for the following season.

The grand finale of the party was the parade of the pig's head through the dining rooms, followed by bands of carolers, fools, and jugglers. Of course, eating and drinking concluded with dancing and drunken revelry. As guests bid their adieus, they were served horseshoe-shaped rolls, honoring St. Stephen, the patron saint of journeys.

Although the Feast Before Forks is a thing of the past, you can enjoy the Boar's Head Inn's hospitality year-round at 200 Ednam Drive in Charlottesville. Phone (434) 296–2181 or (800) 476–1988.

## Better Than a New York Pizza

Crozet

Located a good fifteen-minute drive from Charlottesville, in the heart of Crozet, is a pizza place that doesn't look much like one from the outside. If you want one of Crozet's world-famous pizza pies, you'd better make a reservation (434–823–2132), and bring cash—the restaurant doesn't take credit cards. Despite the inconvenience, it's the hottest spot around.

*Looking for some dough? Let Ben Murphy be your guide!*

International writers from such notable publications as *Fodor's* and *National Geographic* rate its pizza "best in dough." Celebrities of all sorts stop in at 5794 Three Notched Road for a pizza that's not too greasy, with a crust that's nice and thin. There are twenty-five toppings and gourmet pizzas, like artichoke or asparagus with cheese, creating untold numbers of crowd pleasers.

When the family-owned business opened, it was the only place to go in Crozet. Although there are plenty of pizza joints in Charlottesville, no self-respecting University of Virginia student would go anywhere else.

Visit Crozet Pizza's Web site, www.crozetpizza.net, for more information, including their menu.

## Under Mount Pony

Culpeper

Why there's an office building on a farm in Culpeper is a tourist question. Everybody else already knows.

During the cold war, Mount Pony was the Federal Reserve's equivalent of a mattress stuffed with cash. This was to be the Federal Reserve Bank Disaster Recovery site, with enough money in its vault to keep Washington running for thirty days. Although the site was supposed to be a

*There's gold in them thar hills!*

secret, many of the local residents worked as carpenters, plumbers, and masons, constructing a six-story building. Three of those stories were built underground. The three floors aboveground are still visible.

According to the locals, desks were delivered in shrink-wrap, with papers, pens, rulers, and adding machines. They didn't get a glimpse of the cash, though it was there, shrink-wrapped as well and stacked on pallets.

Today the site is still inaccessible. However, plans are underway for the Library of Congress to use the climate-controlled vaults to store its motion picture, television, and recorded sound collections.

## The Egg Came First
Culpeper

Self-taught artist Marie Fox is known in Culpeper as the Egg Lady. But she doesn't have chickens on her farm; her eggs are ceramic. Better than the traditional butter and egg money earned by farm wives, Fox's eggs have taken her to Paris.

She began making "birthday" eggs for friends. They became so popular that the artist painted Christmas eggs, Easter eggs, and a whole host of holiday eggs. "I've made over 600 eggs and shipped them to every state in the union and throughout Europe," she says proudly. One egg found its way into the hands of Jean Leducq, owner of the Prince Michel Vineyards in nearby Leon. Leducq hired Fox to paint the "history of wine" murals in the winery's museum. To make certain that every detail of the gendarmes was perfect, Leducq sent Fox to Paris to research the uniforms in person.

"All because of one stupid little egg," says Fox.

You can find Fox and her works at Windy Acres Creations, 18402 Windy Acres Road, Culpeper. Phone (540) 825–3124.

## Triassic Park
Culpeper

If *Jurassic Park* kept you awake at night, don't go near the Stevensburg Quarry. This site contains the most dinosaur tracks ever found in one place.

In 1989 quarry workers uncovered an ancient mudflat some 250 feet under today's terra firma. The workers noted something amiss: Hundreds of tracks covered the stone. Soon scientists from the United States Geological Survey in Reston swarmed over the site. What these workers had unwittingly uncovered was a mega dino-site, with 4,800 dinosaur tracks in one place. That's the world record.

No need to worry about lurking velociraptors though. These tracks were made some 215 million years ago. Once upon a time, these large leaping lizards wandered around a narrow lake, which spanned Leesburg to Culpeper. Not only are there footprints, there are belly prints, made as these critters dragged across the wet mud.

Tracking the tracks doesn't require clambering about the quarry, thank goodness. You can see them at the Smithsonian Natural History Museum in D.C. or in the Museum of Culpeper History at 803 South Main Street; (540) 829–6434.

## Still Shining!

Culpeper

Milk might be Virginia's "official" beverage, but farmers have been bottling corn for consumption for centuries. It was far easier (and far more lucrative) to move moonshine than bushels of grain down the steep slopes of the Virginia hills.

Stills were tucked away in mountain glades, and the illegal liquor became the stuff of legend. The name "bootlegger" came from the custom of tucking a bottle or two into your footwear before walking into town. The feds took umbrage at anybody making money without paying their appropriate taxes, and "revenuers" came looking for the entrepreneurs.

Seventy-three years and still shinin'.

During Prohibition, moonshine grew in popularity, and the hill folks found ways to make their cars quicker than those driven by the law. The same hill people who outran the revenuers found another outlet for their fast cars: NASCAR was born.

Lots of folk in Virginia still make moonshine, but only one moonshiner does it with a license. It's Belmont Farms Distillery, located at 13490 Cedar Run Road in Culpeper. For almost twenty years, the Miller family has been growing, harvesting, storing, and grinding their own corn for one lofty purpose: making moonshine.

"My grandfather made whiskey back in the twenties. Of course, it was illegal back then. We dusted off the old family recipe and applied for a license, but I couldn't get the license unless I had a still," says Chuck Miller. He located this unique piece of equipment thanks to the friendly folks at the Bureau of Alcohol, Tobacco and Firearms, whose job it is to know these things.

Miller's moonshine is absolutely authentic, distilled the old-fashioned way through the thirty-year-old copper still relocated from Charlottesville. Although the moonshine drips out at 160 proof, the family has to cut it with water to meet legal requirements of 100 proof. "White lightning," the moonshine of old, was sold by its makers at a blinding 190 proof.

According to Miller, who really uses the family "recipe," the copper pot still is actually the secret to their great corn whiskeys, named Virginia Lightning and Copper Fox. "It tastes like moonshine," says Miller, "and it gives you a little kick and makes you feel all rosy."

The Millers give tours at their Culpeper distillery and have a gift shop with some unusual souvenirs. You can purchase the products at Virginia ABC stores or online at www.virginiamoonshine.com. Once you take a swig (out of a Mason jar, please), you'll understand how Virginia Lightning got its name with just a couple of sips. It strikes fast!

## Moton Museum

Farmville

Most students study history. At Robert Russa Moton High School in Farmville, high school students made history by changing the American educational system.

When Virginia's public schools were founded in 1870 under Reconstruction, they were organized as two systems, one for blacks, another for whites. The latter got a better deal, with better buildings, equipment, books, and teachers.

Farmville's Robert Russa Moton High School for black students opened in 1939. Unlike the white school, it had no gymnasium, cafeteria, lockers, or auditorium. Built to hold 180 students, it had 477 enrolled by 1950. Temporary buildings were erected to ease the crowding. The kids and the community called them "tar paper shacks."

The kids decided to take action. On April 23, 1951, innovative students tricked the principal, getting him to leave the building by calling in a false report of truants at the local bus station. In his absence, they assembled and called for a strike. The principal returned from his wild-goose chase and begged them to return to class. They didn't. When the school board refused to meet with the students, they marched on city hall.

The student strike lasted two weeks, but the results are with us today. Farmville became a part of the *Brown v. Board of Education* suit in the U.S. Supreme Court, which eventually led to the integration of the nation's schools. Prince Edward County closed its schools rather than comply with court orders to integrate, and they stayed closed for years. In 1964 another court decision forced the county to reopen its public school system.

Fifty years later, the students reunited at the school, now the Moton Museum, and reenacted their strike. All of them got an A+. Visit Robert Russa Moton Museum, 900 Griffin Boulevard, Farmville. Phone (434) 315–8775 or go to www.motonmuseum.com.

## Presidential Privacy
Forest

Most people know that America's third president, Thomas Jefferson, had a reputation as a bon vivant as well as a statesman. He had a love of fine wine, literature, architecture, and more than a few women. He also had trouble living within his budget.

*Not a secret any more.*

His home at Monticello was among the most beautiful in all the colonies, but Jefferson wasn't content. People would come calling at his home in Charlottesville, tapping on the windows with their parasols, hoping to capture some presidential favor. These folks were the celebrity stalkers of their time. So in the final year of his presidency, Tom started making plans for a presidential retreat.

While modern folk might have a hankering for a beach cottage or motor home, Jefferson wanted a little privacy, so he built his dream house in remote Forest. Called Poplar Forest, the house was such a secret that Jefferson rarely referred to it by name in his letters.

Not content with just a retirement shelter, Jefferson built an architectural wonder, an octagonal brick house, elegantly appointed and landscaped. Even the privies were octagonal brick buildings, landscaped and bunkered from view of the house.

Here he took his early morning horseback rides and kept adding to his library. Both master and slaves would travel the long, bumpy road from Monticello to Poplar Forest, where Jefferson lived out many happy days of his golden years, reveling in "the life of a hermit."

Today you can visit Poplar Forest, now a National Historic Landmark, at Poplar Forest Drive and Fox Hall Road in Forest, just southwest of Lynchburg. Visit www.poplarforest.org or call (434) 525–1806 for more information.

## Stonewall Jackson Shrine

Fredericksburg

Nobody's star shone brighter in the Civil War than Stonewall Jackson's. And nobody's luck ran out more quickly.

Trained at West Point, hero of the Mexican War, and an instructor at the prestigious Virginia Military Institute, Jackson quickly earned the rank of brigadier general in the Confederate army. The nickname "Stonewall" was earned at the Battle of First Manassas, where Gen. Bernard E. Bee proclaimed: "There is Jackson standing like a stone wall! Rally behind the Virginian."

Stonewall was a legendary figure among Northern and Southern troops, inspiring both loyalty and fear, at least until his luck ran out.

At the Battle of Chancellorsville on May 2, 1863, Jackson was accidentally shot by his own men. He was wounded in his left arm and right hand. The wounds were so severe that his left arm was amputated in an effort to save his life.

Field chaplain B. Tucker Lacy buried Jackson's arm in a Lacy family cemetery nearby, and Jackson was sent to Fairfield to recuperate at a plantation owned by Thomas Chandler. Jackson's wife, Mary Anna, and their infant daughter arrived and kept a vigil at his bedside. He was well enough to apologize to his host for not being able to shake hands. And he sat for a photograph at his headquarters.

Despite the best efforts of five doctors, Stonewall succumbed to pneumonia eight days later, on May 10, 1863, in an outbuilding on the Chandler Plantation. His last words were, "Let us cross over the river, and rest under the shade of the trees."

The Stonewall Jackson Shrine is part of the Fredericksburg and Spotsylvania Military Park, off Interstate 95 south of Fredericksburg. The only remaining part of Chandler's plantation is the office, which served

as Stonewall's private hospital. His bed, quilts, and medical equipment are on display.

Jackson and his arm were never reunited. His arm is buried at Ellwood in Locust Grove. The rest of him is buried in Lexington at Washington and Lee University.

The Stonewall Jackson Shrine is located at 120 Chatham Lane in Fredericksburg. The house where Stonewall made his last stand is open Saturday, Sunday, and Monday from 9:00 A.M. to 5:00 P.M. During the summer, it's open daily 9:00 A.M. to 5:00 P.M. Phone (804) 633–6076 or visit www.nps.gov/frsp for more information.

Jackson earned the nickname "Stonewall" for his courage under fire.

## The Pest House
Lynchburg

Tucked away in Lynchburg's Old City Cemetery on Taylor Street are the remnants of a bygone hospital, ominously called "The Pest House." I don't know about you, but if I were suffering from an illness and was sent to a cemetery for treatment, I'd be a lot concerned.

So were the Civil War soldiers who were treated there. Contracting a contagious disease like measles or smallpox was no minor matter in the 1860s. Radical new ideas like hygiene and sanitation were years away. About half the patients died.

Local doctor John Jay Terrell, horrified by the Pest House (the name is short for pestilence), went to work to care for the soldiers. Using what little he had on hand—things like lime, sand, linseed oil, and lime-water—he reduced the death rate from 50 percent to 5 percent. His work continued for three years until the end of the war. Unlike today's business of medicine, Terrell wasn't paid a dime.

"I worked over the dead and dying, some Federals, and remained at my hospital until the first of June 1865, until every man was discharged, then home without a cent to start the practice of medicine," he wrote.

The Pest House is now a museum dedicated to medicine. Modern practitioners would call it primitive; this author calls it horrifying. Dr. Terrell's medical equipment, including an operating table, poison chest, and an asthma chair, crowd the tiny room. The 1860s-era hypodermic needle, big enough to inject a horse, looks like every child's worst nightmare. Even more scary is the tonsil guillotine, an innocent-looking spoon device that snapped off tonsils with its double blades.

There are other tools too, things that look more like implements of torture than healing. There's a tooth extractor that resembles a screw key and a stethoscope that looks like a candleholder. A handy device to find a bullet in the body of a wounded soldier was little more than a metal probe and a piece of porcelain. By tapping on bone and sinew, the doctor would know the location of the bullet by the sound made by the device.

The squeamish may find glass eyes, bone saws, and amputation kits just a little too much to take. When you look at how far medicine has come in a century, the good old days don't look so good at all.

The Old City Cemetery is located at 401 Taylor Street in Lynchburg. Phone (434) 847–1465 or visit www.gravegarden.org.

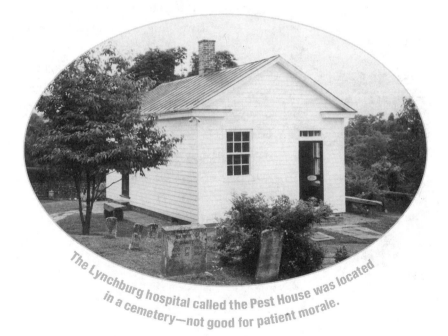

The Lynchburg hospital called the Pest House was located in a cemetery—not good for patient morale.

## How Do You Like Them Love Apples?

Lynchburg

Pity the poor tomato. In the eighteenth century, this maligned fruit was considered poisonous.

According to legend, it was Thomas Jefferson who set the record straight. From the porch of the Miller Clayton House in downtown Lynchburg, Jefferson boldly consumed an entire tomato, bite by bite. Horrified onlookers awaited his demise. It came decades later, and not because of a tomato.

The Hill City Master Gardeners celebrate this mealtime milestone with the annual Thomas Jefferson's Tomatoe Faire. Held the first Saturday in August, the love apple is king at this festival. And there's a tomato queen, a tomato princess, and flower, fruit, and vegetable competitions. A tomato cookbook includes enough spaghetti sauce and salsa recipes to keep plenty of tomatoes busy in the kitchen.

Where was Dan Quayle when this festival was named?

For the thousand or so who attend, the festival's favorite food is, of course, the classic tomato sandwich. That's white bread, mayonnaise, and sliced tomato. Although wheat bread is available, it's discouraged. "It just ruins it," aficionados say. The sandwich costs about $1.00. If you want something fancy, you can add salt and pepper.

The entertainment at previous Tomatoe Faires included a ripe tomato toss featuring local celebrities. "We don't do that anymore," says the festival's organizer. "It's just too messy!"

Thomas Jefferson's Tomatoe Faire is held in early August by the Hill City Master Gardener Association. It's free. For more information, call (800) 732–5821 or go to www.discoverlynchburg.org.

## The Bawdy Ladies of Lynchburg
Lynchburg

Why would a perfectly respectable librarian lead a tour called "The Bawdy Ladies of Lynchburg"?

"I'm the innocent bystander," says Nancy Weiland. "I was doing background research for a novel I was working on, and everybody knew about it. So I was enlisted."

Although Lynchburg's women tend to be of the genteel sort, attending private colleges like Randolph-Macon or Sweet Briar, the city did have a lively red-light district for more than a century.

Wheeler has become an expert on the working girls of Buzzard's Roost, the name given to the adult entertainment district down by the river. Roughly bordered by Jefferson and Commerce Streets, Buzzard's Roost drew a variety of customers, from businessmen to river roustabouts.

"These were ordinary, everyday women thrown into circumstances where they were on their own," Weiland explains. "Some were widows, others were orphans. It was simply business, a matter of survival."

Many of the "ladies" prospered and donated money to community causes, from playgrounds to churches. Although they often attended church themselves, their donations were made through "friends" for respectability's sake.

Among the better-known of these ladies were Agnes and Lizzie Langley, who ran a house on Tenth Street. The mother and daughter catered to local businessmen and made a very comfortable living. According to the 1860 census, Lizzie had $2,000 in personal assets and $3,000 in property. When she died in 1891, she was buried in a bronze coffin costing $700, a king's ransom at the time.

Lizzie and Agnes share a lovely plot and headstone in the Old City Cemetery, which is where the Bawdy Ladies tour begins. Weiland has discovered the names of 700 "bawdies," but she features only 20 of them on the tour. And although her novel is finished, the research continues. Wieland not only leads the tour, she lectures about the subject too. Who said librarians were boring?

These bawdy ladies achieve respectability in the Old City Cemetery—at least until the next tour begins.

Interestingly enough, the Old City Cemetery, located at 401 Taylor Street, is one of Lynchburg's liveliest spots, with tours on gardening, fashion, beekeeping, birding, archaeology, and antique roses. Call (434) 847–1465 for an events schedule or visit www.gravegarden.com.

# HURRICANE CAMILLE

Central Virginia is mighty far from the ocean. The rare hurricane that wends its way west brings little more than a nice breeze and a fall rain. But in 1969 a storm named Camille showed just how mean Mother Nature can be.

And with Camille, she was mighty mean. Nelson County's hills and vales, valleys and hollows caught the brunt of the storm. Twenty-five inches of rain fell in six hours. The land slipped off the mountains, leaving only exposed bedrock. Raging rivers replaced creeks and roadways.

More than a hundred people were killed; thousands more lost their homes, barns, and livestock in the flood.

As you drive through Nelson County, you'll notice everyone has rebuilt on high ground. The only thing left near the Rockfish River is the Hurricane Camille historical marker on U.S. Highway 29, just south of Lovingston.

## Chicken Coop Furniture
Madison

For 113 years, W. J. Carpenter was the king of the chicken coop. He made his nest egg by building the best coops in the business. Carpenter invented and patented the machinery to make them, building a business worth crowing about. After his death, son O. F. Carpenter kept making improvements to the coops. Originally crafted of poplar, they were later made of oak for strength. One day the staff stacked them three high and drove a truck atop the stack. The coops stood the test of truck.

In its heyday, WJ Carpenter on U.S. Highway 29 employed forty chicken coop makers. For those who are rurally challenged, a chicken coop is a small box measuring 3 feet by 2 feet by 1 foot high, used for shipping poultry to market. When Carpenter began, the coops were hauled by wagon to the railroad line in Orange, Gordonsville, or Culpeper. Later, trucks hauled the boxes full of feathers and future fried fowl all over the country.

When plastic arrived on the scene in the 1960s, allowing for a cheaper synthetic coop, WJ Carpenter & Sons tried a sideline: chicken coop furniture. In the barns along US 29, workers started producing chicken coop bookcases, rocking chairs, plant stands, and even a chicken coop baby crib. The parents of active toddlers might like that concept. Shoppers plucked them up. College students especially loved the contra chic of chicken coop furniture.

Sadly, the business has flown the coop, but the buildings still stand in Madison, waiting for a new idea.

## Order of the Golden Horseshoe
Orange County

In the early eighteenth century, lieutenant governor Alexander Spotswood explored Virginia for the king of England. Being an explorer on the frontier had few benefits, and the main recreational activity was toasting the king's health. The liquor, including brandy, champagne, rum, and other spirits, flowed freely. After enough of these drinking parties, Spotswood and his men jokingly named themselves the Knights of the Golden Horseshoe.

When Spotswood returned to Williamsburg after one of his expeditions, he wrote a letter to King George relating his discoveries, and he made a request for a grant to the Order of the Golden Horseshoe.

Someone must have ratted to the king about Spotswood, because when the king's reply arrived, it was a doozy. There was a Royal Proclamation creating the requested order, together with fifty little gold horseshoes and a bill.

Because he had made the request, Spotswood had no choice but to pay.

Spotswood eventually settled in Orange County to build a home in Germanna. Although his elegant brick mansion burned in 1750, the site is open today, appropriately called the Enchanted Castle. (What could be more appropriate for a Knight of the Golden Horseshoe?) The site is undergoing extensive archeological excavation and research by Mary Washington College. Contact the Germanna Visitors Center at (540) 423–1700 or visit www.germanna.org.

## The Funny Farm

Reva

I always thought I'd end up at the Funny Farm. I just didn't know I'd need to make a reservation.

The Funny Farm in Reva is a little inn, located in the foothills of the Blue Ridge Mountains. It's a BB&B—bed, breakfast, and barn. It features large rubber-matted stalls, run-in sheds, heated tack rooms, a wash stall with hot and cold running water, trails, a lighted ring, and paddocks—and that's just for the horses.

Humans stay in one of three individual houses, old sharecroppers' homes updated and gentrified for modern guests who require such amenities as electricity, running water, indoor plumbing, a stove, and a coffeepot. One of the restored nineteenth-century log homes sits under one of the largest holly trees in the United States.

Guests are treated to eggs fresh from the farm's resident chickens. There's also an assortment of dogs, cats, miniature horses, donkeys, ducks, and other critters. Buzz, the pet duck, is plenty tame, but he has a habit of biting the legs of people wearing shorts, so dress appropriately.

Although about half the guests bring their horses, others bring their kids and pets, and some just come for the country atmosphere. Some guests even crash Thanksgiving and Christmas dinners, neighborhood affairs with plenty of conversation and country cookin'.

Mother-and-daughter team Kathy and Samantha Williams provide breakfast fixings, and they'll care for your horses if you come for the foxhunting. For honeymooners, they'll put a log on the fire, and champagne and flowers in the cabin. The rest of the romance is the couple's affair.

When Kathy Williams named the Funny Farm, her brother, a proper Bostonian, was afraid it would drive away the guests. Kathy held fast to the name. "We don't need to call it 'something hall,'" she says. "These are log houses!"

The Funny Farm Inn is located at 2437 Funny Farm Road, Reva; call (540) 547–3481 or log on to www.bbonline/va/funnyfarm.

## Goodnight, John Boy
Schuyler

Don't spend a lot of time with a map looking for Walton's Mountain. It doesn't exist, except in the minds of author Earl Hamner Jr. and the 400 residents of Schuyler, his hometown. In Schuyler, John Boy, Mary Ellen, Jason, Erin, Jim Bob, and the rest are as real as you and I. And much more memorable.

When the Walton's Mountain Museum opened in 1991, 6,000 visitors clogged the roads to this mountain to attend the ceremonies.

An abandoned schoolhouse now re-creates life on the Walton's Mountain that was featured in the popular CBS television series, which aired from 1972 to 1981. Your education on all things Walton begins on hard classroom chairs, with a thirty-minute video of snippets from the show and recollections of cast members. The faces are older but distinctly familiar. The freckles remain.

A series of classrooms contains the sets where homespun America was celebrated. There's the Waltons' kitchen, the site of many a family conflict between Ma and Grandma. (More than one woman in a kitchen creates conflict for a lifetime.) Another classroom holds the parlor; another, John Boy's bedroom. Even Ike Godsey's store survives intact. You can send a postcard or have your picture taken at the Walton's Mountain post office.

Hamner helped assemble all the sets for the museum, which has been Schuyler's salvation. Proceeds from the thousands of persistent fans who visit Walton's Mountain fund all kinds of community endeavors. Profits support a literacy program, a computer learning center, a fire and rescue squad, and a health clinic, as well as scholarships. Everybody gets into the act by baking, sewing, quilting, or volunteering. Neighbors have opened up restaurants and souvenir shops. For groups, the ladies from the Methodist Church serve a midday meal that would make Ma Walton proud: ham and turkey, roast beef and fresh vegetables, homemade rolls, and desserts.

John Boy's bedroom remains the museum's main attraction. The desk where Hamner's alter ego, John Boy Walton, dreamed of becoming a real writer sits by the window. His pants, hat, and shirt hang from a simple hook in this Spartan setting.

Since it opened, the Walton's Mountain Museum averages more than 45,000 visitors a year in the short season between March and November. The roads aren't that good in good weather, so they are sensibly shut down for a long winter's nap. To find the museum, located at 6484 Rockfish Road, you need to travel off US 29 south of Charlottesville to Route 800 and then Route 617. Just when you think you're lost, you're in Schuyler. The actors who had grown up on Walton's Mountain reunite on homecoming weekend, the last weekend in October. Call (434) 831–2000 or visit www.waltonmuseum.org.

If you close your eyes, you can almost hear the echoes. "Good night, John Boy." "Good night, Mary Ellen." "Good night, Ma." "Good night, Pa."

## Plugged into Power

Spotsylvania

There was big excitement in 1829 when gold was discovered in Louisa County. Today the site of the Goodwin Gold Mine, which peaked in the 1880s, is so powerful, it's positively nuclear. The area is now home to Dominion Resources North Anna Power Station.

The company dammed up the North Anna River and created a lake in order to provide cooling waters for its nuclear plant. Named Lake Anna, the 17-mile-long, 13,000-acre lake has blossomed into a resort, with pricey homes lining its shores. The state acquired 8.5 miles of shoreline for average Joes to enjoy, and Lake Anna State Park now has a beach, boat ramps, and hiking trails.

Nobody seems to mind the high-energy neighbor. In fact, Dominion Resources operates the North Anna Nuclear Information Center, where visitors are welcome to learn more about the plant and nuclear energy. Call (540) 894–4394.

The lake is divided into two sections: The "warm" lake handles water discharged from the plant, and the "cool" lake stands ready to do its job at the facility's core. The warm lake is particularly popular with water-skiers, and anglers and environmentalists boast that the fishing is fine. And no, the fish don't glow in the dark.

Lake Anna State Park is located on Route 601 off Route 208 in Spotsylvania. Phone (800) 933–PARK or log on to www.dcr.state.va.us/parks/lakeanna.

## Peanut Butter and . . . Gewürztraminer?
Viewtown

The popularity of Virginia wine has spread. Even on toast and bread. Jessica Hall of Viewtown has taken the fruit of the vine out of the bottle and put it into jars.

It begs the question: *Why?* Why would you turn a perfectly good wine into jelly when you could drink it right out of the bottle and save yourself all that trouble?

Suddenly finding herself a single mother with two toddlers, the young artist cast about for ways to make a living from her mountaintop farm. Hall realized that, although winemaking in Virginia is as old as Tom Jefferson himself, nobody was making wine jelly. She mustered pots, pans, and Mason jars to fill the breach and went to nearby Prince Michel Vineyards to buy a boatload of local vintages. "I did a lot of sampling," says Hall, "but a good wine jelly is not diluted with fruit juice. You can really taste the wine."

Her Bounty from the Farm wine jellies are now sold at Dean & DeLuca, Sutton Gourmet and Whole Food Markets, Culpeper gift shops, and online. (You can e-mail Jessica at wynjly@aol.com.) Varieties include Merlot, Cabernet Sauvignon, Chardonnay, Gewürztraminer, and Spicy Rivanna wine jelly.

Although her kids eat it with peanut butter, Hall has serving suggestions for different varieties. The Gewürztraminer is great with baked Brie and bread or as a side to smoked chicken, endive, and risotto.

Or take the southern route with her recipe for ribs. "Dump a jar of the Cabernet jelly on your pork ribs. Let it marinate overnight. Put it on a slow grill and it's damned near divine." Cheers.

These are some super central Virginia spuds. Or as our friend Popeye might have said, "I yam what I yam and that's all that I yam."

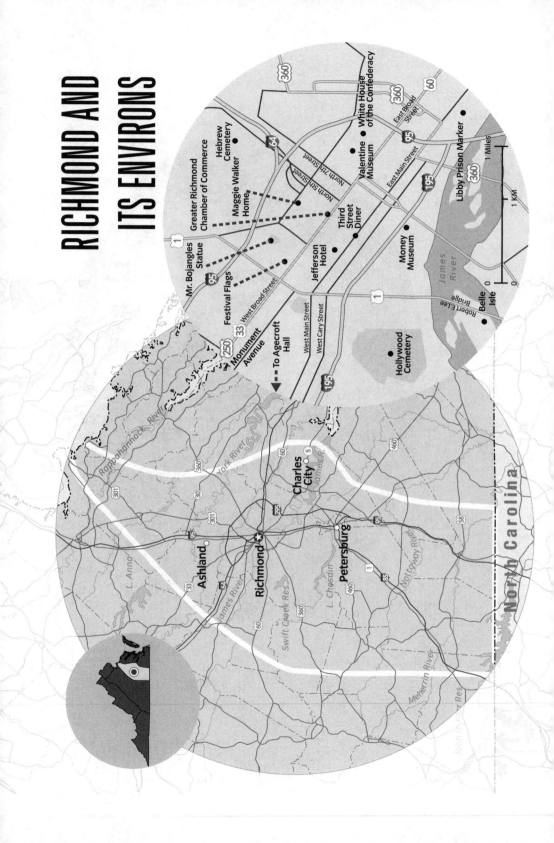

# RICHMOND AND ITS ENVIRONS

Greater Richmond Chamber of Commerce

Hebrew Cemetery

White House of the Confederacy

Maggie Walker Home

Valentine Museum

Libby Prison Marker

Mr. Bojangles Statue

East Broad Street

North 5th Street

North 7th Street

East Main Street

Festival Flags

Third Street Diner

Jefferson Hotel

West Broad Street

Money Museum

James River

Monument Avenue

West Main Street

West Cary Street

Robert E. Lee Bridge

Belle Isle

To Agecroft Hall

Hollywood Cemetery

1 Mile

1 KM

Rappahannock River

York River

Charles City

James R.

L. Anna

Ashland

Richmond

Petersburg

Swift Creek Res.

L. Chesdin

James River

Nottoway River

Meherrin River

John H. Kerr Res.

North Carolina

# RiCHMOND

## and Its Environs

## The Center of the Universe

Ashland

We all know people who think they're the center of the universe, but they're mistaken; the city of Ashland, Virginia, is. At least that's what it says on their stationery. The town, located 15 miles north of Richmond in Hanover County, is within a day's drive of Boston, New York, Cleveland, Detroit, and Atlanta.

Hanover County was named to honor King George I, elector of Hanover, Germany. Although it grew up around the 1735 courthouse, the area became better known for its insurrection than its legislation. Young Patrick Henry developed an interest in law when he heard the political tales of the time at his father-in-law's tavern. Henry rode off to Williamsburg to share the spark with his "Give me Liberty or give me death" speech. He got the former and became Virginia's first elected governor.

A century later, Ashland was developed as a resort for Richmonders, with mineral springs and a racetrack. Today it provides a different combination of attractions: Randolf-Macon College and Paramount's Kings Dominion, a 400-acre amusement park. Tourist information boasts that more than half of the population of the United States lives within 750 miles of Ashland. It's all very interesting, but what makes it the center of the universe? Astronomy? Geography? Attitude? Ambition?

95

Ashland is the center of the universe because the mayor said so in 1976. "It came to me in a flash," says Richard S. Gillis Jr. "I had just been elected mayor, and I was talking to a civic club about Ashland's history. I closed my talk with the phrase *Just remember, my friends, Ashland is the center of the universe.* The name stuck."

## Move Over, Pilgrim: Virginia Held the First Thanksgiving
Charles City

All those *Mayflower* folks have nothing to brag about. A year before they set a single pointy-toed boot on Plymouth Rock, Virginians were celebrating their first Thanksgiving in the New World.

On December 4, 1619, thirty-eight men gathered at Berkeley Plantation to give thanks after a long, hard trip from England. They had sailed from Berkeley Parish to Virginia to seek their fortunes. Upon their arrival they declared, "Wee ordaine that the day of our ships arrival at the place assigned for plantacon in the land of Virginia shall be yearly and perptually keept holy as a day of thanksgiving to Almighty God."

Their commitment to a perpetual Thanksgiving was woefully short lived. The colony was wiped out by disease three years later.

Despite the Plymouth pilgrims and George Washington's efforts, Thanksgiving was a sometime thing. Since men forget such occasions as anniversaries and birthdays, let alone thank-you notes, turkey, stuffing, and pumpkin pie, it took a woman to keep the holiday going. Sarah Josepha Hale, editor of *Godey's Lady's Book,* lobbied for decades to have Thanksgiving declared a national holiday. Finally, Abraham Lincoln set it in stone in November 1863: Thanksgiving would be celebrated annually on the last Thursday in November.

Berkeley Plantation, located between Richmond and Williamsburg, site of America's first official Thanksgiving, now celebrates Thanksgiving on the first Sunday in November. It's east of Richmond along Route 5 (John Tyler Highway) at 12602 Harrison Landing Road. Phone (888) 466–6018.

## Hankerin' for Hardtack and Some Goober Peas?

Petersburg

Missing your musket? Gotta have some goober peas? If your past life has you hankerin' for hardtack, then see if you can pass muster at the Civil War Adventure Camp at Pamplin Historical Park.

Pamplin Historical Park and the National Museum of the Civil War Soldier in Petersburg celebrate the contributions of the common soldier for a reason. Of the three million Americans who served in the Union and Confederate armies, the overwhelming majority fought as common foot soldiers. They fought on more than 10,000 battlefields, and 620,000 of them would never return home.

Their story is told at a 422-acre campus that includes a Civil War battlefield, three historic homes and four museums, costumed interpreters, tours, and trails. But no program puts boots on the ground quite like the Civil War Adventure Camp.

Ages eight to eighty are welcome to muster into the army and take the loyalty oath to either the Confederate States of America or the United States of America. Recruits are issued a wool blanket, appropriate blue or gray uniform, and the opportunity to march backward into all the discomforts of the nineteenth century. Think heat and humidity, chiggers and mosquitoes, gnats and hailstorms. Aah, the glamour, the guts, and the glory of the person in uniform.

Recruits march with their company and learn basic military drills. They learn to shoot muskets with appropriate ordnance, wield bayonets, and fire twenty-four-pound Coehorn mortars at the enemy. "Rebs" and "Yanks" receive basic training in military communications, signaling with ragtag flags.

The lucky ones get to sleep in a bunkhouse; the others sack out on the ground in a two-man tent or nine-man Sibley tent. They chow down on hardtack and stew at evening encampment and entertain themselves with checkers, cards, or songs. In the morning they receive marching rations: hardtack, a gingersnap, some jerky, and dried fruit. Yum!

*Boys in blue and gray pass the muster—whistlin' Dixie is optional.*

Despite the lack of modern amenities and the oppressive heat of Virginia summers, the camp has proven wildly popular. Groups of twenty can reserve their spaces in the sun for $1,400 (no Confederate scrip accepted). Individuals, families, and friends may muster in during regularly scheduled Recruitment Rally Days for $70 per person. And that ain't whistlin' "Dixie"!

Civil War Adventure Camp is held at Pamplin Historical Park, 6125 Boydton Plank Road. Call (804) 861–2408 or visit www.civilwar adventurecamp.org for more information.

# MILK BUILDS STRONG BUILDINGS

There was an old woman who lived in a shoe, so how about a tale on life inside a milk bottle? The Old Richmond Dairy building in Jackson Ward, with its signature white brick milk bottles, has been converted to apartments.

Developer Alex Alexander spent $7.8 million building 113 rental units inside the old facade at 201 West Marshall Street in Richmond. The monthly rentals range from $490 to $845. Because the cream always rises to the top, the most expensive apartments are the ones inside the milk bottles.

## The Governor Goes Batty
Richmond

Although plans for Disney's America, a massive theme park to be built in Northern Virginia, never materialized, the commonwealth did elevate a small furry mammal in a big way.

In one of his last acts before leaving office in 2006, outgoing governor Mark R. Warner designated the state's official Chiroptera. That's the order of the bat. The honor went to *Corynorhinus townsendii virgianus*, the Virginia big-eared bat. Found primarily in Appalachian caves, the big-eared bat is listed as an endangered species at both the state and federal levels.

Calling the critter cute and cuddly might be a stretch, but it sure is unique. Although it stands (or hangs) less than 4⅜ in length and weighs less than twelve grams, the ears tower over its head at 1¼ inches. That's 25 percent of its height.

The state designation was done with a straight face and a little old-fashioned doggerel. The bill honoring the bat was sponsored by delegate Jackie T. Stump of Buchanan County, who took a good bit of teasing about the subject.

In part, the governor's staff wrote:

> I will sign this bill, more or less of free will.
> But I can't do it without having some fun.
> We have a state dog and a fish and a bird.
> And of the fossil I'm sure you have heard.
> So why not a bat?
> What's wrong with that?
> The state beverage is no more absurd.
> Upon my signature now it appears,

The designation will now last for years.

I'll spare you the Latin

If you're seeking the bat in

A guidebook, it's the one with big ears.

I think our bat's up to the test.

If you doubt it, just ask Adam West.

He was TV's Bruce Wayne—the caped crusader's real name—

And could Zap! and Kapow! with the best.

Wouldn't Dr. Seuss be proud?

## Gator Aid
Richmond

When tobacco magnate Louis Ginter set out to build the finest hotel in the south, he was serious. Inside the elegant old Jefferson Hotel on West Franklin Street in Richmond, there's a virtual forest of marble columns, a sea of Tiffany glass, original Valentine sculptures, assorted artwork, crystal chandeliers, and a staircase reputed to be the model for the one Rhett swept Scarlett up in *Gone with the Wind*. Ginter opened the hotel early to accommodate the wedding of legendary beauty Irene Langhorne, who would go on to fame as "The Gibson Girl," the American standard for a hottie in the nineteenth century.

The rich and famous who stayed at the Jefferson would winter in Florida, often bringing back cute little alligators as pets. When the gators grew too big and quarrelsome to keep at home, they'd be placed in the fountain ponds in the hotel's Palm Room, known for its accommodating service. Guests got used to the gators, and the staff would shoo them off the settees and sofas in the morning. One lady, known for her love of sherry, inadvertently used one for a footstool as

she nodded off for her afternoon nap. It was only upon awakening that she realized what she had done.

At one point, the Jefferson's fountains were home to fifteen alligators. The last one, Old Pompey, died in 1918. He was not replaced. But the parade of famous folks continued. In the hotel's museum, off the grand rotunda, is a long list of notables. Anybody who is anybody has stayed at the Jefferson, from Presidents Bush I and II, Ford, Carter, and Reagan, to the legendary Frank Sinatra and America's Redneck Royal— the king himself—Elvis Presley. You can stay in the presidential suite, where Elvis once laid his head on the pillow, for a paltry $1,800 a night.

Check in at 101 West Franklin Street (804–788–8000) or log on to www.jefferson-hotel.com.

## Monument Avenue's New Heroics

Richmond

Monument Avenue is undoubtedly Richmond's most prestigious address. Mansions, shaded by grand old oaks, line the boulevard, which is home to not one, but six monuments.

The first monument was erected on the boulevard in 1890, and it was a really big deal. The Robert E. Lee monument is 60 feet tall and as grand as the gent who, out of loyalty to his home state, led the Army of Northern Virginia, despite his personal opposition to slavery and secession.

Next came monuments to Jeb Stuart and Jefferson Davis, both unveiled in 1907. Stonewall Jackson's was added in 1919.

There was a lull in monument homage for a decade until 1929, when local hero Matthew Maury joined the ranks of the other Confederate heroes. Maury was a maritime genius, outfitting the first Confederate ironclad, the *Virginia*. He also developed the torpedo and became a

pioneer in maritime mapping. He is remembered on the monument as "Pathfinder of the Seas."

Sixty-seven years passed before another monument was added. To this row of heroes of the Confederacy came Arthur Ashe Jr. This gentle athlete, born and raised in Richmond, went on to make history in tennis, as well as in social change. Ashe was the first tennis player of African-American descent to win at Wimbledon.

The sculpture, designed by Paul DiPasquale, was unveiled in 1996. Located at Monument Avenue and Roseneath in downtown Richmond, it depicts Ashe surrounded by children looking up to a hero for a new era.

Monumental monuments make Monument Avenue . . . well . . . monumental.

# FROM "BOOLA BOOLA" TO "BORN IN THE U.S.A."

The Capital of the Confederacy spawned much more than secession. A whole lot of talented folks were born on the banks of the James River. And even more passed through on their way to future fame.

Yalies are surprised to learn that Allan M. Hirsh, the composer of the Yale fight song "Boola Boola" grew up on the 800 block of West Franklin Street.

Other noteworthy natives include Lady Astor, the first woman to be elected to the British House of Commons, and her sister Irene Langhorne. Langhorne was the best-known beauty of her time—think of her as a nineteenth-century Julia Roberts.

Although Edgar Allan Poe wasn't born in Richmond, he was raised there, fell in love there (with his cousin Maria Clemm), and kept a home there. The Poe Museum is a proud part of Richmond culture. Tom Wolfe, author of *The Right Stuff*, is a Richmond native as well. Dancer Bill "Bojangles" Robinson hails from the Virginia capital city, as does tennis legend Arthur Ashe, golfing brothers Bobby and Lanny Wadkins, and Football Hall of Famer Willie Lanier. Amateur golfer Binny Giles, born and raised in Richmond, runs a company called Pros Inc. The amateur is now a promo pro for the pros.

Shirley MacLaine and her brother Warren Beatty spent their formative years in Richmond. And none other than the Boss, Bruce Springsteen, spent some time in Richmond, filming one of his early videos atop a capital office building. Bruce was born in the U.S.A.—New Jersey to be exact—but according to the locals, "If you just pass through Richmond, we'll claim you."

## Bank on It: Maggie Walker Made History
Richmond

America's first female bank president was born in 1867, the daughter of a freed slave who made her living doing laundry for white folks.

As a child, Maggie Walker and her brother would deliver the clean clothes along bustling Broad Street. A member of the first African Baptist Church invited the girl to Sunday school, and Maggie became a vital, active member of the congregation.

Walker became a member of the Order of St. Luke, a benevolent society that helped other free people in the neighborhood. In the late nineteenth century, black citizens had no bank, insurance company, or other businesses to provide services; the Order of St. Luke filled the gap.

It was considered immoral for married women to teach, so after her marriage Maggie dedicated more and more of her time to the benevolent society. In time, she was elected its leader.

Although handicapped by diabetes and confined to a wheelchair, Maggie Walker prevailed. "Let us have a bank that will take the nickels and turn them into dollars," she once said. Walker created St. Luke Penny Savings Bank and became its president.

She also had a husband and two children, started a newspaper, and opened a dry goods store on Broad Street where blacks could work and shop "so we can make jobs for ourselves."

This working mother expanded the Order of St. Luke into a powerhouse with 100,000 members. She also served on the board of directors of the NAACP and was active in the Urban League.

Walker liked living well. She bought her own home in 1894, and by 1922 it had twenty-two rooms. During the Depression, she owned a Packard limousine that cost $7,000. Today's equivalent would be about $80,000, making it a luxury car indeed.

Although Maggie Walker died in 1934, her bank goes on. It's now called the Consolidated Bank and Trust, the oldest continuously operating black-owned bank in the United States. Her home on College Alley off Broad Street is now a National Historic Site. It's located at 600 North Second Street, and the visit is free. Phone (804) 771–2017 or go to www.nps.gov/malw for more information.

## Beachin' It at Belle Isle

Richmond

What was once the site of a Civil War prison is now Richmond's answer to a day at the beach.

From Richmond's downtown, cross over to Belle Isle on the footbridge near Tredegar Street. The footbridge replaced the Double Dime bridge, which got its name from the toll that was levied for crossing. The crossing is free now, and Belle Isle is where you'll find the locals walking their dogs, jogging, and picnicking.

On the island's western end, some foolhardy people don their bathing suits and wade into the churning James River. As the river slips past the island, it gains momentum, and the fun begins for white-water fans.

White-water raft companies offer day trips over the rapids, which range from Class II to Class V. They've got peculiar-sounding names, like Choo Choo Rapids near the Railroad Bridge, and Mitchell's Gut. The big ones begin right at Belle Isle State Park, and there's a white-water walk to watch the wet and wild ones at play.

The rocks at the fall line, where the James starts its long drop to the sea, are a natural wonder. Although local kids use them as a waterslide, slipping through the rapids and then running back up to do it again and again, it's not a recommended activity. Class III rapids can be deadly.

Charles Dickens loved the James. During his 1842 visit, he described the river as "brawling over broken rocks." Nobody brawls at Richmond's Belle Isle today. It's just a city at play where a river runs through it.

# CALL FOR PHILIP MORRIS

Just south of Richmond, right off Interstate 95 and along the James River, is perhaps the biggest cigarette pack in the world. Tall cylinders that seem to reach into the clouds house a cigarette manufacturing plant.

In its heyday, the Philip Morris company made more than 500 million cigarettes a day and offered free tours of the plant. Part of the tours included the history of tobacco, beginning in A.D.. 300, and an ample sampling of the history of cigarette advertising. In its time their radio ad, "Call for Philip Morris," was as ubiquitous as McDonald's television advertising is today.

Times have changed. Tobacco is no longer king of the cash crops; the Philip Morris public tours have been suspended, replaced by an annual open house for families and friends of employees. Cigarette ads have been restricted, and Philip Morris is now an international diversified company. Nevertheless, the building remains the same, one of the last bastions of Richmond's tobacco heritage.

# HENRY "BOX" BROWN

Not all slaves had a Harriet Tubman to lead them to freedom. Some worked their way north along the Underground Railroad, a curious name, since there was no railroad and the only underground was somebody's cellar. And it was a darned long walk from Virginia to freedom north of the Mason-Dixon line.

No escaping slave was more enterprising than Henry Brown. He just used the United States Postal Service to mail himself to freedom in a box measuring 3 feet by 2 feet by 2½ feet. No word on how long he was in the mail, but he arrived safely in Philadelphia in 1849 and earned for a lifetime the nickname of "Box" Brown.

Freedom wasn't quite a sure thing even in the City of Brotherly Love. In 1850, after the U.S. Congress passed the Fugitive Slave Act, which made it legal for escaped slaves to be captured and returned to their southern masters, "Box" broke loose of the United States altogether and lived the rest of his life as a free man in England.

## Cash under Glass

Richmond

Legal tender always seems in short supply and in small bills. The only way most folks get to see a $100,000 bill is at the Money Museum at the Federal Reserve Bank in Richmond.

Wondering whose face is on it? It's a very serious Woodrow Wilson, staring out over his horn-rimmed glasses. If you want to see for yourself, the cash is under glass at this one-room museum on Byrd Street.

The Richmond skyscraper may represent the power of the almighty dollar, but the museum is free. It's small too, but appropriate. Because England prohibited coinage in the thirteen colonies, the history of money in America is quite brief. The curator expanded the subject to include cash since the dawn of man, but it's still a pretty short story. Early man hunted, grew, built, or traded for what he needed. Later, people bought what they needed—and a lot of things they didn't—and that required money.

The museum includes 575 specimens in its collection. Coins and paper are today's fare, but shells, beads, pelts, weapons, farming tools, twists of tobacco, and bricks of tea, all tender at one point, are displayed. These items were hard to tuck into a wallet or coin purse, so around the sixth century B.C. the Kingdom of Lydia made the first coin, called a "stater of Croesus." The old expression "rich as Croesus" meant cash aplenty, but the Greeks upped the ante with a tetradrachm, first coin to have a full design on both sides.

The museum also tells the tale of American rebellion when Spanish "pieces of eight" were used as often as English coins. The Continental Congress authorized banknotes in such handy denominations as one-sixth of a dollar—16.67 cents. Congress authorized the first official U.S. coin in 1787. On it was written *Fugio* (I fly), an interesting inscription in

an age well before aircraft. It was also inscribed with "Mind your business," sound advice at any time in history.

For those who crave the Midas touch, the museum has a gold bar weighing 401.75 troy ounces and a silver bar with a digital readout showing the value and current price of the metals. Of less worth are the Confederate banknotes. A Stonewall was once worth $500, but now it's just a conversation piece. A Grover Cleveland is still worth $1,000. The Money Museum at 701 East Byrd Street is located on the first floor of the Federal Reserve Building. It's open weekdays from 9:30 A.M. to 3:30 P.M. to visitors who call in advance. Phone (804) 697–8118 or log on to www.richmondfed.org.

## Festival Flags
Richmond

Once upon a time, Americans hung out a flag for Memorial Day and the Fourth of July. Thanks to Richmond resident Millie Jones, they now unfurl a flag for almost any reason.

Millie has flags for the first crocus of spring, a baby's birth, and a celebration of the old Thanksgiving turkey. She also has flags for no reason and no season.

"Festival Flags was never meant to be a business," says Jones. "It was just something fun to do."

About thirty years ago, Jones hung out her first homemade flag at her house in Richmond's Fan District. It was intended to announce a party. Curious neighbors called to ask, "Why do you have a pillowcase hanging out your window?" When the local newspaper sent a reporter to ask about its significance, Jones quipped, "It's a festival occasion. Every day is a festival occasion."

Millie made a few flags for friends and neighbors, netting a whopping $200. When Millie's son Jonathan was born, she announced the occasion by hanging out a flag that read IT'S A BOY. The neighborhood news went national when wire services picked up the story. From then on, people called or stopped by, wanting to buy a flag or to learn how to make one.

The business rapidly outgrew her larger home on Monument Avenue. People knocked on her door at all hours, including homeless folks seeking shelter at the building with the flag on it. Wrong flag and wrong building. So Jones opened a retail store in an old automobile dealership. "People say I'm as original as Betsy Ross," said the Festival Flags founder, "and darned near as old."

Millie sold her thriving business to Dave Edwards, who has some of her original customers bringing in thirty-year-old flags that have finally worn out. "We're happy to replace them, and we do all kinds of made-to-order flags," says Edwards.

If you don't have any imagination, the catalog lists more than 125 different flags for sale. Or stop by the showroom at 309 North Monroe Street (800–233–5247; www.festivalflags.com).

## Gadzooks. . . Methinks I Spy a Manor House

Richmond

Richmond's Agecroft Hall isn't a replica of a Tudor manor; it's the real deal, and it was actually a steal.

The house was built in the late fifteenth century on the Irwell River in Lancashire, England. For hundreds of years it was the ancestral estate of the Langley and Dauntesey families.

It wasn't the motion of tectonic plates that moved the manor from Merry Old England to the banks of the James River, it was the power of money. By the end of the nineteenth century, the lords and ladies of the manor had fallen on hard times, and the house fell into disrepair.

In 1925 the house was sold at auction to an American. The horror! Thomas C. Williams, a member of the Richmond gentry, bought the house, dismantled it, and shipped it across the pond. He got a bargain, with some furniture thrown in. Williams had the house reconstructed piece by piece in his Richmond Farms neighborhood.

It wasn't easy to keep up with the Joneses on Sulgrave Road. Williams not only rebuilt the house and furnished it with Tudor and Stuart antiques, he created elegant gardens and grounds surrounding it.

Williams was not only lord of the manor, he was king of the hill. Wonder if he wore a crown to get his morning paper?

Agecroft Hall is located on the James River at 4305 Sulgrave Road. Call (804) 353–4241 or visit www.agecrofthall.com for details.

# CUSTER'S FIRST STAND

After graduating last in his class at West Point, George Armstrong Custer distinguished himself as a soldier in Virginia—for the wrong side. The hapless hero fought for the Union army.

He was commissioned a second lieutenant in the Second Cavalry on June 24, 1861. By July of the next year, the young soldier was a first lieutenant and aide-de-camp. In the Peninsula Campaign intended to capture Richmond, Custer was sent on a reconnaissance mission accompanying 300 cavalrymen to scout the Southern forces.

Riding ahead as a scout, Custer came upon a regiment of Confederate cavalry near White Oak Swamp. Upon hearing Custer's report, Col. William Averell ordered an attack. Union forces charged, surprising the Confederate band. Many surrendered. Custer chased down an escaping soldier and ordered him to surrender, twice. When the Confederate refused to either respond or surrender, Custer shot him dead. According to author Thom Hatch in his book, *Clashes of Cavalry,* this "kill" was Custer's first.

There would be many more to follow in Virginia. Custer fought at Manassas, Antietam, Chancellorsville, Chickahominy, Culpeper Courthouse, Bristow, Yellow Tavern, Cedar Creek, and Appomattox. In 1863 he earned the rank of brigadier general at age twenty-three, becoming the youngest general in the Union army.

After the Civil War, Custer continued his military career despite a court-martial and year's suspension for going AWOL to visit his wife. He would resume command of the newly formed Seventh Cavalry, and the foolhardy "Boy General" and his entire command would perish in the Battle of Little Bighorn in Montana on June 25, 1876. He was thirty-seven.

# A SLOGAN FOR ALL SEASONS

When the tourism slogan "Virginia Is for Lovers" was first written in 1969, it was bold, provocative, and just a little naughty. It was back in the days when Nixon was president, man landed on the moon, and Virginians could buy liquor by the drink. It was also the year of Woodstock and Butch Cassidy.

The catchy slogan was penned by an advertising copywriter working for Martin and Woltz, Inc. For her efforts, Robin McLaughlin was paid a whopping $100 a week. Her work has endured for three decades, and the "Virginia Is for Lovers" slogan has outlived all the other ad copy of the time. Remember "The Wings of Man" campaign? Or, "Show Us Your Larks"? No? You get the point.

By using a heart in place of the v in Lovers, the slogan became the granddaddy of all the "I Hearts" to follow, including the "I Love New York" campaign. Research showed that three out of four Americans correctly identified the Virginia slogan. It's too bad the writer isn't paid each time it's used. She'd be a millionaire.

## A Guard Dog Guardian Angel
Richmond

Tucked away in Hollywood Cemetery in Richmond's Oregon Hill neighborhood off Laurel Street, among the grand monuments and family crypts containing the remains of Richmond's finest, is the grave of a little girl. A simple headstone and footstone mark a family's deep loss. In a loving gesture, the family placed a small iron dog to stand guard at the child's grave.

The dog still stands guard, but exactly how he came to Hollywood Cemetery remains a mystery. Records show that the dog was one of a pair manufactured by the Harwood and Bartlett Iron Company of Baltimore in the mid-nineteenth century. The dogs stood at the entrance to the company's headquarters.

According to local legend, the dog traveled from Baltimore to Richmond as a promotional item for a shop on Broad Street. It worked well, gaining the adoration of the little girl who passed it and patted it on her way to school. When she died, the shop owner wanted her to have it.

Another version has it that the dog was hidden in the cemetery to keep it from being seized and melted down for weaponry during the Civil War. Its placement at the grave may have been pure accident. Whichever story is true, it doesn't matter much. Dwarfed by monuments to presidents, generals, and Richmond's elite, the dog is the most beloved statue in the grand old cemetery. It speaks volumes about love and loyalty. Phone (804) 648–8501 or visit www.hollywood cemetery.org.

# HAPPY'S MURAL MESSAGES

Happy the Artist gives new meaning to the expression. "If walls could talk . . ." In Happy's case, almost any surface will do!

The artist gained Richmond's attention cruising city streets in his bright, multicolored 1969 Rambler decorated with whimsical artwork and moving messages including "Are we having a great day yet?" and "Here goes that car again." After 9/11 he repainted and repatriated the Rambler with the stars and stripes of Old Glory. On top, he added a fireman with angel's wings and praying hands nearly 3 feet long.

Happy now keeps irregular hours at his brightly painted studio at 1727 West Main Street in Richmond (804–833–7822). There are no smocks or berets for this artist. Happy prefers to dress in clown attire with a hat, baggy pants, and mismatched Converse sneakers. He has sixteen different pairs in a variety of colors. "Today I have on a blue low-top and a red high-top," he said. "I just grab two shoes every morning and put them on. Every month or so, I get a pair that matches just by happenstance."

His murals, caricatures, and canvases are whimsical, wonderful, mystical, and edgy social commentary, all with the stroke of a brush. Much in demand by those with the means to commission original work, Happy is currently painting three children's rooms in a $3 million mansion in Tennessee. He's painting a "Dick and Jane" easy reader for the eldest, a seaside theme for the middle child, and a circus for the baby the owners are expecting any day. For a pair of doctors, the artist created a fanciful mural he titled "The Baptism of Barney." Another mural tells the history of a home located on a 26,000-acre land grant from the King of England. It's three centuries of Virginia history told under a mansard roof some 30 feet high.

Born James Patrick Kuhn, Happy's nickname originated with Mexican neighbors who pronounced the J. P. *Hay-pee.* He was a Disney "discovery," found in a Talent Roundup, and he began his professional career at age fifteen as a quick sketch artist. He was a serious art student and energetic entrepreneur in D.C. in the 1960s, and his edgy portraits of Watergate, Nixon, Ford, and the impeachment process made their way onto national television.

Today Happy's murals grace homes, casinos, hospitals, and corporate offices in forty-two states and six countries. One of his largest, for Capital One, is 90 feet long and 28 feet high. The subject of the mural is molecular fusion. Go figure!

The childlike wonder on the canvas comes from more than creative energy. It comes from experience. Happy is the father of eight, grandfather of four, and the great-grandfather of one elementary school student.

This rambler's work is but hardly begun.

A mural of jungle animals for a posh newborn's nursery recently cost the parents more than $5,000. Bet that made the artist happy! You can see some of Happy's work online at www.happytheartist.com. Taking a peek is free, and it's guaranteed to make you smile.

## Land of the Lost

Richmond

Richmond was the site of the most infamous prison of the Civil War. Never has a building or its inhabitants been so unlucky.

Three warehouses, each four stories tall, were built by John Enders Sr. in the early 1800s. Founder of Richmond's tobacco industry, Enders had become wealthy and owned much of the real estate around the city docks. He died accidentally when he fell off a ladder through a construction hatch in the central warehouse.

When his slaves learned that Enders had not freed them in his will, they burned down all of his buildings between 21st and 22nd Streets. The warehouses were spared.

A Yankee ship captain, Luther Libby, leased the west warehouse. The building didn't do him much good either; most of his business was with Northern ships, and the Civil War put a stop to that. After the Battle of First Manassas in 1861, Libby was given twenty-four hours to get out, and Northern prisoners were warehoused in the building. The Libby & Son sign stayed up, so throughout the war and subsequent history, the building was known as Libby Prison.

More than 50,000 men passed through the prison, and a lucky few escaped. After Richmond fell, the tables turned on the South, and Libby held incarcerated Confederates.

In 1888 a Chicago syndicate bought the buildings. Its intent wasn't Mob business but plain old American tourism. A famous architect from Philadelphia was hired to dismantle the building and label each piece for reconstruction. It was no small feat; Libby prison's pieces filled 123 twenty-ton railroad cars.

The infamous prison was reconstructed in Chicago on Wabash Avenue in 1889. Renamed the Great Libby Prison War Museum, it proved popular and profitable, attracting crowds of its own during the 1893 World's Fair.

The museum closed in 1899, and part of the prison wall was used in the construction of a new coliseum. Some bricks went to builders and others to souvenir hunters. The Chicago Historical Society used the bricks to construct its Civil War room. Beams, timbers, and other wood parts were sold to an Indiana farmer for his new barn. On these beams are the signatures and initials of countless, hopeless Libby prisoners.

Today all that remains of the Libby Prison is a historical marker along the floodwall at 20th and Dock Streets off Cary Street.

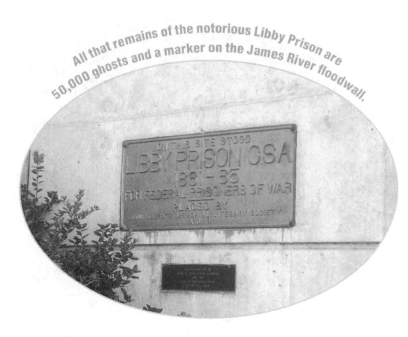

All that remains of the notorious Libby Prison are 50,000 ghosts and a marker on the James River floodwall.

## Pieces and Parts

Richmond

Although sculptor Edward Valentine has been dead for more than seventy years, his studio is exactly as he left it. At Richmond's Valentine Museum at 1015 Clay Street, the artist's violin rests by his desk, as if he's about to pick it up and play us a tune. His tools are neatly stored, awaiting the hands that move no more.

On an even more macabre note, death masks of heroes and presidents, artfully designed plaster casts, seem to return the stares of visitors.

In a corner the body of Robert E. Lee reclines; around him are the hands, feet, and torsos of sculptures that won't assemble themselves without their creator. They remain whole only in the mind of the once-great artist, whose elegant works romanticized figures from the Civil War.

Death masks of loved ones were once popular household decor. They haven't made a comeback.

*Where national heroes hang out with gods and goddesses, (a politician's dream come true).*

Also stored at the museum are various unsold works of the artist. There are several busts of *The Nation's Ward,* a sentimental sculpture of an African-American man that was once popular in the homes of Northerners. Valentine mass-produced these for the Chicago World's Fair in 1893 and sold a bunch.

It's a little eerie, these bits and parts of art undone. And so is the intact studio. Listed by the National Trust for Historic Preservation, Valentine's studio is one of four surviving nineteenth-century sculptor's studios in the United States that are open to the public. The busts and casts and masks along the walls are a little worse for wear. There are angels with dirty faces, and a busy spider has cast his web from Lee's nose.

The Valentine Museum/Richmond History Center is open daily. Phone (804) 649–0711 or visit online at www.valentinemuseum.com/sculpture.

# MEAT THE MONEYMAKER

This Valentine story isn't about hearts and flowers, but it is a love story nonetheless. And the love potion was formulated from meat juice.

The Valentine Museum on Clay Street was a gift to the City of Richmond from the wealthy Valentine family. It includes a remarkable 1812 Federal-style home, which the family bought from Aaron Burr's attorney, and a vast collection of decorative arts, costumes, textiles, and photographs once owned by the Valentines.

Meat was the source of the money. A spoonful of "hamburger squeezing" probably doesn't sound all that appealing, but it was the tried-and-true tonic for nineteenth-century ladies. In 1870 Mann Valentine's wife, Maria, was very ill. The devoted husband, a good Mann, created this "pleasant, tasty, nutritive mixture" to help her recover. Surprisingly, Maria got well, and Mann got busy.

Aided by his seven sons, the enterprising spouse began bottling the tonic in the basement and sold the elixir in little brown vials. Women drank it up, and Valentine's Meat Juice made the family a fortune. The company produced the tonic until 1980, 110 years after the first beefy bottle came up from the basement.

## A Bit of the Old West in the South

Richmond

It's not even southwest of Richmond, but it's southwestern through and through nonetheless.

In the heart of Virginia's garden club world, Saguaro Hill is a shocking departure from the boxwoods and azaleas gracing most Richmond homes. The Mexican villa is a little out of place and a lot popular in northern Henrico County.

Surrounded by all kinds of cacti, the white faux-stucco house at 10816 Staples Mill Road has been mistaken for a motel, a restaurant, a religious retreat, and the tourist attraction that it is.

Upon retiring from his job at the telephone company, J. T. Pemberton followed his dream and built his southwestern-style house just to please himself. Ironically, it pleases a lot of other people too. He's beleaguered by requests from the public for tours, and so many vehicles have pulled into his driveway that Pemberton has installed a locked entrance gate.

He's become accustomed to his home being an attraction though. He gives free tours to schoolchildren and garden clubs but tries to limit these to three a month. He also holds an annual benefit tour for the Humane Society, drawing as many as 1,000 people a day.

Behind the walls of Saguaro Hill, Pemberton is really raising Arizona. The yard is an eclectic mix, with stone tables pieced from a local quarry, an authentic nineteenth-century chuck wagon, a 150-year-old oxcart, a 350-pound bell, and a totem pole carved from an old gum tree. His critters include two desert turtles, rabbits, burros, dogs, cats, and exotic waterfowl that wander around a 48,000-gallon U-shaped swimming pool, painted black and surrounded with boulders so that the setting resembles the desert.

The yard is always a work in progress.

The interior is as quirky as the exterior. Inside, there are one hundred species of cacti, adobe fireplaces, Mexican tile, and dozens of unique pieces of southwestern memorabilia. Think boots, cowboys, and Indians. The house also has a gym, two courtyards, and an Arizona room. For a house in the Old Dominion, it's certainly Old West.

Says Pemberton, "I enjoy creating something new that's authentic. It wouldn't be any fun if it weren't. I don't want anything that's phony."

## Solid As a Rock(fish)
Richmond

You can order it on the menu at any tony eatery in the commonwealth. The snootier ones call the succulent, mildly flavored fish striped bass, but in most places in Virginia, it's rockfish. Or just plain "rock."

The species was threatened with extinction by overfishing, so Virginia Game and Fisheries enacted a rockfish ban in the 1990s. It worked, and the fish are back in the James River, on dinner plates, and curiously enough, all over Richmond.

The "catch of the day" at the Museum of the Confederacy.

To celebrate their return, Richmond had 200 epoxy fish created, painted, and displayed all over town. Many were "caught" by local citizens for their homes and offices. To see those that got away, visit the Confederacy White House of the at 1201 East Clay Street, the Museum of the Confederacy at 12th and Clay Streets, or the Greater Richmond Convention Center at 401 North Third Street.

## Swords into Plowshares
Richmond

The only military cemetery outside Israel that honors Jewish war dead is smack-dab in the middle of old Richmond. Interred here are thirty Jewish soldiers killed during the battle for Richmond. They were true sons of the Confederacy, coming from their home states of Louisiana, Mississippi, Georgia, Texas, the Carolinas, and Virginia. Their final home is this stately cemetery at Fourth and Hospital Streets.

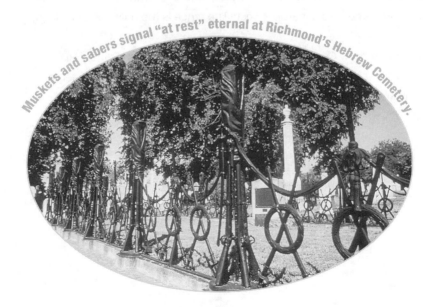

Muskets and sabers signal "at rest" eternal at Richmond's Hebrew Cemetery.

At the Hebrew Confederate Cemetery, one soldier's name was incorrectly inscribed, and Henry Gintzberger became Henry Gersberg. He might have been misidentified for eternity if it weren't for the dedicated sleuthing of J. Ambler Johnston, Richmond architect and historian, and chairman of the local Civil War Centennial Committee. Johnston's father had fought in the Civil War and had witnessed Gintzberger's death and was haunted by it. J. Ambler searched for Gintzberger for twenty years. After discovering the name Gersberg on the central marker in the soldier section at the Hebrew Cemetery, Johnston checked the war records. No such person served during the Civil War. But German immigrant Gintzberger had, and a correction was made in 1963.

To honor Gintzberger and his twenty-nine comrades in arms, the Hebrew Ladies Memorial Association, organized in 1866, commissioned artist Maj. William Barksdale Meyer to build a fence for the site. This is no ordinary split-rail affair. The ironwork fence, a complicated piece of military art, includes muskets, sabers, and artillery caps. The grillwork is embellished with wreathes of laurel, unfurled Confederate flags, and a Confederate cap set atop a post. The fence is the only one of its kind, and a fine tribute.

The Hebrew Cemetery is on Richmond's east end in Fulton Hill on Jenniescher Road. For information, contact the Beth Ahaba Museum and Archives at 1109 West Franklin Street; phone (804) 353–2668.

## The Town That Burned Itself Down

Richmond

When Union troops marched on Richmond, the capital of the Confederacy, residents feared the worst. But in fact it was a few Confederate soldiers who burned down the town.

No wonder they lost the war.

An evacuation order went out, and the fine folks of Richmond grabbed everything they could carry. They filled wagons and carts with family silver, art, and imported furniture. In a final defiant gesture, Confederate troops took a torch to Shockoe warehouse and other buildings that were chock-full of tobacco. The long-leafed "weed" had a better reputation than it does today. Tobacco was the cash crop, and nobody wanted the invading Yankees to seize anything of value.

It doesn't take a genius to realize that tobacco burns like the dickens. Predictably, the fire spread quickly. A good stiff wind sent the blaze on its way through the business district. Richmond burned and burned and burned some more.

When Federal forces marched into town, there wasn't much left. More than twenty blocks had burned, consuming 600 homes along with most of the city's banks and hotels. Government buildings were gone too, including the post office, the state courthouse, the war department, and the railroad depots. Although the losses were devastating, the *Richmond Whig,* in reporting on the fire, focused on the loss of liquor—a real catastrophe.

The city council had ordered that all the liquor be destroyed. Straggling Confederate soldiers helped themselves to the booty, and the newspaper reported that "pandemonium reigned." The *Whig* bemoaned another blow: the loss of city taverns. "The fire made sad havoc with the saloons, and none of any account remained."

Thankfully, they were rebuilt, and there are watering holes aplenty in modern Richmond.

## The Tacky Christmas Lights Tour
Richmond

To be listed on the Official Tacky Lights Tour list requires a minimum of 50,000 lights. Good taste is not a requirement. Noted for its genteel conservatism, Richmond lets loose around Thanksgiving and pulls out all the stops to get ready for Christmas.

Red-nosed reindeer stand by nativity scenes, ET climbs out of a chimney, and Santa's elves keep company with characters from *The Simpsons* and *Snow White*. It's a kitschy delight.

Started in 1986 by local radio personality "Mad Dog" Gottlieb, the tour has attracted the whole town. Each year the *Richmond Times-Dispatch* publishes the addresses of the homes on the tour, and people beg to be listed. Says reporter Cynthia McMullen, "One resident fell off a ladder and broke his arm while installing his lights, and he called to apologize that they all weren't up. His friends and neighbors stepped in to finish the job so his house could be listed on the tour."

One family lights up their dog in a wired coat and spends December evenings sitting out on the front porch waving to the passing cars. Local kids have gotten into the act, selling hot chocolate and cider at traffic bottlenecks. Limousine and tour companies conduct tours that can last up to four hours. A sixteen-passenger limo loaded with candy canes and Christmas music will set you back $500.

The hoopla, which causes traffic jams from Thanksgiving through Christmas, has become a Richmond tradition. Local companies have joined in the fun, outlining seven of Richmond's tallest buildings in thousands of white lights.

To tour the tacky Christmas lights, check out the *Richmond Times-Dispatch* online at www.timesdispatch.com. The tour list appears in the Flair Section after Thanksgiving.

## Third Street Diner
Richmond

Located at Third and West Main Streets, Third Street Diner is a Richmond institution, serving up more than just a great meal. It's got a potful of history that's not on the menu: The building once served as a morgue. Not too appetizing an origin, but folks are dying to come in anyway.

Despite its unique original use, the Third Street Diner has a fifties feel and a jukebox to match. You can get breakfast all day and all night. The place is also noted for its blue-plate specials and goodies of Greek origin. It only closes from 2:00 to 7:00 A.M. on Mondays.

The diner has a regular, respectable daytime clientele, but in the wee hours, between 2:00 and 5:00 A.M., the patrons can be questionable, casualties of the club scene at Shockoe Bottom staggering in for a cup of coffee or a plate of eggs.

They leave revived, which would have delighted Sally Tompkins, a Civil War nurse who worked at the site when it housed the dead and dying. She had a reputation for saving the sick and wounded. Revive yourself! Phone (804) 788–4750.

# YOU'RE REALLY RICHMOND IF YOU DINE AT UKROP'S

A Richmond-based grocery store chain is known for its ridiculously high level of service. Even if you buy only a single gallon of milk at Ukrop's, bag boys will offer to carry it to your car for you. Why, then, are so many people leaving the store without food? Because they've already consumed it.

Ukrop's is where real Richmond residents go to eat. No, they don't nosh out of boxes or bins; they line up at the coffee bar or enjoy a romantic dinner for two served up hot Monday through Friday. Tables are tucked at the front of the store, and pairs of people will be spooning up the day's special at bargain-basement prices. Tightwad twosomes might enjoy mandarin orange salad, garlic bread sticks, and garden salad with Italian dressing for under $12.00 per couple. It's cheaper than cooking at home and much tastier. Pork chops with gravy, butter beans and corn, skillet potatoes, and country dinner rolls can also be had for under $12.00 for two. Lunch is even cheaper at Ukrop's grill. A homestyle meat loaf sandwich on fresh focaccia is less than $7.00. Add some jasmine rice or lo mein noodles, a beverage, and New York–style cheesecake to finish off the meal. Of course, romance drains from the atmosphere when customers push carts past the diners, but heck, this is a grocery store after all.

The first store's doors opened in Richmond in 1937, and Ukrop's can now be found all around central Virginia. There's a central bakery and kitchen in Richmond, and many of the Ukrop's stores have a grill and cafe with a menu offering the same items sold unprepared in the stores. They also have a First Market Bank and Ukrop's Dress Express, where you can buy uniforms and corporate apparel. If they rented rooms off the back, you could live quite well at Ukrop's.

## When Jefferson Lost His Head

Richmond

A marble statue of Thomas Jefferson has been greeting guests in the lobby of the elegant old Jefferson Hotel on West Franklin Street for a century. He's had more than his share of indignities lately: He's been adorned with vegetables and modeled a chef's hat for a new hotel brochure.

That's small potatoes compared to the insult and injury old Tom suffered in the fire of 1903. When the hotel began to burn, employees set about to rescue its namesake. An enterprising bunch, they gathered a pile of mattresses and toppled the leader off his pedestal, decapitating him.

The fire never reached the lobby, sparing its Tiffany windows and rotunda, but its centerpiece statue was now of a president who'd lost his head. The hotel commissioned a nephew of well-known Richmond sculptor Edward Valentine to make the repairs. To mask the scar, Valentine carved an ample marble ascot. It looks quite dashing and dignified, and most passersby today are none the wiser.

## William "Bojangles" Robinson

Richmond

We know Mr. Bojangles danced. We know that from the popular 1970s ballad and from old Shirley Temple movies. If you visit his statue in Richmond at Leigh and Jefferson Streets, it's hard to get the song out of your head. The statue is frozen middance, but the song dances around. "There was a man Bojangles and he'd dance for you . . . in worn out shoes . . ."

What we know about Bill "Bojangles" Robinson is far less than what we don't. Christened Luther at birth, Robinson absolutely hated his name. In a severe case of sibling rivalry, Luther stole the name Bill from his younger brother. The real Bill objected, but Luther persuaded him

with his fists. The old Bill became Percy and Luther became Bill "Bojangles," tapping his way into everyone's heart.

Born in 1878, he started dancing for coins at the age of six on street corners and in the saloons of Richmond. In 1907 Bojangles was a waiter at the Jefferson Hotel, hoping he'd be discovered by one of the important people staying there.

And he was, after he "accidentally" spilled soup on producer Marty Forkins's white suit. He danced all the way back to the kitchen to get a towel to mop up the mess. From that spill on, Forkins was the dancer's business manager for life.

*Everyone over thirty knows what Mr. Bojangles does, right?*

Although Bojangles was a highly successful nightclub entertainer, earning as much as $3,500 a week, he didn't dance for a white audience until he was fifty years old. When he was to be honored by England's King George, he danced up the stairs to receive the award from his highness. The stair dance became his signature.

Bojangles held the world record for running backward: 75 yards in 8.2 seconds. In New York, to celebrate his sixty-first birthday, he danced down Broadway, from Columbus Circle all the way to 44th Street.

Beloved by all, William "Bojangles" Robinson was appointed honorary mayor of Harlem and mascot of the New York Giants. When he died in November 1949, 60,000 people passed by his coffin at funeral services in New York.

Mr. Bojangles is still dancing 24/7 on a triangle all his own at West Leigh, Adams, and Chamberlayne Parkway in Jackson Ward.

# THE CAPITAL(S) OF VIRGINIA

Quick, can you name the capital of Virginia?

If you said Richmond, you'd be right. But you'd also be right if you answered Werowocomoco, Jamestown, Williamsburg, Wheeling, Alexandria, or Lynchburg. Virginia has plenty of capital tales to tell.

Werowocomoco was where Chief Powhatan ruled his territory when the colonists arrived at Jamestown in 1607. The village was located on the Pamunkey River just a stone's throw from where the pesky Englishmen would settle in for the duration.

Jamestown served as the capital of the colony since it *was* the colony for years, until the gang got smart and moved upriver away from the swamps and mosquitoes toward Williamsburg in 1699. Their move was only possible because the natives had been pushed back out of the area.

The capital moved from Williamsburg to Richmond in 1780, declaring independence from Great Britain. Virginians felt the government would be safer inland since Britain ruled the seas. The Americans were proven wrong when an army of British soldiers (led by Benedict Arnold) marched into Richmond in 1781.

Then there was the matter of the Civil War. Richmond became the capital of the Confederate States of America, complete with its own president (Jeff Davis) and own White House. The state capital became the capital of the new country.

Union loyalists simply disavowed the change and moved the capital of the state to Wheeling in 1861. When West Virginia joined the Union as its own state in 1863, the capital of the Restored Government of Virginia was moved to Alexandria (the longest-occupied city of the Civil War). After the South was defeated, the capital was relocated back to Richmond.

If you prefer the Southern version of history, the capital of Virginia remained in Richmond throughout the war, except for four days in April 1865, when Confederate government officials, in retreat from the advancing Union armies, met in Lynchburg. At the moment, the state government is still meeting in Richmond.

Other commonwealth "capitals" of note include:

**Bedford** "Christmas Capital of Virginia"

**Chincoteague** "Clam Capital of the World"

**Danville** "Last Capital of the Confederacy"

**Deltaville** "Boatbuilding Capital of the Chesapeake"

**Front Royal** "Canoe Capital of Virginia"

**Gordonsville** "Fried Chicken Capital of the World"

**Highland County** "Trout Capital of the Eastern United States"

**Martinsville** "Sweatshirt Capital of the World"

**Middleburg** "Unofficial Capital of Virginia's Hunt Country"

**Newport News** "Shipbuilding Capital of the World"

**Roanoke** "Capital of the Blue Ridge"

**Rockingham County** "Turkey Capital of the World"

**Smithfield** "Ham Capital of the World"

**Strasburg** "Antiques Capital of Virginia"

**Tangier Island** "Soft-shell Crab Capital of the World"

**Wachapreague** "Flounder Capital of the World"

**Winchester** "Apple Capital of the World"

Richmond, the capital city for centuries.

SA 50
WHITE HOUSE OF THE CONFEDERACY

Built in 1818 as the residence of Dr. Joh Brockenbrough, this National Historic Landma is best known as the executive mansion f the Confederate States of America, 1861-186 President Jefferson Davis and his family live here until Confederate forces evacuated Richmo on 2 April 1865. After serving five years the headquarters of Federal occupation troo the house became one of Richmond's fi public schools. In 1890, the Confedera Memorial Literary Society saved the mans from destruction and between 1896 and 19 used it as the Confederate Museum. The Soci restored the house to its wartime appearan and reopened it to the public in 1988.

# THE SHENANDOAH VALLEY

Pennsyvania

Shenandoah Caverns

Edinburg

Woodstock

Winchester

Strasburg

White Post

Maryland

Tygart L.

Mount Storm L.

Maryland

West Virginia

Sutton L.

Basye

Bridgemont
New Market

Summersville L.

Timberville

Harrisonburg

Mount Solon

Churchville

Grottoes

Staunton

Hot Springs

Lexington

Natural Bridge

Salem    Roanoke

Smith Mountain L.

Leesville L.

L. Ama

Swift Creek Res.

L. Chesdin

James River

North Carolina

0        50 Miles

0        50 KM

# The SHENANDOAH

## Valley

## Dough for Does and Bucks for Bucks

### Basye

It doesn't cost anything to visit Gail and Alex Rose's Fallow Deer Farm in Basye, but there's a donation jar in the gift shop calling for Dough for Does and Bucks for Bucks.

As proprietors of one of only two fallow deer farms in Virginia, the Roses carve out a living selling whatever people will buy. "He's the poet," says Gail. "I'm the poor dirt farmer." You can pick whatever vegetable is in season for $2.00 a pound, or pick eggs out of the cooler from a United Nations of hens. The chickens come from Ireland, India, Spain, Romania, France, Poland, Italy, China, and North and South America.

But most people wend their way onto Crooked Run Road to see the fallow deer. This ancient breed was brought to Europe from southwest Asia (what is now Iran and Iraq) by the Romans and became a favorite animal on royal hunting preserves. The herd of tiny spotted deer enchants the children, who get to name newborn fawns. However, it's best not to count on an annual reunion. The following year, the same deer could be in the refrigerator, selling as tenderloin, steaks, rump roast, or ground up as Bambi burgers for $5.00 a pound.

In fact, one of the most popular events is an annual grill-your-own day, when the Roses team up with the local ostrich, buffalo, and chicken farmers. It's not for vegetarians.

Deauville Fallow Deer Farm is at 7648 Crooked Run Road in Basye. Call (540) 856–2130 or e-mail the Roses at deer1@shentel.net for more information.

Hey, you lookin' at me?

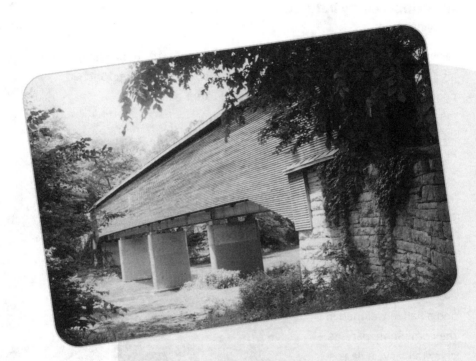

Only eight covered bridges survive in Virginia. This one is located in Bridgemont.

## Amaizingly Corny but True

Bridgemont

Farming isn't the most lucrative career these days, so to supplement his income from corn, soybeans, hay, wheat, cows, and horses, Shenandoah farmer Timothy Day has become a reluctant maze master. From August through mid-November, his cornfield on Route 720 in Bridgemont becomes an agrarian adventureland. The 2-mile-long maze of pathways cut into his cornfield draws more people than crows.

About 10,000 people visit Day's Maize Quest each year. Most folks wander around for about an hour and a half, enveloped in the corn. Some parents carry tall bicycle flags so their children of the corn can find them.

Timothy Day harvests a cash crop of tourists at Maize Quest.

Many visitors spend four hours or so with game sheets, storyboards, and a 3-D map that's readable only if you can figure out its clues. It isn't homespun fun for all. One claustrophobic guy just rammed through the corn like a rampaging bull, damaging the carefully crafted design. Embarrassed, he didn't ask for a refund of his $6.00 admission.

Halloween is a haunting experience at Maize Quest. Open until 10:00 P.M., it's popular with teenagers who spend the evening jumping out, screaming, and scaring each other. Many dress for the season: One night Jesus, two clowns, and Howard Stern lined up to go through the maze. Sighs Day, "It's just a way to keep the farm."

This creativity in corn has its business end too. Every year there's a new design from creator Hugh McPherson. "It's a franchise," says Day. "My brother saw it in a magazine."

Maize Quest is located close to the Meems Bottom Covered Bridge off U.S. Highway 11 and Route 720 near Mount Jackson. Phone (540) 477–4200 or visit www.cornmaze.com.

## James Edward Hanger Historic Monument
Churchville

You'll know you're in Churchville after you cross over Whiskey Creek on U.S. Highway 250 west of Staunton. Four churches highlight the hamlet. Except for the Wool Festival and Pumpkin Festival out at Chester's Farm, Churchville is pretty quiet. Its only ongoing tourist attraction is the James Edward Hanger Historic Monument stuck smack-dab in the middle of town.

Hanger was a Churchville teen who wanted to enlist in the Army of the Confederate States of America in 1861. A food ambulance corps, laden with supplies for the Confederacy, passed through town on its way to West Virginia. Hanger hung on to the group and bedded down

with them in a nearby barn, fired up and ready to go. At dawn he woke suddenly to the sound of gunfire. Hanger jumped from a hayloft to grab his horse, but he never left town. In the skirmish, he was severely wounded by a cannonball.

Union troops found him later in the day and surgeons amputated one of his legs above the knee, making Hanger the first amputee of the Civil War. The traumatized teen went home and took to his room, spending hours whittling and working with barrel staves and scraps of wood. Three months later, he amazed his family by walking down the stairs on an artificial leg that hinged at the knee.

That invention not only made Hanger's life easier, it made him rich. He made "Hanger limbs" for other area amputees, and the state legislature commissioned him to make artificial limbs for wounded veterans. His patent led to a thriving business. When he died in 1919, Hanger Company had branches in London, Paris, Philadelphia, Pittsburgh, Atlanta, and Saint Louis.

Today Hanger Orthopedic is traded on the New York Stock Exchange and has more than 1,000 employees in forty-three states. *Fortune* magazine ranked it as one of the fastest-growing companies in the United States.

## The Fishing Pharmacist
Edinburg

Harry Murray will fill a prescription for what ails you or fix you up with a little fly fishing. Murray's Fly Shop on Main Street in Edinburg is nirvana for anglers because Harry is the man: The unassuming pharmacist behind the counter is one of the nation's foremost experts on the sport.

Murray is the author of seven books, videos, and DVDs. He's also written countless magazine articles on fly fishing, and he travels with the Virginia Department of Tourism promoting the sport. His last tour

was to Tokyo, where he caught the imagination of enough Japanese sportsmen to bring them to the Shenandoah's streams to fish. He also exports his hand-tied flies all over the world.

Murray started fly fishing in high school. Because his family had lived in the valley for six generations, he had broad knowledge of the best streams. His avocation soon became a full-time business in its own right. "I just got into it about twenty years ago," explains Murray. "I began offering a guide service, then published a catalog and it grew and grew."

He's noticed a natural evolution in the anglers he teaches. First they want to catch a lot of fish, then big fish, then challenging fish. "If you stay with it long enough," Murray says, "it's just the personal satisfaction you get out of being outdoors. When I get up in the streams, I feel closer to God." One of the fisher-man's books, *His Bless-ings through Angling*, reflects the spiritual element of the sport.

The flies in his office don't seem to bother angler Harry Murray in the least.

Murray taught fly fishing at nineteen summer courses called Murray's On the Stream Fly-Fishing Schools. He also taught locally at Lord Fairfax Community College for twenty-two years. Many of the students repeat the Advanced Fly Fishing course over and over again. "It's like old home week," says Murray. "The Lutheran pastor took the course for fourteen years straight. I told him, 'Either you're a poor student, or I'm a bad teacher.'" Murray now offers classes in bass and trout fishing right from his fly shop.

Murray's office is perched right above one of his favorite trout streams, and his lampshade is decorated with an assortment of flies. Some guys have all the luck!

Murray's Fly Shop is at 121 Main Street in downtown Edinburg, just a mile off Interstate 81 (exit 279). Phone (540) 984–4212 or log on to www.murraysflyshop.com.

## A Cool Place to Party
Grottoes

Although all caves are pretty darned old, Grand Caverns could be the oldest paid attraction in the nation. Tours have been offered to the public for more than 200 years. Thomas Jefferson was a tourist at the caverns, along with other notables. Located in Grottoes, about 20 miles northeast of Staunton, the caves were discovered in 1804. Entrepreneurs had the natural attraction open for tourists by 1906. Early guided tours were illuminated by candlelight and later by lantern.

In the nineteenth century, residents of the Shenandoah Valley would party hearty in the ballroom of Grand Caverns. They would dance, drink, and dine amid the stalactites and stalagmites, some of which still have candle-wax buildup from serving as natural candelabrums. "There

was no better place to have an event in the heat of a Virginia summer," says Sergei Troubetzkoy, Staunton's tourism director.

The Grand Caverns served as quarters for both Union and Confederate armies during the Civil War. Many soldiers etched their names and units on the limestone walls. Even the father of our country, George Washington, wasn't above scratching his name on cave walls; he signed his name in the Madison Caverns right next door. The Madison Caverns are no longer open to the public, but the Grand Caverns are still going strong. Take exit 235 off I–81 and head east to Grottoes. Phone (888) 430–CAVE or visit www.grandcaverns.com.

## A Stitch in Time

Harrisonburg

If the closest you come to a needle and thread is the mending kit in your hotel room, the Virginia Quilt Museum will win you over to the uniquely American art form of quilting. With leftover bits of fabric, women on the frontier used quilting as a form of self-expression. Often patched together on flour sacks, a quilt was a unique wedding or baby gift that could take an entire season to complete by hand.

After the death of a loved one, the deceased's leftover clothes would be patched into a funeral quilt, the only respectable way for a widow to keep warm. Creative patterns became a standard, and women would outdo each other with color and repetition. There are star quilts, wedding ring quilts, crazy quilts, log cabin quilts, sunbonnet baby quilts, and thousands of other kinds of quilts.

Although the quilting bee has fallen from favor, it was an important social event where women shared their opinions on everything from the news of the day to the latest medical treatments.

The Virginia Quilt Museum is a resource center for the study of the role of quilts in American culture. It displays contemporary and antique quilts with rotating exhibits. Located at 301 Main Street in Harrisonburg, the museum has a patchwork of days it's open. It's best to call first, (540) 433–3818 or go to www.vaquiltmuseum.org.

## Springs and Things

### Hot Springs

Social life in nineteenth-century Virginia included the summer circuit of visiting the springs. Bubbling up out of the ground, Virginia's springs were hot, warm, and cold, and they smelled of alum, sulfur, and other stinky minerals. Languid summers were spent in and around the liquid, sipping and dipping in the waters.

An advertisement promised visitors "The cure for Rheumatism, gout and nervous diseases." Both the well and the sick mingled freely at the resorts. Staff carried the ill on a peculiar contraption called the invalid's chair, which dipped guests right into the water.

Of all the springs resorts—and there were dozens—only two still receive guests. The Homestead, the grande dame of Virginia, has welcomed weary wanderers for 240

Good for what ails you: a little dip, a sip, and a sprinkle from a mineral spring.

years. The Homestead owns both the Warm Springs and the Hot Springs, and you can bubble about in both. The Warm Springs (at a constant 98 degrees) feature the oldest spa structure in America, built in 1761. Both Thomas Jefferson and Mrs. Robert E. Lee were frequent visitors.

Thomas Bullett built the first Homestead Resort near the Hot Springs in 1766. Legend has it Bullett built the hotel because he grew tired of his freeloading guests lolling about in the Hot Springs, the toasty 104-degree pools. Anybody who owns a beach house will understand. A grander version of the Homestead opened in 1846. Ads in *Harper's Weekly* and *Godey's Lady's Book,* complete with doctors' testimonials, drew nineteenth-century guests by the thousands.

A new spa was constructed in 1892 and renovated, refreshed, and refurbished over the years. Modern treatments like salt scrubs, herbal wraps, and Swedish massage have been added, but you can still take a spout bath like in the good old days. Although they don't promise to cure anything, there's a treatment called "The Traditional," which consists of a long float in a private tub that overflows onto the floor, followed by a massage and facial. Traditions are meant to continue.

The Homestead is located on U.S. Highway 220 in Hot Springs. Phone (540) 839–1766 or (800) 839–1766, or visit their Web site at www.thehomestead.com.

Health doesn't come cheap here.

# AMERICA'S OLDEST GOLF HOLE

Taking the waters might be good for your health, but soaking too long can give you wrinkles, so the Homestead, the centuries-old resort and spa in Virginia's Allegheny Mountains, added the game of golf in 1892. The number one tee is the oldest continuously operating hole in the United States.

Created as a six-hole course, it probably got the guys home in time for chores, so it was expanded to eighteen by 1913. In 1994 the Homestead sank another $1 million into improvements to meet the needs of modern golfers.

Dust off those knickers and play the "Old Course." Even for those wielding Big Berthas and contemporary clubs, the Old Course will still get your blood pumping. It's a 6,211-yard par 72 course that commands respect. Now a Pinehurst Company Resort, the Homestead's greens fee has changed a good bit too. A round of golf on the Old Course will cost you more than $100.

## A Tale of Two Tails

Lexington

Lexington, Virginia, is, surprisingly, a center of military history. On the campus of Washington and Lee University, Robert E. Lee rests in peace in a Victorian Gothic chapel with many of his family members. Revolutionary War hero "Light Horse" Harry Lee is entombed there as well, and Lee's beloved horse, Traveller, is buried just outside, by the crypt door. A plaque marks the grave site.

Stonewall Jackson's horse, Little Sorrel, is much easier to see. Thanks to the art of taxidermy, Jackson's horse still stands at the Virginia Military Institute (VMI) Museum at Jackson Memorial Hall in Lexington.

The museum has 15,000 artifacts and was built with compensation funds from the federal government, which had burned the school in a fit of pique. VMI cadets were instrumental in the defeat of Union forces at the Battle of New Market.

Inside, near Little Sorrel, is the coat Jackson wore when he was accidentally shot by one of his own men. Despite the indignity of being permanently on display, Little Sorrel fared better than his master did. Little Sorrel survived the Civil War and died at the Old Soldier's Home in 1886 at age thirty-two. Although he's been dead for 120 years, he's still a good-looking animal.

The VMI Museum is located in Jackson Memorial Hall on the VMI campus. Call (540) 464–7334 or visit www.vmi.edu/museum for information.

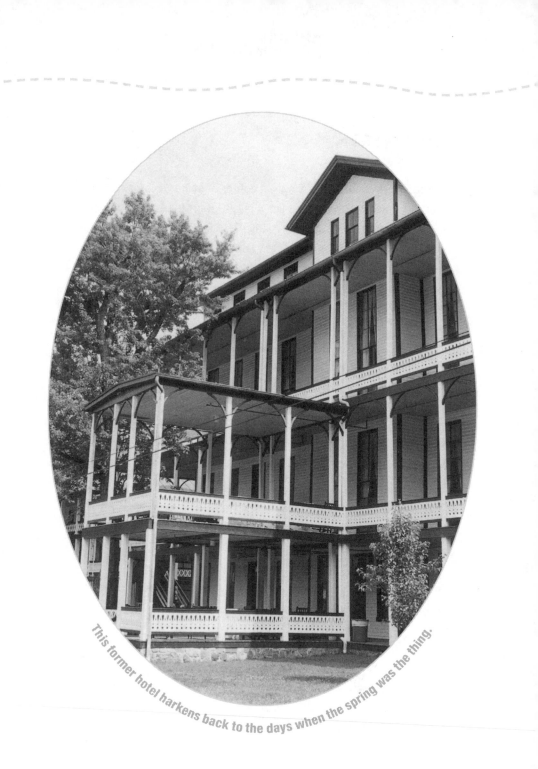

This former hotel harkens back to the days when the spring was the thing.

## Virginia Horse Center
Lexington

You'll see a lot of horse monuments kicking around the Old Dominion, but one of the best places to catch real horseflesh is at the massive Virginia Horse Center off Route 39 in Lexington.

Jodhpurs, jackets, and riding helmets are de rigeur at this massive facility, the largest of its kind. Spanning some 600 acres, the center celebrates one of Virginia's oldest industries. The seating area holds more than 4,000 spectators. Events, most of them free, are held almost every weekend throughout the year. There are draft pulls, rodeos, dressage events, horse shows, and horse sales.

In April the Horse Festival shows off a healthy industry that has survived the information age and is thriving. The Virginia Horse Center is located north of Interstate 64 in some stunningly beautiful country. Phone (540) 463–2194 or visit their Web site at www.horsecenter.org. You just might get the urge to saddle up and see more of it.

## Joust for Fun
Mount Solon

Natural Chimneys has been the site of annual jousting tournaments since 1821. That makes the event the oldest continuously held sporting event in North America. The Hall of Fame Joust is held the third weekend in June and features a medieval mood. Knights in shining armor, century-old lances, and steadfast steeds are the order of the day. A second tournament is held the third Saturday in August. No knights get knocked off their horses these days. Instead, the riders attempt to put their lances through tiny rings while riding at top speed. It's much harder than sinking a basket from midcourt.

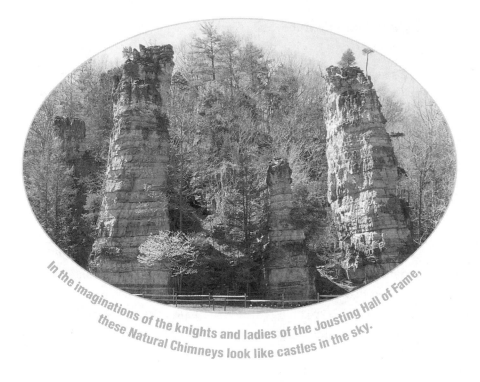

In the imaginations of the knights and ladies of the Jousting Hall of Fame, these Natural Chimneys look like castles in the sky.

The Jousting Hall of Fame Museum may tell you more than you want to know about the ancient sport. It's an equal-opportunity event, despite its founding before Title IX. Women and men are nominated to the Jousting Hall of Fame for their achievements in the sport. More than fifty exhibits honor the Hall of Famers.

Admission to Natural Chimneys includes the Jousting Hall of Fame located in the visitor center. It's a deal at $6.00 per car. Natural Chimneys Regional Park and Campground is off I–81, exit 240. Go west to Bridgewater and follow the signs. Phone (888) 430–2267 or log on to www.nationaljousting.com.

## Foamhenge

Natural Bridge

If you're traveling down US 11 and spot Stonehenge atop a grassy knoll in the Blue Ridge Mountains, you're not hallucinating. If you see Druids, you are. In summer or in solstice, you're eyeing Foamhenge, a full-size replica of the 5,000-year-old mystery made entirely of foam blocks.

What started out as an April Fools' joke is now a tourist attraction thanks to the manic mind of Matt Cline. The artist who created bizarre sets for Alice Cooper and haunted attractions around the country was up to his ears pouring ears for pirates at Enchanted Castle Studios when he had a brainstorm. As he explained: "About fifteen years ago, I was up in Winchester checking out these huge foam blocks for a project. While the salesman saw blocks of foam, I saw Foamhenge. It was in the making for a long time. I get an idea and it wiggles its way into my brain, then I just wait for the opportunity to present itself."

Cline partnered with the owners of Natural Bridge and created companion attractions to give more zip to this ancient (but static) stone bridge. While Thomas Jefferson might have been awed by the natural formation, today's traveler likes a little more excitement.

Cline captures the kids and the curious by the score with Professor Cline's Monster Museum and Escape from Dinosaur Kingdom (noted for the critters eating Yankees). The owners of Natural Bridge gave him permission to erect his monument of monoliths with modern materials near their zoo.

Cline took the time to consult with a tour guide at the real Stonehenge and shaped each stone to conform to the originals in England. While it took the B.C. builders 1,500 years to erect the monument, Cline built Foamhenge in about ten days—just in time for April Fools' Day 2004. Although the monument is built with the same stuff as packing peanuts, Cline suggests it might be more mighty than the original. "It's not biodegradable," he said. Natural Bridge is located off I–81 at exit 175. Call (877) 252–0046 or visit www.naturalbridgeva.com.

## Boys Will Be Boys, and Some Will Be Heroes

New Market

It took a group of schoolboys to send the Federal army packing at the Battle of New Market on May 15, 1864. About 6,500 Union troops took on 4,500 Confederate soldiers in the Shenandoah Valley outside the village of New Market.

Among the Southern forces was a group of schoolboys, young cadets from the Virginia Military Institute who left their studies at Lexington to join in the fray. The school earned the nickname "West Point of the South" by supplying 1,700 soldiers for the Confederacy and sixteen for the Union army.

Leaving the younger cadets behind, 215 boys between the ages of fourteen and eighteen joined Confederate General Breckinridge near New Market.

During the fierce battle, the young cadets charged the Federal battle lines, led by Lt. Col. Scott Shipp. Despite heavy fire, cadet casualties, and the loss of Colonel Shipp, they continued to advance.

Federal Signal Corps Capt. Franklin E. Town witnessed the boys' steady advance. "They came on steadily up the slope . . . Their line was as perfectly preserved as if on dress parade," reported Town.

The cadets took the Federal gunners with their bayonets, and Confederate soldiers saw the VMI school flag waving over the enemy guns. The next day General Breckenridge congratulated them: "Boys, the work you did yesterday will make you famous."

Of the 257 cadets who fought that day, 10 would die and 57 were wounded. Every year on the campus of the Virginia Military Institute, when the names of those killed at the Battle of New Market are called, cadets reply, "Dead on the Field of Honor, sir."

The heroism of the VMI cadets is honored at the Hall of Valor Civil War Museum at 305 Collins Parkway in New Market Battlefield State Park. Phone (540) 740–3033 or go to www.vmi.edu/museum/nm for details.

## Mini-Graceland

Roanoke

The king still sings—in miniature—on Roanoke's Mill Mountain. Dyed-in-the-wool Elvis fan Kim Epperly had visited Graceland more than a dozen times. To be closer to her idol, she begged her husband, Don, to build her a Graceland of her own.

As any good husband knows, it's easier to say yes than no, so he set about building a king's castle fit for his queen in their yard at 605 Riverland Road. Using Graceland as his model, he miniaturized the estate from fourteen acres to fifty-five square feet. He replicated the house in its most minute detail, including the pillars, stone wall, and fountain at the entrance.

So far, there have been no mini-Elvis sightings at Roanoke's mini-Graceland, one of the Star City's littlest big attractions.

Mrs. Epperly loved it so much she wanted more. So between 1987 and 1991, Don added replicas of Elvis's birthplace in Tupelo, Mississippi; the Assembly of God Church where Elvis first sang in public; Vernon Presley's home; Elvis's Memphis car museum; and the Heartbreak Hotel. Elvis had played in Roanoke on four different occasions, so they added a mini–Roanoke Coliseum, where the king performs in perpetuity to a full house.

As their Graceland garden grew, so did the guests. Presley pilgrims from across the United States, Europe, Israel, Russia, Mexico, and beyond found their way to the mini-Graceland. President Jimmy Carter paid homage, and Virginia artist George Kline donated a life-size singing Elvis to the Epperly effort. The garden became the third most visited attraction in Roanoke. When the couple encountered health problems, the Men's Garden Club took on mini-Graceland's maxi maintenance.

Although Graceland suffered some damage in a 2005 snowstorm, fans are still invited to visit the house between 10:00 A.M. and 10:00 P.M. Now, that's devotion!

## Star Light, Star Bright, the Only Star I See Tonight
Roanoke

Created by Roanoke merchants to jump-start the holiday shopping season in 1949, a nighttime neon bulb-burner has become the symbol of the city. Like the Hollywood sign in the hills high above Los Angeles, the Roanoke Star atop Mill Mountain has become a landmark and symbol integral to the city's identity. Aircraft passengers see it first from a distance of 60 miles.

Unlike other Christmas displays, the star was built to last and last. It's 100 feet high, set on a steel structure weighing 60,000 pounds. Designers wanted to make it windproof, so its concrete base weighs 500,000 pounds.

During opening ceremonies, it was likened to the Star of Bethlehem. When radio commentator Lowell Thomas congratulated the town's businessmen, a star was born. It stayed lit past Christmas and has remained so for fifty-six years. For many years the star was red; then it glowed white; during the bicentennial, the star was red, white, and blue, as it has been since September 11, 2002.

No longer the largest star in the states (El Paso, Texas, built a bigger one), it still symbolizes the Shenandoah Valley. Incidentally, *Shenandoah* is a Native American word. Loosely translated, it means "daughter of the stars."

It's a fifteen-minute drive from downtown Roanoke to the star. Signs are everywhere. Phone (540) 342–6025.

A star is born.

157

## A Short Walk through a Long History

Salem

The city of Salem's been around for a while—8,000 years or so. Archae-ological research proves that Native Americans lived here until the first Europeans arrived. In the 1800s about twenty-five families settled in the area, and the town became the seat for the newly established Roanoke County. In 1847 Roanoke College moved itself to Salem from Augusta County. It wasn't a big move: All of the college's resources fit in a single wagon.

Dozens of structures in Salem are now included on the National Reg-ister of Historic Places. A self-guided walking tour brochure leads you on a lovely stroll around a compact twenty-four-block area. At 12 Union Street, a brick structure called New Castle has had more lives than a cat. Originally constructed as a home, it became slave quarters when its owners built a bigger and better place. After the Civil War, New Cas-tle was the site of a chewing tobacco factory. After World War II, it became a private school called North Cross. Today it houses Old Salem Furnishings.

The walking tour brochure is available at the visitor center of the Salem Museum, located in the Williams Brown House; (540) 389–6760.

## Don't Rain on My Parade

Shenandoah Caverns

No need to shiver at presidential inaugural parades or huddle among the masses in Manhattan for Macy's Thanksgiving Day parade. There's a perpetual parade indoors at American Celebration on Parade. Here you can see remnants of parades gone by. It's located at Shenandoah Cav-erns, and the man-made attraction is a fun contrast to the natural one down below.

Gigantic eagles, flags, dragons, rabbits, and swans rest alongside Rose Bowl parade critters whose petals have fallen, replaced by paper and grass seed. The 40,000-square-foot building is big enough to contain a 100-foot train, a 35-foot Rolls-Royce, and a lot more. The colors are brilliant, the themes cheery. It's American cheese at its best.

Hargrove, Inc., the contractor for the 2001 presidential inaugural, has created floats and decorations for inaugurations and other parades since Harry Truman was president. On display are the giant American eagle that flew over Pennsylvania Avenue at the start of the Bush II era and Dick Cheney's Wyoming float. The backdrop stage settings from the inaugural ball let you seal your visit with a presidential photo op.

The company's founder created the museum as a "giant attic" for floats of past parades. "After building so many parade floats, I felt it was sad that these huge pieces of celebration art were often discarded after one appearance," says Hargrove. Now the parade never ends.

American Celebration on Parade is at Shenandoah Caverns off I–81, exit 269. It's open year-round. Call (540) 477–4300 or visit www.american celebrationon parade.com.

Parades in perpetuity.

## Bard None

Staunton

Will Shakespeare had imagination. So did the Shenandoah Shakespeare Company in the little town of Staunton, which decided to reconstruct Will's favorite theater. It was a bit of a challenge, because Shakespeare and his cronies have been dead for four centuries. Architect Richard Burbage was also long gone. He left no blueprints for the original Blackfriar's Theatre, built in England on the banks of the James River in 1596.

The Blackfriar's could entertain as many as 500 people, including the groundlings, who were the riffraff of the theater crowd. If displeased, they were known to throw garbage at the actors. That might be a good way to control the Hollywood crowd, which sometimes reverses the process and throws garbage our way.

A host of historians, researchers, scholars, and architects went to work in Staunton on re-creating the theater. It's not surprising that the resulting new Blackfriar's cost a king's ransom, some $3.7 million. It's a wooden beauty with a balcony that any Juliet would love and a trap door for fairies to use some midsummer night. It's also lit with chandeliers, each holding twenty-four candles. Shakespeare didn't have to deal with fire codes and government bureaucrats, so the reproductions have candles of the electric sort. It also seats far fewer than the original, 320 in all.

Like in the good old days, there is bench seating and a few king's chairs for modern-day royalty. If you want a seat back, you can rent one for $2.00. House lights stay bright, as in Shakespeare's day, so the actors can see if you snooze. Stages are unadorned, decorated mainly by imagination. Women didn't take to the stage until after the 1660s, so although the Shenandoah Company contains men and women, either gender may play any role. This dedicated group of thespians wants to help reluctant theatergoers overcome their fear of Shakespeare, a syndrome they call "Shakesfear."

Blackfriar's Playhouse is located at 10 South Market Street in downtown Staunton, just minutes off I–81 and I–64. Phone (540) 851–1733 or visit www.americanshakespearecenter.com.

## Elder's Antique and Classic Automobiles
Staunton

Bruce Elder is a car guy's car guy. In the auto business for twenty-eight years, Elder wanted to relocate from New Hampshire winters to someplace warmer. After searching nationwide for a building with a solid automotive history, he found a 1912 dealership at 114 South New Street in Staunton. The three-story vintage showroom was once the home of Augusta Motor Sales, the largest dealership in the South. Now it's the home of Elder's Antique and Classic Automobiles. It's also home to Bruce, his wife, and his four children. Talk about living above your station.

The 27,000-square-foot home and showroom contain about one hundred rare and collectible automobiles—and they're all for sale. The showroom is only open Friday and Saturday, but if Elder leaves a door open, people flock in uninvited. "I almost have to slam the door on their tongues to get them to leave," he says. The original dealership installed an auto elevator that's still in working condition, so cars can be found on the first, second, and third floors. There are old Cadillacs, Lincolns, Rolls-Royces, Mercurys, Porsches, and Horsches. Yes, Horsches, made by the German auto manufacturer of high-end cars in the early twentieth century. Elder owns Nazi Hermann Goering's Horsche.

He also has a 1972 Cadillac limousine once owned by North Carolina senator Lauch Faircloth. Elder will sell you a 1961 Cadillac owned by John Lee Pratt, once the single largest stockholder in General Motors. After Pratt's death, his will instructed his attorney to give away $1 bil-

lion to charity. It took him nearly two years, but it was the "funnest job" the attorney ever had.

The most famous vehicle Elder ever sold was "Chitty Chitty Bang Bang," which he bought from a bank when the hot dog king of Atlantic City went bankrupt. Chitty was one of three cars custom-made for the movie. The children's book was written by Ian Fleming, creator of Bond, James Bond, so the car was the star of the show. Chitty had a skiff-type body made of polished mahogany with an aluminum hood and Ford running gear. The fantasy car had to fly, float, and drive on land. Elder bought Chitty, stored it at Marjorie Merriweather Post's estate, and sold it to the Cars of the Stars Museum in England.

Unlike most dealerships, you won't see Elder's advertising. Most business comes from referrals, and Elder exports cars all over the world. He'll find just the one you're looking for, unless he buys it for himself first. "My business is like letting a drunk run the bar," he says. "I have all kinds of cars." Elder is very partial to the 1940 Ford coupe first sold at the original dealership, a 1946 Cadillac that starred in *Hearts in Atlantis,* and lots of old Lincolns and Mercurys.

"There's nothing better than going to a class reunion in an old clapped-out Cadillac and getting all the attention while the $60,000 Mercedes and Lexus are ignored," says Elder.

Grab your own unique ride with one phone call to (540) 885–0500.

## Willie Ferguson Thinks Big
Staunton

The whimsical work of sculptor Willie Ferguson has been popping up all over Staunton for more than a decade. A giant pair of his metal ballet slippers, once featured in *Time* magazine, now welcomes visitors to Ferguson's Metal Foundry in Staunton. They're not alone either. Keeping the slippers company are a 14-foot-tall metal Pinocchio, a couple of 6-foot flowerpots blooming with real flowers, a Gulliver-sized sundial, and a work boot big enough for Paul Bunyan to lace up.

Although the foundry welcomes visitors to wander around the driveway, it's a real working shop. "We're metal surgeons," says employee Gail Schowker. "We repair all sorts of things, from car doors to manure spreaders, but the sculptures are what get attention . . . If all we did was sculpture, we'd starve to death."

Ferguson converted the old Augusta Dairy into a giant metal shop. It has plenty of room to fabricate the giant crutches, watering cans, plows, and books he's been commissioned to do. The art usually finds a home in a public place, but it isn't publicly funded.

When this Pinocchio tells a lie, it's a big one.

When the watering can went up in town, people raised Cain that their tax dollars paid for it. It was quite a fuss, said Schowker, a big mistake. The garden club paid for it.

You can see for yourself what all the fuss is about at 765 Middlebrook Avenue, Staunton. Phone (540) 885–5658.

## Jumbo the Fire Engine

Staunton

Don't confuse Jumbo with Dumbo. Jumbo doesn't fly or eat peanuts. Jumbo is a fire truck.

You can see Jumbo day or night at the Staunton Fire and Rescue Department. The station is open from 8:00 A.M. to 10:00 P.M., and visitors are welcome any time the firefighters aren't out on an emergency run. During the year, Jumbo gets as many as 5,000 visitors.

The firefighters will greet you and offer a tour of the station and a look around at some of the other antique fire equipment, some from the 1700s. They're quite proud of Jumbo. The 1911 Robinson Chemical Fire Engine, made in Saint Louis, is the only surviving vehicle of its type. Jumbo was the very first motorized firefighting apparatus purchased in Virginia. Although the truck still runs, they don't take it out of the station.

The name isn't meant to be cute. Firefighting is serious business. Jumbo was the name given to the equipment by its manufacturer.

The fire department itself is much older than its prized possession. It was established in 1780 as a volunteer department and now has a permanent paid staff of twenty-seven firefighters, as well as volunteers. Keeping Jumbo company are contemporary vehicles with more pedestrian names, such as Truck One or Truck Two.

Stop by 500 North Augusta Street to say hi to Jumbo and give a special thanks to our firefighters. Both have served long and well. The Staunton Convention and Visitors Bureau will be happy to help you find Jumbo and other city "must-sees." Call (800) 332–5219.

## Powerful Prognosticator
Strasburg

Wouldn't it be peachy to have your own personal prognosticator? Someone who could see the future and prevent personal disasters? Consider the possibilities of a dear seer who could help you avoid those career-crashing choices, ruinous relationships, and investment disasters like buying stock in Enron or start-up Internet firms.

Whether you're a believer or a skeptic, it's worth a wander out to Strasburg, where astral music sets the mood at the Jeane Dixon Museum and Library. Open by appointment only, it takes intuition to access the eerie institution. Established in 2002 by Dixon's dear friend and financial advisor, Leo Bernstein, the museum is an odd assortment of her bedroom furniture, evening gowns, hats, personal mementoes, jewelry, crucifixes, books, and big predictions.

First Lady Nancy Reagan relied on the services of Jeanne Dixon, as did U.S. senators and an assortment of Hollywood types. Dixon rose to prominence after she predicted the outcome of the 1960 presidential election and the JFK assassination that would follow. She also predicted the election of Richard Nixon and Burt and Loni's divorce, and hinted at the 9/11 attacks in notations in a book on Nostradamus.

Although Dixon was a devout Catholic, she believed equally in the world of the paranormal. Astrology, divination, reincarnation, revelations, and predictions were all lumped together by the psychic as a divine gift. Her feline, "Mike the MajiCat," lived for twenty-five years. That's long enough for a cat to be classified as a "familiar."

The Jeane Dixon Museum displays with equal aplomb an autographed sweatshirt from the cast of *The Golden Girls* and an exhibit on the links between the twelve apostles and the twelve signs of the zodiac. It's a good thing Jeane Dixon was born in more enlightened times when witch burning fell from fashion.

The family donated this "psychic stuff" to Bernstein after Dixon's death in 1979. He has no explanation of why he opened the museum, but he does believe he can feel her presence within its walls at 132 North Massanutten Street. In fact, he thinks her soul resides in the building. Phone (540) 465–5884.

## Got Milk?

Timberville

The milkman might be missing from modern life, but if you think the glass bottles with cream on top are gone too, just hold your Holsteins. You can buy a creamy bottle of nostalgia at the very modern Shenville Creamery in Timberville.

The dairy farm didn't have a lot of public exposure until a bumper crop of strawberries led owners Leon and Ida Heatwole to set up a card table by the road. The berries were promptly picked clean, and a new enterprise had begun.

The 200-acre farm has its own dairy herd and an observation area where you can watch the whole udderly fascinating process. Gone are the days of the dairy barn and the three-legged stool. This is a modern moo factory, where the fresh milk is chilled to 40 degrees and pasteurized but not homogenized. That lets the cream rise to the top.

If a milk mustache doesn't excite you, there are other more flavorful ways to cram in the calcium. There's the Bakery and Ice Cream Parlor, where you can put some a la mode on a piece of pie. Or try some of the moo by-products: butter, yogurt, cheeses, dips, and spreads.

Fifty acres of the farm are dedicated to fresh vegetables, which are also for sale. Too bad they don't grow cookies.

The Shenville Creamery and Garden Market is located off I–81, exit 264. Take a right onto U.S. Highway 211 and turn right onto Plains Mills Road. Once you cross the river, the creamery is 3.2 miles on your left. Phone (540) 896–6357.

## Dinosaur Land

White Post

Beware the brontosaurus! Make like Fay Wray and cling to King Kong's enormous hand. Pose with the slightly dusty and very hairy Cave Man.

This unlikely scenario is quite possible at Dinosaur Land in White Post. Long before *Jurassic Park* made fear of dinosaurs an American phobia, this roadside attraction was pulling patrons kicking and screaming into its prehistoric forest.

Dinosaur Land was founded in the 1960s, which is pretty prehistoric to today's kids. Thirty-seven different fiberglass monsters loom behind the Hollywood-sized sign, gas pumps, and omnipresent gift shop. Beyond the moccasins, postcards, and rubber dinosaurs are some recognizable stars, like the triceratops, stegosaurus, saber-toothed tiger, and pteranodon. Some unlikely monsters have escaped from the sea! You might have thought you would be Jaws-free on the Shenandoah backroads, but here you'll encounter a 70-foot octopus and a 60-foot shark.

When Joseph Geraci opened the attraction, it was an immediate hit, and over the years it has drawn as many as 20,000 visitors a year. It's still in the family, run by daughter JoAnn Leight.

Although much of Dinosaur Land remains exactly as Geraci imagined it, pine trees and oak trees have grown up throughout the park, creating a seemingly prehistoric forest. The most recent addition came in 1996, when artist Mark Kline added a rather bloody battle between a monster-sized T. Rex and a titanosaur. From the condition of the

titanosaur, the outcome is clearly in T. Rex's favor. There aren't any special effects, other than the beasts themselves. The place is lit up by the imagination only. And that's a blast from the past.

Each dinosaur is labeled with a complete description of when and where it lived, what it ate, and other fun facts. Chances are the kids will know more than the adults. The educational component aside, it's worth the trip just for a family photo in King Kong's paw.

Dinosaur Land, located between Front Royal and Winchester at the crossroads of U.S.Highways 522 and 340 and Route 277, is open from March through December. Admission is charged. Phone (540) 869–2222.

## Fruity to the Core
Winchester

Since the earliest settlement, the western ridge along the Shenandoah Valley has been known as Apple Pie Ridge. The baker of that pie is unknown, but we do know that a young George Washington planted many of the apple trees there.

Little George's appleseed led to big business. Winchester is the heart of apple country, with about twelve million bushels harvested every year. They're eaten whole, here and abroad, or converted into applesauce, apple juice, apple vinegar, apple butter, apple pies—well, you get the idea.

Winchester is apple to the core. Spring arrives with the Apple Blossom Festival, and fall begins with the Apple Harvest Arts and Crafts Festival. Even Union Gen. Philip Sheridan's headquarters, maintained as a historic site, have not been immune to the ubiquitous fruit. In 1924 a massive wooden apple from a parade float was plopped at the site. When it "rotted," it was replaced. People had just gotten used to it.

Motorists can get a guided tour of the Apple Trail with a cassette tape from the Winchester–Frederick County Visitors Center, 1360 South Pleasant Valley Road. Phone (800) 662–1360 or go to www.visit winchesterva.com.

## Many Mini Mansions
Winchester

Virginia's landed gentry are noted for having both time and money—uncommon commodities that lead to uncommon behaviors. When tourists travel to the manors and mansions around the commonwealth, they're awed by the habits and habitats of the rich. One common habit is collecting—wives, wine, horses, carriages, art, antiques, trust funds, stocks, real estate . . . anything on the expensive side.

Julian Wood Glass is an excellent example of the breed. A descendant of James Wood, who received a 1,200-acre land grant in the Shenandoah Valley in 1735, Glass inherited Glen Burnie Mansion in 1955. He immediately transformed it with the help of friend and colleague R. Lee Taylor. The results were stunning.

While Glass traveled throughout Europe collecting the finest antique furniture, silver, glassware, and original oil paintings, Taylor turned his attention to collecting on a much smaller scale: 1 inch to the foot. In Glass's absence, he began to build miniature mansions and furnish them in style. Taylor's tiny creations were big on grandeur. Think Tara and Shadows on the Teche and a Louis IV parlor. He even re-created Glass's house, Glen Burnie, down to commissioning a miniature reproduction of one of the oil paintings.

What began as a winter hobby became a passion. Taylor sewed tiny silk draperies and made mini Oriental rugs. He used period wallpaper for the walls and insisted that everything be authentic. The lights really

illuminate, the tiny place settings at the table are real china and fine silver, and the drawers in the furniture open and shut. The tiny leatherbound books contain actual text from *Quotes from William Shakespeare, North American Birds,* and other tomes. When you see a teensy-weensy wine bottle, it is full of the real vintage listed on the miniscule label.

Being a different size can be very confusing.

Then, he got serious.

Over several decades, in a wee bit of spare time, R. Lee Taylor assembled fourteen mini mansions and rooms replicated in exact detail with 4,000 objects created by seventy of the world's finest miniature artists. After his death in 2000, the mini mansions stayed on the Glen Burnie property for all to see—but definitely not touch—at the Museum of the Shenandoah Valley at 901 Amherst Street in Winchester. Call (888) 556–5799 or log on to www.shenandoahmuseum.org.

## Who the Heck Is Buried in Patsy Cline's Grave?
Winchester

If you want to pay homage to Patsy Cline, ask anybody in Winchester for assistance. From McDonald's to Burger King to the visitor center, it's common knowledge where this body is buried. What they don't tell you is that her grave marker has the name *Dick* on it. That refers to her married name, Virginia Dick. The name we know, Patsy Cline, is in parentheses.

The voice that helped country music cross over into the mainstream boldly began at WINC Radio in Winchester. Born Virginia Patterson Hensley, little Patsy was a bold one, a feminist before feminism had a name. She died in a plane crash in Tennessee in 1963, along with fellow Opry stars Hankshaw Hawkins and Cowboy Copas. Patsy's body came home, and a bench now marks her grave. There's a bell tower dedicated in her honor at the burial site in the Shenandoah Memorial Park.

Thousands pay homage to the deceased diva every year, leaving pennies and flowers at her grave site in remembrance. With the help of a brochure from the Winchester visitor center, Patsy's pilgrims troop along memory lane to the days when Patsy was a waitress at the soda fountain at Gaunt's Drug Store. The singer, who came from a hardscrabble

background, quit school to help support her family. She insisted on singing live on the radio station and cut her first record at GNM Music. She married Gerald Cline at the ripe old age of twenty-one, using his name when she appeared on Arthur Godfrey's Talent Scouts. She sang "Walkin' After Midnight," which sold more than one million copies. The marriage ended, but she kept the name professionally. She remarried, had a baby, and resumed her career with appearances on the Grand Ole Opry and hits like "I Fall to Pieces" and "Crazy."

Upon her death, her husband, Charlie Dick, chose the name and the inscription on her gravestone. He wanted her last last name to be his.

Shenandoah Memorial Park is 3 miles south of town on Patsy Cline Memorial Highway. Call (800) 662–1360 for other Patsy sites, or log on to www.visitwinchesterva.com for Patsy Cline tour information.

To leave flowers for Patsy, log on to www.patsified.com.

# VIRGINIA TRIVIA

- What Virginia town served as a battleground for two of the most important battles of the Civil War?

  *Manassas*

- What was the outcome?

  *Confederate victories*

- What is the world's largest military installation?

  *Naval Station Norfolk*

- Who was Virginia's first African-American governor?

  *Douglas Wilder*

- What is Virginia's wealthiest county?

  *Fairfax*

- Which eight presidents came from Virginia?

  *George Washington, James Monroe, Thomas Jefferson, James Madison, William Henry Harrison, Zachary Taylor, John Tyler, Woodrow Wilson*

- What is Virginia's biggest city?

  *Virginia Beach*

- State flower?

  *Dogwood*

- State fish?

  *Brook trout*

- State dog?

  *Foxhound*

- State butterfly?

  *Tiger swallowtail*

- State bird?

  *Cardina*

- State bat?

  *Big-eared bat*

## By the Time I Got to Woodstock

Woodstock

By the time I got to Woodstock, I was three decades late and in the wrong state. This little town off I–81 in the Shenandoah Valley is better known for its rifles and agrarian roots than its riffs.

Woodstock was founded in 1752 on a land grant from Lord Fairfax. The first resident, Jacob Mueller, named his new town Muellerstadt after his favorite citizen, himself. But George Washington sponsored an act in the House of Burgesses, and the town's name became Woodstock.

The town's most famous citizen was John Peter Gabriel Muhlenberg, who came to town as a Lutheran pastor in 1772. He woke up the congregation on the morning of January 28, 1776, with more than just hymns, fire, and brimstone. As Muhlenberg recited from Ecclesiastes (and the Byrds song)—"There is a time for every purpose under heaven . . . a time for war and a time for peace"—he pulled off his clerical robes. Underneath he wore the uniform of America's Continental army. Known as "the fighting parson," Muhlenberg served with Washington as commanding officer of the Eighth Virginia Regiment.

The Civil War tore through Woodstock, with local men serving in the Stonewall Brigade and the Muhlenberg Rifles. Union soldiers led by Sheridan swept down from the north, torching the crops that fed the Confederacy. Locals who lost their crops, barns, and mills remembered the event as "the burning." Sheridan wired Washington: "I have made the Shenandoah Valley of Virginia so bare that a crow flying over it would have to carry its knapsack."

Since there's little call for rifles in the valley these days, by the time you get to Woodstock, you can hear the music. The Shenandoah County Fair held each August includes more than tomatoes and the tractor pull. There are nightly grandstand concerts with entertainers like George Jones and Billy Ray Cyrus. Call (540) 459–2542 or visit www.woodstockva.com for information.

# THE NORTHERN NECK AND MIDDLE PENINSULA

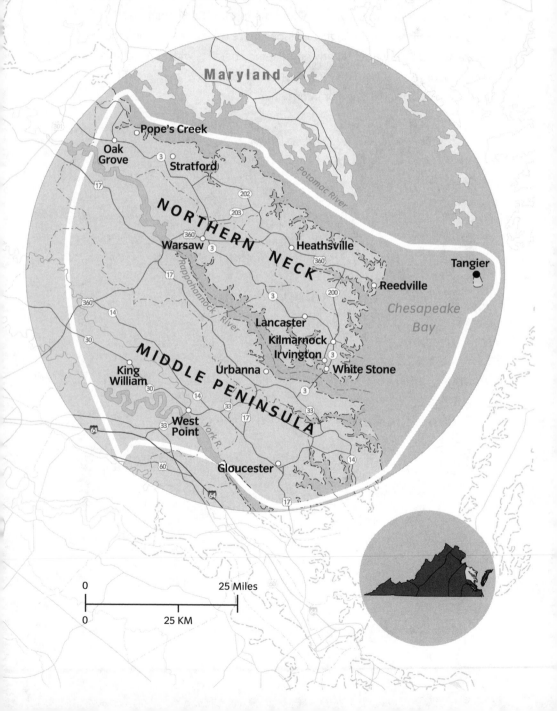

Maryland

Pope's Creek

Oak Grove

Stratford

*Potomac River*

NORTHERN NECK

202

203

360

Warsaw

3

Heathsville

360

17

*Rappahannock River*

200

Reedville

Tangier

360

14

30

Lancaster

*Chesapeake Bay*

Kilmarnock

Irvington

Urbanna

White Stone

3

King William

30

14

MIDDLE PENINSULA

33

West Point

33

17

33

*York R.*

64

60

Gloucester

14

17

64

0      25 Miles

0      25 KM

# The NORTHERN NECK

## and Middle Peninsula

### And Then a Bulb Went Off

Gloucester

The town of Gloucester springs to life every April with its daffodil festival. Not only are the loud yellow blossoms a sure sign of spring, they are golden in more ways than one. Daffodils mean money on the Middle Peninsula.

It began simply enough. Gloucester's early colonists tucked away a few bulbs in their gear and planted them in their new world. It proved fertile ground. Three centuries later, the fields were full of them.

The enterprising Eleanor Smith of Toddsbury, untroubled by the idea of child labor, paid the local kids a dime for each hundred daffodils they picked. Then she shipped them by steamboat for sale on the streets of Baltimore. The jaunty blooms proved so popular (and cheap), they became known as the "poor man's rose."

Since there were plenty of poor men in the 1920s and 1930s, thanks to the Great Depression, the daffodil industry took off. Virginia became the Daffodil Capital of America! Today, they're also grown commercially in the Pacific Northwest, and the United States still ranks among the top three daffodil growers in the world.

Continuing the growing tradition are Brent and Becky Heath of Gloucester. Brent and Becky's Bulbs, at 7900 Daffodil Lane, ships "future flowers" to appreciative gardeners around the world. The cou-

ple experiments with new hybrids at their nearby farm home. The work is supervised by their cats, Daffy and Dilly.

With dozens of species and hundreds of hybrids to describe, Becky had an idea. A bulb went off. The former teacher wanted to show, not tell, about the varieties and planted a living catalog. In season at the bulb shop, customers wander along rows of daffodils and other flowering things, sniffing, seeing, touching, and celebrating this rite of spring. With the printed catalogue in hand, they stop and circle a variety that they want in their own yards. It's so much more pleasant than paging through those piles of catalogues at home. It seems Becky Heath has a thing or two to teach those mass merchandisers.

For more information, go to www.brentandbeckysbulbs.com.

*A daffodil hobbyist turned hybridist.*

## Hughlett's Tavern Rangers
Heathsville

To the rescue—there's a tavern in danger! Nothing raises the alarm faster than the possible loss of a watering hole. Especially one that has been providing libations for more than three centuries.

Hughlett's Tavern sprang up in the late 1680s, supplying water to the courthouse and food and drink for the court's visitors. It must have been wildly successful, because it was expanded six times. It went from a tiny two-room "ordinary" to a 110-foot-long building with a second-story veranda. In 1866 John and Felicia Rice bought the building and renamed it Rice's Hotel, of course. They ran a fine establishment, but chains changed the hotel business, and Rice's closed in 1900. In 1990 family member Cecilia Fallin Rice donated the dilapidated tavern to the Northumberland County Historical Society.

That's when the Tavern Rangers rode to the rescue. For a decade, dozens of volunteers worked to salvage the old structure. It was a labor of love and libations. In November 2001 Hughlett's Tavern reopened for business.

Local residents Brandon and Bobbie Levine run the Tavern Restaurant (804–580–7900). Stop by for lunch or dinner Wednesday through Saturday, or belly up to the bar and raise a toast to the Tavern Rangers. They know what's worth preserving. To join the Tavern Rangers, call (804) 580–3337.

# KING OF THE NORTHERN NECK

In September 1649 King Charles II granted all of Virginia between the Rappahannock and the Potomac Rivers to seven Englishmen as a proprietary. That's all of the Northern Neck, Fredericksburg, Prince William, Fairfax, Arlington, and Loudoun Counties. These guys had hit the jackpot.

Even they didn't know how big a jackpot it was. Because the land hadn't been mapped or surveyed beyond the river shore, they were unaware of the size and value of the gift. Along with the land, Charles had conveyed all the rights and entitlements of an English baron to "build towns, castles and forts, endow colleges and schools and . . . enjoy the patronage of churches." The lucky owners could also give, grant, or sell the land within the proprietary.

No matter where you travel in the original patent, you'll run into one of the beneficiaries of this generous royal gift. Robert "King" Carter patented 11,000 acres in 1727 and 19,000 acres in 1729. His sons George and Landon snapped up grants exceeding 21,000 acres. At the time of his death, "King" Carter held 300,000 acres of land, 1,000 slaves, 2,000 head of cattle, and 100 horses. Carter was indeed "King" in the colonies.

## Stairway to Heaven
Irvington

Robert "King" Carter, one of the most powerful planters in Virginia, spared no expense in the building of Irvington's Christ Church in 1735. It's an impressive structure that has proved to be as durable as it is beautiful. The old brick building has walls 3 feet thick and a massive limestone slab floor. Built to last, Christ Church still holds regular worship services on most Sundays.

Modern worshippers must be a lot less hardy than earlier congregations though. Christ Church has neither heat nor air-conditioning, so on days when you could freeze ice cream inside or melt butter, worship is moved elsewhere.

Going to church in "King" Carter's time was an all-day affair. Members must have had staying power or rubber rumps to sit on those hard wooden benches for hours at a time. The high-backed pew boxes were assigned according to the wealth and power of those who purchased them. Old "King" Carter sat right up front.

This levitating pulpit lets the pastor peek on those who sleep.

The pulpit is a massive affair, with three different levels above the ground floor. On the first level, ordinary announcements were made. On the second level, items of more ethereal news were shared. And high above the crowd in the skybox level, the minister preached the sermon. Not only was he climbing the stairway to heaven, he could see inside the boxes and notice who was nodding off.

Christ Church is open April through November. There are tours and a gift shop for nonworshippers. It's on Route 646 outside of Irvington. Phone (804) 438–6855.

## In the Altogether in the Great Outdoors
Irvington

When you stay at the elegantly offbeat Hope and Glory Inn in Irvington, don't be surprised if you see guests headed outdoors for their showers. Wandering through the garden in the inn's signature white terry robes, you'll see oldsters and honeymooners waiting their turn to be in their altogether in the great outdoors. It's not that the inn doesn't have plenty of indoor plumbing—each guest room and cottage has its own private bath with tub and shower—but most guests revel in the novelty of bathing under the blue sky above during the day, or the stars at night. The outdoor bath is open year-round, with few takers in the cold weather months.

It includes a claw-foot tub, a pedestal sink, and a shower. There aren't any worries about splashing water on the floor either. It's a plain old stone patio with drains. Exhibitionists need not apply; there's total privacy. Wood fence walls and plenty of shrubbery prevent peeking by nosy neighbors!

The outdoor bath is not the only surprise at Hope and Glory. Once a plain old elementary school, the compound is now the scene of the lush life: cushy terry robes, designer soaps and shampoos, and gourmet breakfasts. Entertaining sculptures and art objects pop up in unlikely places. In the living room, a wooden replica of the inn holds the television set. Clever chess sets have been created, with an assortment of salt and pepper shakers serving as knights, queens, rooks, and pawns.

The unusual name for the inn came from one of its owners. Bill Westbrook had a long career in advertising before becoming an innkeeper. His partner, Peggy Patteson, remembers that when they first saw the dark and dreary house, Westbrook quipped, "There's definitely hope for this place . . . and there will be glory."

Walls were removed, floors and walls were whitewashed, and the space was filled with light, bright, and breezy furnishings along with local antiques and oddities. White birch branches serve as curtain rods in some of the upstairs rooms.

Snow shower? Meteor shower? The outdoor bathroom is open to the elements year-round.

"We're for the young and young at heart," says Patteson. "The Hope and Glory makes you smile. It reminds you of your grandmother's house and gives you happy thoughts." Unlike at Grandma's, you can get naked outdoors.

The Hope and Glory is hard to miss. It's a great yellow house in Irvington next to the town park. Phone (800) 497–8228 or log on to www.hopeandgloryinn.com.

## Whatever Floats Your Boat!
Irvington

In 2005 the Tides Inn held an eightieth birthday party for Miss Ann. During the fete the lady didn't have much to say. That was a shame, because she has a long and storied past.

*Miss Ann* is a 127-foot yacht, listed on the National Register of Historic Places. During WWII, she was painted battleship gray and commissioned the *Aquamarine* PYc-7 in a ceremony at the Washington Naval Shipyard. She served the Naval Research Lab conducting underwater sound and communications experiments. *Miss Ann* also served as tender to two presidential yachts, the *Potomac* and the *Williamsburg*. After active duty the yacht very nearly went on a world cruise with her new owner, a retired army colonel who had a home in the Philippines.

Luckily it proved to be beyond the means of the military man, and the yacht was sold to E. A. Stephens, the founder of the Tides Inn, an elegant riverfront resort on King Carter Drive in tiny Irvington (804–438–5000; www.tidesinn.com). The yacht was refitted and renamed the *Miss Ann*. Today she's owned by the resort, and monied guests cruise the Chesapeake Bay while drinking fine wines and sampling Ghirardelli chocolates. It's fitting because *Miss Ann* was born with the proverbial silver spoon in her intake.

She was created in the Roaring Twenties especially for John and Elsie French. He was a Detroit banker, industrialist, and yacht collector. She was a spender. He wanted the fastest and most stable yacht money could buy. She wanted to decorate it and spent $20,000 on the interior. On April 10, 1926, Mrs. French christened the luxury yacht *Siele,* an anagram for her first name.

Later that day the couple set out (with a complete crew, of course) for the maiden voyage. They left New York Harbor for an extended cruise through the St. Lawrence River to take the *Siele* home to Detroit. Mrs. French was relaxing on a couch in the main salon when a storm came up. A rogue wave hit the yacht, and as it rolled, she was launched across the salon and landed on another couch on the port side.

*At eighty Miss Ann has yachts and yachts of stories to tell.*

185

After her short flight and cushy landing, Mrs. French went belowdecks to her cabin and waited until the yacht docked. She reappeared with her personal maid and luggage in tow and transferred to a first-class railcar. She would never sail aboard the *Siele*—or any other ship—ever again.

## Smile and Open Wide
Irvington

Not many people smile when they're walking into the dentist's office, but Irvington's Dr. Bob has changed that. Goofy grins are the order of the day as patients pass by the 10-foot toothbrushes at his front door. Crafted to serve as porch pillars, these unusual icons are a very visible reminder to brush after every meal.

Smile and open wide.

When dentist Robert S. Westbrook built his new offices in Irvington, he engaged the help of a creative team. The talented trio included his brother, Bill Westbrook; architect Randall Kipp; and Sandra Matthews, a local artisan better known as Miss Vinyl Pants. Sandra got her unusual nickname from being able to do anything with vinyl, from patching runs in her panty hose to making big banners and intricate architectural moldings. Miss Vinyl Pants was charged with the task of making the toothbrushes. She enlisted the help of a local boatbuilder, who humored her and built the handles and heads from fiberglass. Then she used fiber optic technology to craft the bristles from vinyl. She attached the bristles to the boards and glued them to the porch supports. Suddenly, there's a porch you can wrap a smile around.

Inside the dentist's office are lots of Polaroids of patients with toothy grins. You might want your own picture taken with the behemoth brushes. Just don't forget to smile.

Dr. Robert Westbrook's offices are on Route 200 in Irvington.

### Real Estate
Kilmarnock

Born at Sampson's Wharf, the last steamboat stop on the Great Wicomico River, Curtis Sampson is as native as they come in the Neck. During his working days, he managed the elite Tides Inn, where people would settle on the water and be catered to for weeks at a time. Sampson made every day an occasion for his guests, but he went overboard at Christmastime, crafting elaborate replicas of local landmarks as part of the festive displays.

One year, he made a dollhouse to top off a massive sideboard in the main dining room. More a mansion than a dollhouse, Sampson's holiday creation was 8 feet long and nearly 6 feet high. The exterior was built of

real wood siding, and the roof had real shingles cut to fit. Sampson, an avid collector of Northern Neck antiques, had an eye for elegance. He had accumulated a huge collection of miniatures that needed a good home. The result was more real estate that he'd imagined.

Sampson's mini manor had seven rooms with hardwood floors and Oriental carpets cut from the real antique variety. Sampson added tiny blown milk-glass lamps and a hanging chandelier that lights up. Each room bustled with little porcelain people in period costumes. The house was a huge hit at the Tides Inn, and after the season ended, Sampson took it home. "Thank goodness I had a big house," he said.

When Sampson retired from the inn, he opened an antiques shop and took the dollhouse with him. "It was too big to go up the stairs," says Sampson, "so we had to take the windows out and haul it in through there!"

Sampson closed his individual shop and joined forces with local antiquers, the Bonners, in their expansive Kilmarnock Antique Gallery. The dollhouse followed (coming out the same window it went in). It now has a permanent home and a permanent following with the tourists who adore browsing through the blocklong gallery of antiques and collectibles.

Unlike other items in the gallery, "The dollhouse is simply not for sale," says Curtis.

Kilmarnock Antique Gallery is at 144 School Street. Phone (804) 435–1207.

# FERRY ME BACK TO OLD VIRGINNY

In a region noted for its water, it's not surprising that ferries ply the waters on the Northern Neck. Two of the five remaining free ferries in the commonwealth are found here. If you love to wait and you love the smell of diesel fuel, you'll love these little throwbacks to the days when we waited well.

The Sunnybank Ferry crosses the Little Wicomico River at Ophelia. It was established to shorten the way to work for fish factory workers in Reedville when saving 10 miles over the long way by road made a big difference.

On the Northumberland Heritage Trail, a Virginia scenic byway, the Merry Point Ferry crosses the Corrotoman River from Lancaster to Ottoman, saving you a very long drive from Lively, Virginia.

# BEWARE THE BAY

On a hot summer day, it's tempting to take a swim in the Chesapeake Bay. The beautiful blue water of the nation's largest estuary can look mighty tempting. But take a clue from the locals and watch out for the dangers of the deep . . . or the shallows. There are plenty of pesky blue crabs to pinch your tasty toes, and the occasional *tylosurus crocodilus crocodilus*. No, it's not a crocodile; it's a hound needlefish, a needle-nosed nasty that propels itself through the water, occasionally impaling an ankle. It eats other fish, darting around shallows looking for a breakfast of trout or croaker. There have even been some needlefish fatalities in the United States. Don't let one swim into your chest, neck, or other essential anatomy. It's not good for much, and you probably won't find one appetizing enough to eat: Its bones and flesh are green. As unappealing as it sounds, the needlefish is a negligible risk compared to another danger floating in the Chesapeake.

When the water warms to a temperature fit for human swimming, other little creatures float in to join the fun. The stinging nettles arrive in the bay in the late summer, bringing the stings along for the ride. When you refer to stinging nettles in other parts of the country, you're referring to a plant. Near the Chesapeake Bay, they're talking about a jellyfish. Its official name is *Chrysaora quinquecirrha;* its unofficial name is *ouch.*

This yucky, gelatinous white creature with a mushroom-cap top and streaming tentacles stings anything and everything in its path—including you. The stinging nettle can't attack. It just floats along with the tide and currents, minding its own business until you brush up against it.

There are dozens of folk remedies for stings. You can apply baking soda to take away the itch. Others swear by Adolph's Meat Tenderizer. A newer folk remedy requires a credit card to scrape the sting. That's what they mean when the card advertisers say, "Don't leave home without it."

Chillin' in the Chesapeake can sting when the nettles float in for their summer visit.

If you see people wading into the Chesapeake in tennis shoes and jeans or water-skiing in wet suits, they're not necessarily protecting themselves from the cold. A bunch of stings can really ruin your day.

Some beaches have outsmarted the creatures and captured the summer swimming market by installing nettle nets on their beaches. It's worth the entry fee.

## Making a Baby
### Kilmarnock

Anybody can make a baby at the Doll House in Kilmarnock. No, there's no cloning going on within the little cottage on North Main Street, although there might as well be.

Workshops led by owner Brenda Shirah teach students how to build a baby that has an uncanny resemblance to its creator. She's not the least bit troubled when someone calls, wanting to come over and "make some babies." Adults can produce one in about six hours, a marked improvement from the normal nine months. Children are much quicker. The little ones make plastic little ones in as little as four hours.

Shirah also does a healthy business in mail-order babies. People send snapshots of their children, and she sends them their own childlike doll.

For the fumble-fingered, the Doll House also features hundreds of dolls and adorable huggables from around the world, with prices ranging from less than $10 to more than $400. There are brides and bears, baby dolls, Raggedy Anns and Andys by the score, and ornate imported dolls with delicate bisque faces.

*These cloned cuties come with a bonus: They don't cry, whine, or need their diapers changed.*

The petite and loquacious owner got into the baby business quite by accident. When surgery sidelined her bookkeeping career, she thought she'd try to make a doll or two as a hobby. Word spread, and soon people were calling her to teach them how. After her husband encountered a strange woman in his house for a doll lesson, he said to his wife, "Why, you might as well open a shop." She did.

The Doll House is located at 50 South Main Street in Kilmarnock. Phone (804) 436–9033.

## Pay the taxes yet, deer?
King William and West Point

If Chief Powhatan had known the annoying habits of the English settlers, he may have thought twice about forming an alliance with them. He was already the prince of power from his capital Werowocomico on the Pamunkey River, having consolidated thirty tribes with 8,000 subjects and a fighting force of 2,400 warriors. While he may have intended to alter the balance of power with other Native American tribes, the chief's actions had an unexpected outcome.

His daughter, Pocahontas, would marry Englishman John Rolfe, who would profit from the native weed, tobacco, and haul the girl off to merry old England, where she amused the royals. But the Indians won in the end. Rolfe was killed in a war with the Powhatan tribe in 1622.

The settlers at Jamestown survived thanks to the game, fish, and corn provided by Chief Powhatan's people. The settlers would repay the chief's kindness by snatching most of his land.

Although Powhatan and Pocahontas got most of the press and a Disney film contract, some of Virginia's Indians have survived. There are eight remaining tribes with about 4,000 total members. The tribes are recognized by the commonwealth but not the federal government. That means no casinos from the feds, but the recognition exacts a price in Richmond. No one resides in the Commonwealth of Virginia without paying state taxes.

Every fall around Thanksgiving, tribal members travel to Richmond to render unto Caesar what is Caesar's. As the Virginia tribesmen arrive at the steps of the capitol in full regalia, the governor comes outside to greet them. In a simple ceremony, the Native Americans give thanks for their land and their state and present the governor with a deer or wild turkey. The governor accepts the deceased animal with his thanks. The game is then dressed, cooked, and delivered to an area food bank to nourish the hungry.

If Chief Powhatan had known that feeding the colonists would continue for four centuries, he might have reconsidered his initial offer.

Learn more about Virginia's native tribes at the Pamunkey Indian Museum and Reservation in King William at 2052 Lay Landing Road (804–843–4793), and the Mattaponi Indian Reservation and Museum at 1467 Mattaponi Reservation Circle in West Point (804–769–2229).

## Row, Row, Row Your Boat

Lancaster

If you're into sculling, consider a vacation with a coach at Calm Waters Rowing School in Lancaster. There's no escaping instruction because you live with the coaches. Their home, the Inn at Levelfields, is a stroke or two above the average abode. No camp cabin was ever like this. Each room has a fireplace and hardwood floors; the game room has a big-screen TV. It's great for watching the game, but part of the sculling experience is reviewing your day's progress on videotape. And don't expect camp chow; the school has a cook to prepare exceptional meals so you can focus on your technique.

The coaches aren't your average camp counselors either. John Dunn was the rowing coach at Cornell University for more than two decades and a medal winner at the World Championships in 1975 and 1976. Charlotte Hollings, Dunn's wife, who was on the U.S. national team, earned a silver and a gold at the World Championships in 1985 and 1994. Both have also earned their oars coaching at the Craftsbury Outdoor Center in Craftsbury, Vermont, and at the Florida Rowing Center.

Campers are invited for three-, four-, or seven-day stays. Each day is packed with plenty of time to row your boat. There are three sessions scheduled daily, two coached and one informal outing. Nonrowing spouses can get a discount for their slacking while the sculling partner is busy all day. The inn is located on a private freshwater lake where you can row, row, row your boat better than before.

Calm Waters Rowing is at 10155 Mary Ball Road in Lancaster. Phone (800) 238–5578 or log on to their Web site, www.calmwatersrowing.com.

## The Goat Walk
### Oak Grove

Goats are known to be nimble. At Westmoreland Berry Farm, hopping hooves are put to the test. A ramp leading from the goat pen rises rapidly and crosses the road 20 feet above the farm. Guests are surprised to see a goat peering down at them as they drive up. A small elevator system worked by a pulley hauls goat chow up as a reward. The goats have visitors well trained: They eagerly part with their quarters to keep the treats coming and the goats walking the ramp.

The goats are the stars of the show at this Northern Neck institution. Generations of goats have been named after nursery rhymes. There's Twinkle, Star, "Howwe," and Hansel and Gretel. See them walk the plank for a quarter's worth of corn April through Christmas. Call (800) 997–2337 for details.

**Great Caesar's goats! These cute skywalkers wander over visitor's heads at Westmoreland Berry Farm.**

## It's the Berries

Oak Grove

Located along the Rappahannock River, Westmoreland Berry Farm was once a plantation known as Leesville. The manor house burned after being attacked by Union gunboats during the Civil War and was never rebuilt. What grew up instead is berry nice indeed.

The owners of the land since the early 1980s, the Alan Voorhees family, met a young couple interested in organic farming. A friendship developed, and the family gave Chuck and Anne Geyer free rein to turn the idle land into their dream farm. The Geyers began to plant trees, bushes, berries, and produce in the 1980s. The Voorhees family donated an adjoining tract of land to the Nature Conservancy, creating a large riverfront park.

The two families planted much more than seeds, however. Westmoreland Berry Farm is now the most visited tourist attraction in the Northern Neck. Who would have thought that pick-your-own would be the first pick for entertainment in the region? Crowds with buckets and baskets stream in from May through October.

Berry season begins in May with strawberries. It gains momentum through the summer with cherries; tayberries; black, red, and purple raspberries; blueberries; and peaches. Fall brings grapes, apples, gourds, and pumpkins.

Westmoreland has grown with the berries. A little restaurant serves sandwiches and snacks to picking people, and features a popular "sundae of the day" with a seasonal fresh fruit topping. You can also buy prepicked produce, jams, jellies, and honey.

People are welcome to pick, picnic, and play while a staff of forty-five does the work. It's all the fun of the farm without the work.

Westmoreland Berry Farm is at 1235 Berry Farm Lane, off Route 3 in Oak Grove. Phone (800) 997–2377 or visit www.westmorelandberry farm.com.

# A HALE PALE ALE

Based on a secret formula created by Arthur Carver Sr. in the 1920s, Carver's Original Ginger Ale is as good for the soul as it is for the stomach. Ginger is good for what ails you, and in this ale the ginger is blended with artesian well water.

Beneath the Northern Neck Bottling Company's plant in Montross is a 650-foot-deep artesian well, which puts the hale in the ale. It's also blended with cane sugar. The recipe includes no fat and no caffeine to make you jumpy. It also doesn't have capsicum, the hot red pepper that gives other ginger ales their bite.

For years Carver's has washed down many a burger and crab cake. It's a Northern Neck tradition. The folks who make Carver's consider their ginger ale a work of art. When the company introduced it in 1992 at the International Fancy Food and Confection Show in Washington, D.C., the drink received good reviews from Beverage World and entered the tony world of haute cuisine. Bottlers now recommend that Carver's be served in a champagne flute chilled to between 34 and 38 degrees. Ice, if it must be added, should be rinsed first for purity's sake.

Carver's is so good that it was recently purchased by Coca-Cola. The locals are complaining that it doesn't taste the same.

## George Washington's Birthplace, Sort Of

Pope's Creek

When George Washington was born in February 1732 at Pope's Creek in Virginia's Northern Neck, he was "to the manor born." The cost to build the house was 5,000 pounds of tobacco. Imagine rolling hogsheads of tobacco to the mortgage broker.

George's house contained ten bedsteads, thirteen tables, fifty-seven chairs, eight chests, and assorted other household items. Most Virginians lived in one-room houses, but George's birthplace was rather grand.

The house that now stands on the property is not George's birthplace. That burned on Christmas day in 1799. The Washingtons had plenty of houses, so this one was never rebuilt.

What you see at the George Washington Birthplace is another structure, built in the 1930s. It's not an exact replica of the original, just a house of the era. Called "The Memorial House," it's not built on the original site either, although at the time they thought that's where it was being constructed.

During the bogus birthplace's construction, workers unearthed the foundations of the original house a few feet away. The workmen promptly covered them over with dirt, ostensibly to preserve them. I think they were burying the evidence. Maybe they were just a mite embarrassed at missing the site? In any case, an oyster shell outline now points to the real location of George Washington's birth.

George Washington Birthplace National Monument is located at 1732 Popes Creek Road. It's preserved as a working plantation with numerous outbuildings, gardens, and animals. Phone (804) 224–1732 or log on to www.nps.gov/gewa.

# WASHINGTON SLEPT AROUND

You could spend the better part of a vacation visiting Washington plantations in Virginia. In George's day, these sites were a two- or three-day ride on horseback, an uncomfortable proposition at best.

Although many places claim "Washington slept here," these are some of the sites where George is known to have rested his head:

• *Pope's Creek.* Washington lived there for the first three years of his life until moving 80 miles up the Potomac River.

• *Little Hunting Creek.* Little George lived at this plantation on the Potomac until he was six. He returned later in life when the plantation had a new name, Mount Vernon.

• *Ferry Farm, Fredericksburg.* George lived at this plantation on the Rappahannock until he was sixteen. When his father passed away in 1743, George's half brother, Lawrence, inherited Little Hunting Creek and Pope's Creek, and George was to have Ferry Farm when he came of age. When Lawrence died, Washington rented Little Hunting Creek (later to be known as Mount Vernon) from his widow until her death. It became his in 1761.

• *Morristown, New Jersey, and Valley Forge, Pennsylvania.* George and Martha wintered over in these towns during the American Revolution.

## Something's Fishy Here
Reedville

Reedville's a town built on the bounty of the bay and a fish that wasn't caught for eating. Reedville grew rich fishing for menhaden—not a glamor fish by any stretch of the imagination. In fact, its nicknames are downright nasty: alewife, vunker, pogy, fat-back, and the worst of all, bugmouth. It seems that a crustacean parasite likes to attach itself to the mouth of the menhaden. Bugmouth sure is descriptive if not attractive.

A member of the herring family, the menhaden spawn in the ocean; the youngsters grow best in estuaries like the Chesapeake Bay. Their migratory patterns are like those of senior citizens: They head south for the winter and north to New England for the summer. Reedville was the perfect spot to catch these fat-filled fish. The menhaden were once the second-largest fish harvest in the United States. They were rendered into oil, protein meal, and soulbes for fertilizer and feed.

Rendering tons of fish may have made Reedville prosperous, but it also raised a rather strong odor, which wafted around town. Some folks thought it smelled like money. Today there's only one fish factory left in Reedville, and the watermen have turned to fishing for crab, oysters, and other more lucrative seafood.

With many of the captain's houses restored, Main Street is postcard pretty. The town doesn't smell fishy now either. However, one tradition remains: On the first weekend in May, the town gathers for a blessing of the fleet with prayers for the safety of the watermen and a bountiful harvest from the bay.

Visit the Reedville Fisherman's Museum at 504 Main Street. Phone (804) 453–6529.

# SCANDAL AT STRATFORD HALL

A younger woman wooing an older man from his wife is standard fare in Hollywood films and romance novels, but sometimes history offers as much, if not more, melodrama than fiction.

Let's call our historical soap opera Stratford Hall and set the stage in early nineteenth-century Stratford, where the Lees were a well-established, old-line Virginia family with a vast plantation.

The Lees had it all: wealth, prominence, power. Henry Lee IV was related to Revolutionary War hero "Light Horse" Harry Lee and to beloved Civil War general Robert E. Lee. Young Henry had inherited the family estate and married Ann McCarty in March of 1817. Soon after the wedding, Ann's younger sister, Elizabeth, came to live with the new couple. Elizabeth McCarty loved life at Stratford Hall Plantation, so much so that she wanted to become a permanent member of the family. That should have been a red flag to her older sister.

The plot thickens. In 1817 Elizabeth petitioned the court to have her guardianship transferred from her stepfather, Richard Stuart, to her sister's husband, Henry Lee. In order to become Elizabeth's guardian, Henry was required by the court to post a $60,000 assurance bond to guarantee his sound management of her wealth. He did so, and the trio lived together lavishly at Stratford Hall, a happy, albeit unconventional, family.

A year later the tale begins to turn into a tangled and tragic triangle. In 1818 Ann gave birth to her first child, Margaret. In 1820 toddler Margaret took a tumble down the steps of the great house and died. In her grief, Ann turned to morphine. In his grief, Henry turned to Elizabeth.

Henry and Elizabeth's affair didn't remain a secret for long. Among Virginia society there were whispers and rumors of an illicit pregnancy. People talked about Ann's morphine addiction and her husband's philandering.

The scandal took its toll. Henry made an attempt to preserve his family's good name and sent Elizabeth away to Montross, Virginia, to live with her grandmother. The pregnancy rumors persisted.

The scorned Elizabeth returned to court and petitioned to have her guardianship (and her fortune) reverted to her stepfather. But Henry had spent much of Elizabeth's inheritance during her days at Stratford Hall. To pay his debts, Lee sold Stratford to William Clarke Sommerville of Maryland for $25,000. The *Stuart v. Lee* court case dragged on for nine long years. The Lees lost their ancestral home, and much more.

## Stratford Hall Plantation
Stratford

Built in the 1730s, Stratford Hall was a working plantation, a "towne in itself" wrote an early visitor. Centuries later, it's still a working plantation—the oldest in the United States.

Better known for its family than its farming, Stratford Hall produced tobacco, wheat, barley, oats, flax, and corn. Sheep, cattle, hogs, and chickens were raised there. Boats were built, bricks were fired in the kilns, grain was ground. There was a ship's store, a tobacco warehouse, and a wharf for marine traffic.

But Stratford Hall also produced a lot of Lees. Among them were signers of the Declaration of Independence, a hero of the Revolutionary War, and one of the leading men of the Civil War, Robert E. Lee.

The Lees were among the first to arrive in Virginia, and they left a lasting impression. Richard Lee arrived in Jamestown in the late 1630s and quickly ascended to prominence as a member of the House of Burgesses, the high sheriff, a colonel in the militia, and a member of the Council of State. He also amassed 16,000 acres in Virginia and Maryland—including 1,000 acres that would become Mount Vernon—and produced seven children.

One of Richard's grandchildren, Thomas Lee, was blessed with intelligence and foresight. Seeing great fortunes sailing up the Potomac, Lee bought 1,443 acres of land in the Northern Neck. After an arson fire destroyed his home, he began construction of a new one in 1734, naming it Stratford Hall after the family estate in England.

The Robert E. Lee Memorial Foundation purchased Stratford Hall in 1929. Directors hail from all fifty states, Europe, and Great Britain; two of them are direct descendants of the Lees. Directors, who are actively involved in fund-raising and promoting the plantation, have a guesthouse on the property, which is theirs to use for life.

Today Stratford Hall retains the Camelot quality of the glory days. Horses and cattle graze, sheep and goats roam over 1,700 acres, crops are grown, and the gristmill grinds corn, wheat, buckwheat, and barley, supervised by a plantation manager. There are also accommodations and a restaurant on the property, so visitors can live like a Lee, if only for a day or three.

Call (804) 493–8038 or visit www.stratfordhall.org for more information.

## Pardon My English

Tangier

Located between Virginia's Northern Neck and the Eastern Shore, smack-dab in the middle of the Chesapeake Bay, are a series of little-known islands. That busybody Captain John Smith discovered the islands in 1608. One of them bears his name. Divided between Maryland and Virginia, these islands have never been "discovered" and developed as a vacation destination like the U.S. Virgin Islands. Virginia's islands, although they're just 12 miles off the mainland, are pretty darned remote and nearly inaccessible throughout most of the year.

Tangier Island holds the distinction of being one of the few places where a version of Elizabethan English is spoken daily. The island's first land patent was issued in 1670, and the first settlers arrived around 1668. As legend has it, they were Crocketts, and there are plenty of Crocketts still living on Tangier. By 1800 there were seventy-nine people on the island, most of them Crocketts or Crockett descendants. Since they were all kin and only had one another to talk to, Elizabethan English stayed in use long after the Virgin Queen had turned to dust.

The families farmed and fished, and life went on until the War of 1812; the British showed up on Tangier 1813. The invaders made them-

selves at home, digging wells, building breastworks and houses, and mounting a cannon. When they sailed off for their attack on Baltimore in 1814, the island's Methodist pastor preached a warning about their defeat. Whether by divine intervention or dumb luck, the pastor was right. The British lost the battle, we gained a national anthem, and life on Tangier Island went on as before.

There were storms and epidemics of cholera, measles, tuberculosis, and smallpox. And usually once a year the bay froze over, allowing islanders to walk to the mainland for supplies. The big change came in the 1840s when cities discovered seafood, and Tangier islanders have been watermen ever since. They're still Methodists, they still speak Elizabethan English, and most of them are still Crocketts.

Native Tangierman Captain Freddie K. Pruitt transports visitors to Tangier Island everyday except Monday, May through mid-October. His boat leaves from Onancock Wharf at 10:00 A.M. sharp, returning at 3:30 P.M. so he can be home for supper. The cost is $25 round-trip per person in cash. Credit cards are a little too newfangled.

## Something Slimy This Way Comes
Urbanna

The annual Oyster Festival held in tiny Urbanna is a big celebration with a parade, music, an oyster queen, and thousands of oyster sandwiches served. The slimy shelled critter is shucked, dipped, battered, and fried. For five bucks you can buy one deep-fried marine mollusk served up on two pieces of white bread. The locals slather them in catsup or cocktail sauce. It's an acquired taste!

While this festive scene celebrates these shelled citizens of the lower Chesapeake, oysters were once cause for alarm. For more than one hundred years, Virginians waged a bloody battle with "oyster pirates."

Commonwealth watermen resented any "foreigners" coming for their catch, even if the foreigners were their neighbors and countrymen from adjoining Maryland. In 1868 the Marylanders retaliated, establishing the Maryland Oyster Navy. This special police force was supposed to bring order to the Chesapeake Bay and Potomac River. It did not. In fact, the wars continued for almost a hundred years.

In 1882 Virginia governor William E. Cameron, a crony and colleague of Samuel Clemens (aka Mark Twain), personally led an assault against "foreign" oyster dredgers in the Chesapeake Bay near the Rappahannock River. After the Civil War oysters had become quite the cash crop for Virginians, and the governor needed the support of the working class. His showmanship in the chilly waters worked.

The disagreements over who would control the waters (and the oysters) continued ad nauseum. In 1947 a *Washington Post* reporter wrote, "Already the sound of rifle fire has echoed across the Potomac River. Only 50 miles from Washington, men are shooting at one another. The night is quiet until suddenly shots snap through the air. Possibly a man is dead, perhaps a boat is taken, but the oyster war will go on the next night and the next."

The wars continued until 1962, when laws regulating water and fishing rights were passed under President Kennedy. Oyster sandwich anyone?

For more information call the Urbanna Oyster Festival Foundation at (804) 758–0368 or visit www.urbannaoysterfestival.com.

## Rubble with a Cause
Warsaw

Imagine receiving a plantation as a wedding gift. It certainly surpasses the toaster and can opener in the gift category, but a plantation is darned hard to wrap. That's exactly the gift that Francis Lee and his bride, Rebecca Tayloe, were given by Col. John Tayloe in 1769. The couple received a 1,000-acre plantation called Menokin on Cat Point Creek in Richmond County. After the wedding, they went right to work on building their dream estate.

Being a Lee meant leadership in colonial Virginia. Francis served in the Virginia legislature and the Continental Congress. He'd been busy; he also founded the town of Leesburg. Francis and his brother, Richard Henry Lee, were also the only pair of brothers to sign the Declaration of Independence.

In January 1797 both Francis and Rebecca died and were buried together in Mount Airy. Because they had no children, the house passed through a handful of owners. By the twentieth century, Menokin had fallen into ruin. In 1940 the Historic American Building Survey documented the house as an important architectural site. The association removed the paneling and woodwork for safekeeping.

The Menokin Foundation calls the house "Rubble with a Cause." The site is open to visitors and is used to train students in archaeology and eighteenth-century construction. Someday they hope to take the woodwork out of storage and restore the house to its original splendor.

Menokin is 4 miles northwest of Warsaw off Route 3 on Menokin Road. Contact the Menokin Foundation in Warsaw at (804) 333–1776.

# WHY WARSAW?

It hardly looks like Poland, this little town in the middle of the Northern Neck. It has a Wal-Mart and a McDonald's, a local community college, and a nice little museum in the Old Clerk's Office that tells the story of Richmond County. Warsaw was created as the county seat. Initially named Richmond County Courthouse due to a lack of imagination, the town was renamed Warsaw in 1831. Nobody seems to know why. There were no Polish settlers in the area, but historians guess that the name change was in support of the Polish struggle for independence from Prussia.

Warsaw has many more reasons to be named Manila instead. Town native William Atkinson Jones was a Civil War veteran and a member of Congress during the Spanish-American War. Jones authored the Philippine Independence Bill of 1916, which took sixteen years to pass. The bill laid the ground rules for Philippine self-government. For his efforts, Jones was much beloved and became known as the George Washington of the Philippines. In gratitude, a score of towns, streets, and bridges in the Pacific Rim nation were named for him.

Warsaw showed its gratitude by building him a memorial: St. John's Churchyard. The funds were raised with the help of a penny drive by Philippine schoolchildren. To celebrate the Philippine Centennial, the president's wife, Amelita Ramos, came to Warsaw in 1998 and placed a wreath at the memorial in honor of Jones. Despite the international hoopla, the town's name remains Warsaw.

## Rocket Billy's
### White Stone

The Northern Neck is known for its seafood, but you'd be surprised to learn that the best bowl of seafood bisque and the best crab cakes come out of an 8-by-16-foot trailer parked by the side of a road. Rocket Billy's red, white, and blue rolling restaurant is set in a parking lot at 851B Rappahannock Street in White Stone.

Patrons pull up and line up from 6:00 A.M. to 3:00 P.M. to chow down in their trucks or at one of the picnic tables under the awning. Particularly popular are the salt trout breakfast, with two eggs, hash browns, bread, and jelly, and the fried bologna and egg sandwich.

Billy Ancarrow and his bride, Barbara, take particular pride in their seafood offerings. Sure, they serve burgers, dogs, fries, and onion rings from their roadside attraction, but the real draw is Billy himself. He has more anecdotes than menu items, and the stories fly faster than the fish sandwiches. "This guy was ordering the other day, and I said, 'Hey, you look a lot like Roger Mudd,'" remembers Billy. "The man looked up and said, 'That's funny. I am Roger Mudd.'"

Rocket Billy's stands for some of the best seafood on the Northern Neck. Shirt and shoes not required.

Sometime chef and full-time entertainer Rocket Billy loves his job.

The name Rocket Billy's comes from his stint in the Marine Corps. When asked how he got the name, he said, "I'd better not say." When asked why he opened the rolling restaurant in remote White Stone, he answered quickly, "It was the worst idea I ever had in my life." The couple works daily in the tiny space, but there's no conflict. "When I show up, she leaves," he says.

Rocket Billy's serves breakfast and lunch, but never on Sunday. Phone (804) 435–7040.

## No Gas to Go at Willaby's

White Stone

You can't buy gas at the filling station in White Stone, but you sure can get filled up. The old gas station has been reincarnated as Willaby's Restaurant. For more than a decade, customers have been lining up under the gas pump awning for a hearty lunch. You enter through the original garage door to a bona fide restaurant with twelve tiny tables. The only grease is the kind used for the delicious french fries and onion rings. You could eat off the floor now; it's that clean. Mechanics' tools hang on the walls, reminders of thousands of past repairs on vehicles long gone to the junkyard.

Owner William Barnheardt enjoys filling tummies instead of tanks at lunchtime at this former gas station in Virginia's Northern Neck. The menu is eclectic, but the most popular items are the pork barbecue and the crab cakes. So popular is the barbecue that Willaby's bottles its "Extra Special Sauce" for sale at the register. This zesty concoction of soy, ketchup, white wine, mustard, sugar, cornstarch, and spices puts a real zing in a sandwich. Barnheardt, who is also a popular caterer around these parts, bottles four different kinds of sauce, including Tidewater Tonic (with vinegar, red pepper, and selected spices) and a peanut sauce.

You'd presume that since the peanut is a product of many Virginia farms, the sauce would be a local specialty. It's not. Barnheardt discovered it on a trip to Holland, which has a large Indonesian population. He came home and replicated the taste. It may become a local delicacy.

Willaby's Restaurant on Route 3 in Whitestone serves lunch daily from 11:00 A.M. to 3:00 P.M. Phone (804) 435–0044.

# WHAT'S SO FUNNY ABOUT A HA-HA?

If you have a hankering to wander around an old Virginia garden on a moonlit night, watch your step!

Early Virginia plantation owners took pride in carving formal gardens out of the wilderness. A well-designed garden was a sign of sophistication—a touchy subject among British subjects. The American landed gentry planned intricate allees, boxwood mazes, grassy lawns, flower beds, and grape arbors. They imported bulbs and root stock from Europe, and generally fussed over how to make their gardens grander than their neighbors'.

But living on a working plantation meant having plenty of livestock around the place. Sheep, horses, cows, goats, and fowl grazed at will. So to prevent them from noshing in the garden, planters built their gardens at a higher elevation than their pastures and separated the two domains with a wall called a Ha-Ha, a sort of sunken trench with a wall or fence running down the middle.

From the estate house, guests could gaze over an impressive expanse of garden with an unobstructed view. For the livestock below, the view was far less inviting. They looked across a gully to a wall that was anywhere from 3 to 6 feet high—high enough to discourage even the most agile animal from getting to the prized magnolias.

The trouble with the Ha-Ha is that is was designed to be invisible from the garden. Guests who had a little too much wine with dinner sometimes stepped right off the end of the garden and into the company of a herd of sheep. It wasn't unheard of for guests to sleep it off where they fell.

You can see notable examples of the use of the Ha-Ha at Gunston Hall Plantation in Mason Neck, George Washington's River Farm in Alexandria, and Stratford Hall Plantation in the Northern Neck.

# TIDEWATER AND THE EASTERN SHORE

Arlington

Alexandria

Maryland

L. Anna

Rappahannock River

Chesapeak Bay

Chincoteague

Accomac

Wachapreague

Pungoteague

York River

James River

Williamsburg

Jamestown

Surry

Waverly

Smithfield

Fort Monroe

Norfolk

Virginia Beach

Portsmouth

Newport News

Hampton

Suffolk

Lake Drummond

0        50 Miles

0        50 KM

# TIDEWATER

## Debtors' Do's and Don'ts

Accomac

Behind its picture-perfect colonial architecture, Accomac has a debt to pay to society. Chosen as the site for a new county seat in the 1600s, it wasn't the most hospitable place for early European settlers. John Dye, Accomac's first settler, wrote to British authorities that he had "been beaten and abused" by the king of the Matompkin Indians. Nonetheless, other settlers followed, and a town grew up around the courthouse. By 1835 the town had a tavern, a church, thirty-nine homes, and a newspaper. It also had a debtors' prison. Located on Courthouse Avenue, the prison is now the town's most famous landmark.

Today the average American who carries more than $8,000 worth of credit card debt, in addition to car loans and home mortgages, is rather befuddled by this old custom. Nowadays if your debts become unmanageable, you're looking at bankruptcy; in colonial Virginia, unpaid bills meant time in the slammer.

The prison, with its heavy wooden doors and iron bars over the windows, was no picnic. Debtors were kept under lock and key until the bills were paid. The system of garnishing wages seems enlightened in comparison.

Oddly enough, you can get the key to the prison from the commissioner of the revenue at the county office building across the street. No financial statement is required.

Nearby Eastville also has a preserved debtors' prison, which segregated the general criminal population from those who failed to pay their bills. This key is free from the clerk's office (757–787–2462).

And by the way, the restaurants and merchants of Accomac and Eastville take credit cards.

## Changing Times
Accomac

Accomac's first courthouse was built in 1756, and county records date back to 1663. It's the second oldest set of court records in the United States. Neighboring Eastville has the oldest, but Accomac's may be the most interesting.

Visitors with a nose for history can pick among the ancient record books. Find the huge bound volume labeled *Accomack County Orders 1714–1717*. On the flyleaf is neatly penned a line of graffiti: "God Save the King."

But a revolutionary spirit was rising. Beneath it, another hand had written "God Damn the King."

The records of Accomack County (with a *k*) are kept in the town of Accomac (without the *k*) in the clerk's office to the west of the Courthouse Green. For information, call (757) 787–2460 or visit www.esva tourism.org.

# GIMME THE MAP OF HAMPTON ROADS

When you look around Hampton Roads, all you see is water. It's not even freshwater, it's brackish—great for crabs and mosquitoes but nasty for drinking. Why this waterworld is called Hampton Roads requires a good eye and a better education.

At Hampton Roads, there are rivers, an estuary, a bay, and an ocean. The James River flows southeast from Richmond, growing wider by the mile. It's joined by the Chickahominy River and flows past Jamestown to a great natural port at the mouth of the Chesapeake Bay and the confluence of the Atlantic Ocean. Hampton Roads is Virginia's most populated region, comprising nine cities and seven counties. There are also a lot of roads, bridges, and tunnels—more tunnels in this metropolitan area than anywhere in the world.

Hampton Roads was named Southhampton by Lord Delaware to honor the third Earl of Southhampton. The earl staunchly supported the colonization of Virginia and sponsored many expensive expeditions to the New World. In the early 1600s, roadstead was a commonly used nautical expression for a safe place for ships to anchor. Ships would head to the Earl of Southhampton's roadstead. Too much of a mouthful to spit out, the harbor name would evolve to the shorter, snappier nickname Hampton Roads. It came to represent not only the harbor but also the entire area. When you see a road sign to Hampton Roads, you're actually heading toward the cities of Chesapeake, Hampton, Newport News, Norfolk, Poquoson, Portsmouth, Suffolk, Virginia Beach, and Williamsburg. All roads don't lead to Rome, especially the ones you sail into.

## The Real Poop on the Ponies

Chincoteague

The origins of Chincoteague Island's wild ponies are a mystery. Nobody knows where they came from. What we do know is that they're the only wild herd east of the Rocky Mountains.

Legend has it that a Spanish galleon was shipwrecked off the shores of Assateague; some of the mustangs on board swam to shore and survived. Other less colorful theories abound. Wherever they came from, the ponies were like manna from heaven to those English colonists walking in the wilderness, providing them with instant transportation and free labor.

The ponies are still there, having adapted to the island's environment. Once a year, they go for a swim and thousands show up to watch.

Ponies are pricey now that there's fame in the name Chincoteague.

All the hoopla about the pony swim had very pragmatic beginnings. Chincoteague's wooden buildings had a propensity for burning down on a regular basis, and the town didn't have a fire department. The locals turned to their favorite asset one more time, selling the ponies to fund their firefighting equipment. The annual swim, pony penning, and auction has been held annually since 1924 (except during World War II). The ponies were pumped up by the addition of breeding stock from the Assateague estate of Joseph Pruitt and twenty Western mustangs in 1939.

In 1962 a freak storm devastated the island and the pony herd. Firemen contacted people who had bought ponies at auction, and many were bought back and brought back to Chincoteague to replenish the herd.

The ponies are fine and still draw thousands of eager buyers to the tiny town on the last Wednesday and Thursday in July. On Wednesday the ponies swim the channel under the firemen's protection; on Thursday they're auctioned off to progeny-pleasing parents. In the good old days, a pony could be had for twenty bucks. Today, spoiling your kid can cost a few grand.

You can find out more about these historic horses at www .chincoteaguechamber.com/pony or by calling (757) 336–6161.

# THE CHESAPEAKE BAY BRIDGE-TUNNEL

Smack-dab in the middle of the Chesapeake Bay, you can buy some souvenirs for the folks back home, catch a fish, or pick up some extra cash. First opened in 1964, the Chesapeake Bay Bridge-Tunnel was named one of the Seven Engineering Wonders of the Modern World. It cost $450 million and took seven and a half years to complete. For tourists, it eliminated 95 miles and an hour and a half of travel time from New York to Virginia Beach. For local folks, it just made it easier to get to work. This 17.6-mile road goes over and under the waters of the Chesapeake Bay, eliminating the slow and cumbersome ferry system and easing travel from Virginia's Eastern Shore to Hampton Roads.

Engineers built four islands in the middle of the bay, using 1,183,295 tons of rock. When man creates an island, he packs in plenty of creature comforts. The first of the four islands, Sea Gull Island, has an ATM, restrooms, a fishing pier, a souvenir shop, and a restaurant, of course.

Get a waterfront view at a table at Sea Gull Pier Restaurant, order some seafood, and watch the ships sail into Hampton Roads. Although there's no Captain's Table, it's the cheapest cruise you'll ever take. The toll is only $12 one-way, and there's absolutely no chance of seasickness either. Learn more at www.cbbf.com.

## The Gibraltar of the Chesapeake

Fort Monroe

The U.S. Army combats twenty-first-century terrorism from a stone fort with a moat. Fort Monroe, founded in 1819 and named after America's fifth president, was originally constructed to protect Hampton Roads from invaders in ships with sails. Despite 187 years of advances in warfare and the dawn of the nuclear age, Fort Monroe is still in use today as the home of the U.S. Army Training and Doctrine Command, protecting Americans from new threats.

The largest stone fort ever constructed in the United States, Fort Monroe took fifteen years to build. It's so massive, it's earned the nickname Gibraltar of the Chesapeake. The primary entrance is called the main sallyport, an old expression meaning "the way to walk across." The same stones that withstood the footfalls and hoofbeats of soldiers and their steeds in the Spanish-American War now carry the occasional Humvee and SUV.

It was the most heavily armed fort in the United States, designed for 380 guns. The largest, a l5-inch Rodman cannon, was cast in 1860 and named for President Lincoln. The gun was used to pound the Confederate batteries near Norfolk.

Fort Monroe was as famous for its soldiers and distinguished visitors as for its fortifications. Abraham Lincoln and Marquis de Lafayette felt safe enough to stay here at Quarters Number One. Robert E. Lee was stationed here from 1831 until 1834 as a lieutenant of engineers working on the completion of the fort. And Edgar Allan Poe served as sergeant major of artillery here in 1828. Military life held little appeal for the quirky writer. He sold his enlistment in April 1829 for $75 and returned to ravens and civilian life.

At the end of the Civil War, the president of the Confederate States of America was held in a small cell for more than two years. After the

Confederate defeat, Jefferson Davis faced a barrage of charges, including treason, the assassination of Lincoln, and mistreatment of Union POWs. Some say his spirit still haunts the place.

The Casemate Museum at 20 Bernard Road in Fort Monroe contains artifacts and displays on the history of Fort Monroe and the Coast Artillery Corps, including Jefferson Davis's cell. Phone (757) 788–3391.

## Blackbeard's Last Battle

Hampton

Blackbeard's last port of call was Hampton, Virginia. The friendly folks in this old port city celebrate every summer with a festival in his honor. It's doubtful he enjoyed his final visit much. After hunting down the old pirate off Ocracoke Island, North Carolina, Lt. Robert Maynard sailed into Hampton in triumph, with Blackbeard's severed head swinging from the ship's prow.

Born William Teach, Blackbeard went out of his way to look scary. He'd braid his beard and bedeck it with bows and candles. Talk about living dangerously! His ship, the *Adventure,* actually flew the skull and crossbones, the international symbol for the bad boyz of the seventeenth century: pirates.

Piracy was a lucrative enterprise along the eastern seaboard for more than one hundred years. Instead of having real jobs, these seaborne marauders looted and pillaged their way from the West Indies to the coastal Carolinas, and were brazen enough to sail up the Chesapeake Bay. Their thievery cost the colonial economy plenty. When Virginia governor Alexander Spotswood had had enough, he sent two vessels and fifty-five men led by Maynard to teach Blackbeard a lesson.

After hunting down the pirate, Maynard's men ran the *Adventure* aground and hid belowdeck on their ship, the *Jane*. When Blackbeard

clambered aboard, Maynard and his men scrambled up and engaged the pirate band in a fierce and bloody battle.

Blackbeard got a dose of his own cruelty and was shot dozens of times before Maynard beheaded the body. After the bobbing head showed the locals there was nothing more to fear from the old pirate, it was put to further use. Officials stuck Blackbeard's head on a pole and plunked it down at the entrance of Hampton Creek. The objective was to point out that piracy was an unacceptable commercial venture in Virginia. It was a point well taken; piracy declined in the early eighteenth century. The place is still called Blackbeard's Point.

Their success on November 21, 1718, is celebrated at Black-beard's expense the weekend following Memorial Day on the waterfront. There's dancing and dining on pirate cuisine, a reenactment of the battle between Blackbeard and Maynard, and a pirate's parade. Call (800) 800–2202 or visit www.hamptoncvb.com.

*Reenactors beware!*

# HAMPTON HAPPENINGS

Spanish explorers actually arrived in Hampton in September 1570, but they called it Kecoughtan and they didn't stay. First settlement honors go to the English.

Hampton is the first continuous English-speaking settlement still in existence. Roanoke residents disappeared after scrawling CROATAN on a tree. (Who knows what they meant?) Jamestown settlers moved upriver. Henricus was abandoned for Richmond. But Hampton, settled in l610, is still happening.

Hampton is the site of several other "firsts" and "onlies":

America's first English Christmas celebration took place in Hampton. Captain John Smith and his band, who had bunked down with American Indians at the Kecoughtan village because of extremely cold weather, celebrated the holiday on December 29, 1608.

The first Africans to arrive in America landed at Hampton. A Dutch ship set slaves ashore at Old Point Comfort on August 20, 1619.

Hampton is the site of the only existing African-American missionary chapel in Virginia. The Little England Chapel was built in 1879 to house worship services for freed slaves.

Hampton is where the first free public education was offered. Kids who hate going to school should take note. They can thank Benjamin Syms, who bequeathed his property for the first free school in the country on February 10, 1634.

The first organized teaching of African Americans took place in Hampton in 1861. Miss Mary Peake, a freeborn black, began to teach slaves to read and write, which was against the law at the time.

Hampton had the right
stuff to become the first
training ground for
American astronauts.
Established in 1917 as
the first national civil
aeronautical research
lab, the National Advi-
sory Committee of
Aeronautics (NACA) was
a natural to take flight as
NASA in 1958. Here America
planned its first space program
and trained its first astronauts. The
Mercury Seven—Scott Carpenter, Gor-
don Cooper, John Glenn, Gus Grissom, Walter
Schirra, Alan Shepard, and Deke Slayton—would arrive shortly
afterward and later were launched into the public eye. NASA Lang-
ley Research Center in Hampton still plays an important part in
America's space program. Driving tours are available during the
summer months.

*The Little England Chapel is at 4100 Kecoughten Road in Hampton.*

Twenty-nine German sailors, casualties of a German U-boat that
sank off North Carolina, were secretly buried in Hampton National
Cemetery on Aril 15,1942.

And Hampton Coliseum opened on January 31, 1970, with a per-
formance by Jack Benny. Really!

# MISSILE-TOE

In the olden days, Druids with golden sickles harvested mistletoe growing from oak trees. They made quite a production of it. White-robed priests sacrificed two white bulls on the sixth night of the new moon to be sure that prayers were answered. The ancients believed the plant to be magical with the power to bestow life. It was also considered an aphrodisiac. That's always a plus.

Mistletoe may have magical powers besides making people kiss at Christmas, but the plant has some public relations problems. A parasite that sends roots into the host tree, it also has a fairly unappealing name. In Anglo-Saxon, *mistel* means "dung" and *tan* means "twig." Dung on a twig is hardly a sweet nothing you can whisper in your beloved's ear.

Mistletoe grows naturally in Virginia. As a popular holiday decoration, it has a price on its head. When Virginians harvest the plant, they don't show it the same respect as the Druids did. In fact, they can be downright disrespectful.

If the mistletoe is growing low enough to the ground, a plain old ladder works fine. If it's out of reach, the harvesters will try a rock or two, but they need a pretty good aim. In Virginia's hardwood forests, the mistletoe might be 50 feet or more up in the trees. That's when you use the old Virginia method for mistletoe harvest: load the shotgun with buckshot and shoot it down. Kerblam. Kiss. Kiss

## A Tree Grows in Hampton

Hampton

So what's so special about an oak tree? The old oak on the campus of Hampton University has survived far more than the Civil War and a century of students and their antics. The tree has become a symbol of freedom for six generations of African Americans.

In 1861 Mary Peake risked her freedom to teach slaves to read and write in the shade of this old oak. Peake was one of the fortunate few black Virginians of the time to have been born free. Educating slaves was against the law at the time.

Two years later, slaves assembled under the oak to hear a message written by the president of the United States, Mr. Abraham Lincoln. It was called the Emancipation Proclamation. The simple message forever changed the lives of those assembled.

History has been happening under the Emancipation Oak since the 1860s.

Just five years later, Hampton Institute was founded on the site, dedicated to the education of the newly freed African Americans. Founder Gen. Samuel Chapman Armstrong pronounced that a good education should influence "the head, the hand and the heart." The school continues today as Hampton University, which educates students from all backgrounds. Its museum contains one of the most extensive collections of African, Native American, and African-American art in the United States. And to think it all began under the branches of an old oak tree.

Emancipation Oak is located on the campus of Hampton University at East Queen Street. It stands to receive visitors every day. For guided tours of the campus, call (757) 727–5328.

## Rocking Plymouth . . . Two Times the Jamestowns
Jamestown

Every fall, thousands of elementary school kids commemorate the "First Thanksgiving." Some kids get to play Indians, with the plum part going to Squanto; others get to play pilgrims. Wearing funny hats, they celebrate a new life in New England at Plymouth Rock.

In reality, the first Thanksgiving was held in Virginia at Berkeley Plantation on December 4, 1607. And the first permanent English-speaking settlement was founded in Jamestown in May 1607, a full thirteen years before any landfall at Plymouth Rock.

Why the common misperception? Maybe the pilgrims had a better publicist. Or, being on the losing side of a major war might have caused "southern" history to be mildly overlooked. Probably, it was the theory that the remains of the Jamestown Fort had been washed away by the James River centuries ago. That theory was proved false by the Jamestown Rediscovery Project, which dug up the truth and is putting eighty zillion artifacts on display to prove it.

In honor of the first settlement, which gave us the roots of our multi-ethnic culture, government, language, and law, there's a party planned for Jamestown dubbed "America's 400th Anniversary." And it will be held at both Jamestowns.

Visitors agree, glassblowing can be a gas.

Yes, Virginia, there are two Jamestowns. The original site, Historic Jamestowne, (note the old-timey e) is located on Colonial Parkway and operated by the National Park Service and the Association for the Preservation of Virginia Antiquities (757–229–1733; www.historic jamestowne.org). The archeological dig is still in progress, and visitors may experience a find right before their eyes. They can bask in the glow of America's first free enterprise, a glass-blowing factory that was part of early Jamestown. There's also a church, the James River, the new Archaearium full of artifacts, and the real site where actor Colin Farrell (aka Captain John Smith) landed in The New World.

Jamestown Settlement is just a few miles away on Colonial Parkway, and it's operated by the Commonwealth of Virginia. Jamestown Settlement (757–253–4838; www.historyisfun.org) includes a visitor center, expansive museum, and outdoor living-history area where you can clamber aboard the seventeenth-century sailing ships or walk through a reconstruction of the fort, settlers' cabins, and a Powhatan indian village.

Although the two Jamestowns confused visitors in the past, the sites now work closely together to tell the real tale of the first continuous English-speaking settlement in the New World. And the 400th anniversary celebration will hold a national teach-in and a televised special, perhaps to finally set the record straight. Visit www.jamestown1607 .org for more information about the celebration.

Real guns—but loaded with black powder instead of bullets.

# DON'T CALL IT THE *MERRIMAC*

In these parts, the protagonist in the famous battle of the ironclads was the CSS *Virginia.* Those crafty Confederates took a Federal frigate named the *Merrimac,* refurbishing it with 4 inches of iron, ten heavy guns, and a 1,500-pound iron ram on her prow. They renamed it the CSS *Virginia* and steamed off to war. It destroyed the USS *Cumberland* and the USS Congress (a ship, not a body of leaders), and tore up the USS *Minnesota.* The next day, March 9, 1862, the Virginia took on the *Monitor,* a Union iron-clad, right in the Hampton Roads Harbor.

Although it was a fierce battle that drew media attention, it ended in a draw. Due to their new metal armor, neither ship suffered significant damage. There was a loser though: wooden warships, which would never be built again.

The CSS *Virginia* was scuttled to prevent her from falling into Union hands, blown apart by the 16,000-pound arsenal of black powder in the ship's magazines. After arguments over who had the salvage rights, the U.S. Navy prevailed.

Several of the salvaged timbers made their way to a cane maker who raffled them off as souvenirs. One winner promptly took his prize over to Fort Monroe and proudly presented it to a prisoner, with the thanks of the people of Virginia. The prisoner was former president Jefferson Davis.

Portions of the CSS *Virginia* are all over the place. The propeller shaft and anchor are at the Museum of the Confederacy in Richmond, beams found their way into the Cosgrove home, the ship's bell sits in the Chrysler Museum, and armor plates and artifacts are at the Hampton Roads Naval Museum and the Portsmouth Naval Shipyard Museum. Replicas of the *Virginia*'s gun turret and a portion of her casemate are on display in the Hampton Roads History Center. There are so many pieces of the *Virginia* on display, locals joke that if they were reassembled, there would be two ships.

## Swamp Water and a Ghostly Canoe

Lake Drummond

Scientists explain the ghostly apparitions on Lake Drummond, located in the heart of the Great Dismal Swamp in Hampton Roads, as burning methane, but locals know better. Sightings of a birch bark canoe gliding across the water are as common as snakes in the Great Dismal. And they go back centuries.

Legend has it that right before her wedding, an Indian maiden died suddenly. Her husband-to-be refused to accept her death. Seeing a meteor, he believed that her spirit had disappeared into the swamp. Convinced that this light was his love, he crafted a birch bark canoe and set out to find her. The groom never returned.

Irish poet Thomas Moore wrote a poem about the legend, "The Lake of the Dismal Swamp." It concludes:

> *But oft from the Indian' hunter's camp,*
> *This lover and maid so true*
> *Are seen at the hour of midnight damp*
> *To cross the Lake by a fire-fly lamp,*
> *And paddle their white canoe.*

Hanging in the Virginia Museum of Fine Arts in Richmond is a painting called *Dismal Swamp.* Created in 1840 by American artist George Washington Mark, it portrays a couple in a white birch bark canoe, a firefly lamp held high in the velvet darkness.

## The Crabtree Collection of Miniature Ships

Newport News

If you've ever struggled to put together a model ship from one of those box kits, tying tiny rigging to the mainsails, you know that Satan is alive and well in the world. Model kits are frustration in a box.

Imagine building sixteen painstakingly accurate miniature ships with no plans, no tools, and no parts. You'll begin to understand the sainthood of Dr. August F. Crabtree, who spent twenty-five years on the project.

Crabtree was the grandson of a Scotsman who built boats on the River Clyde, so shipbuilding was in his blood. Inspired by a collection of model ships, he began to reconstruct the history of man's love affair with the sea one vessel at a time. He began with a tiny dugout canoe and graduated to a wooden raft. The next vessel was a greater challenge. He built an Egyptian seagoing vessel from the eighteenth dynasty.

Because authentic wood wasn't available, he cut and seasoned his own. Because tools weren't available in this Lilliputian size, he modified dental instruments to meet his needs. And, because there was little information available about early seagoing ships, Crabtree corresponded with naval archaeologists until he found the answers.

Crabtree built a Roman merchant ship, William the Conqueror's vessel, and replicas of the *Santa Maria* and the *Pinta* from Columbus's forays into the New World. Crabtree's magnum opus may well be the Venetian galleass, with 359 tiny carved figures.

The Crabtree Collection of Miniature Ships is now on display at the Mariner's Museum, 100 Museum Drive, Newport News. Phone (757) 596–2222 or log on to www.mariner.org.

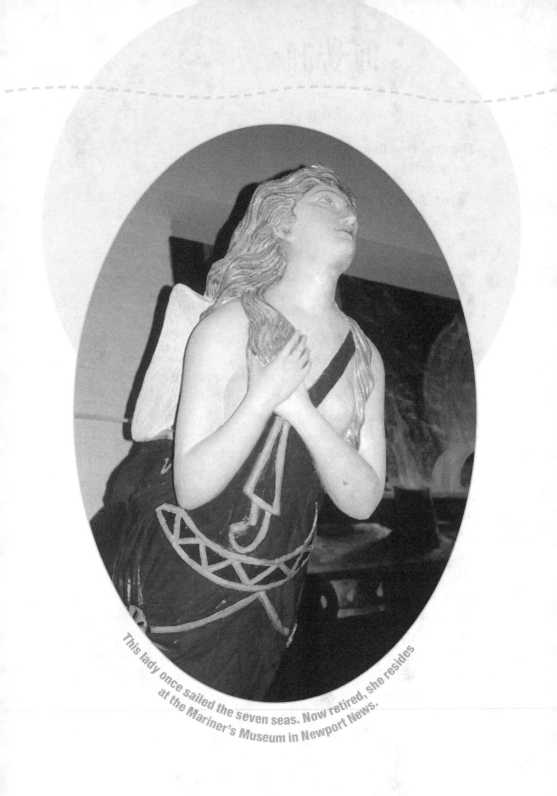

This lady once sailed the seven seas. Now retired, she resides at the Mariner's Museum in Newport News.

## He Has Returned

Norfolk

Norfolk might be a Navy town, but one of the greatest generals of the United States Army chose the city as his final resting place.

Right in the center of town, just a stone's throw from the water, sits the MacArthur Memorial, which not only contains the general's earthly remains but also two million items from his colorful and controversial career. The general is interred in what was once Norfolk's grand city hall.

You can spend hours working your way through tons of correspondence, personal artifacts, flags, photographs, newspaper clippings, and newsreels. The memorial also displays his 1950 Chrysler Imperial—the general's favorite car—in use from 1950 until his death in 1964.

**Nothing less than an "Imperial" for this general.**

MacArthur's career included some impressive commands. He served as the Supreme Allied Commander of the Southwest Pacific Theater in World War II and was awarded the Medal of Honor. The five-star general accepted Japan's unconditional surrender on board the USS *Missouri* in Tokyo Bay in December 1945. At the start of the Korean War, MacArthur was appointed the Supreme United Nations Commander. The forthright general ruffled the feathers of countless politicians, and President Truman removed him from command in April 1951. Outspoken to the end, MacArthur embodied the values of duty, honor, and country.

MacArthur chose Norfolk as his final resting place not as an affront to the U.S. Navy, but because it was the home of his mother. Being a military man for most of his life, as well as the son of a Civil War hero, home was always elusive.

The MacArthur Memorial is located at MacArthur Square in downtown Norfolk. Phone (757) 441–2965 or visit www.macarthur memorial.org.

Always in command, MacArthur even chose his own burial site.

## The World's Oldest Ice-Cream Cone Machine
Norfolk

You might think you're just enjoying a darned good ice-cream cone, but you're actually biting into a bit of confectionery history at Doumar's Drive In. The ice-cream stand at Monticello and 20th Street in Norfolk uses the oldest existing cone-making machine in the world. The Smithsonian Institution has validated that fact.

The ice-cream cone first caught the American public's attention at the World's Fair in Saint Louis, Missouri, in 1904. Before that momentous day, we ate our ice cream out of paper cups with little wooden spoons.

Everyone was so enamored with the "cone," which allowed you to eat ice cream while walking and talking, that Abe Doumar, a Syrian immigrant who worked the fair, designed a four-iron baking machine to mass produce the little cakey containers. Abe made enough profit to bring his parents and three brothers to the United States. The Doumars became the first family of American ice-cream cones and sold the confection all along the eastern seaboard.

During the Jamestown Exposition of 1907, which everyone has pretty much forgotten about, Abe opened a business at Ocean View Amusement Park in Norfolk. Sons John and Charles opened Doumar's Cones, Candy, Soda, and Cigars in 1912 adjacent to the New Wells Theater. It had two tables and six chairs.

When the Great Depression hit, the Doumars consolidated and opened up a drive-in at 20th Street and Monticello Avenue. It's the same one that thrives today. The ice-cream cone was such a good idea, everybody ate it up! Call (757) 627–4163 or go to www.doumars.com for more information.

## The World's Largest Military Station
Norfolk

When Eugene Ely flew his 50-horsepower Curtiss airplane off the bow of the USS *Birmingham* in Hampton Roads in 1910, no one imagined what that brave act would lead to. This and later demonstrations of the possibility of shipborne aircraft contributed to the formation of the world's largest military installation.

Located on Sewell's Point, the 3,400-acre Naval Station Norfolk is home port to 75 ships and 134 aircraft. Based on supported military population, it's the largest military installation in the world.

Although naval officers had long agreed the land was perfect for a base, it wasn't until the onset of World War I that the government acquired the property. Construction began on July 4, 1917, and within a month, housing for 7,500 men was complete. By the end of World War I, there were 34,000 enlisted men on base.

Battleship gray is always fashionable in Norfolk.

Naval Station Norfolk played a vital role in fighting the German U-boat offense against the East Coast. Between January and April 1942, eighty-two ships were sunk by German U-boats; U.S. forces sank only eight U-boats during that same period. But the U.S. Navy ramped up its patrol areas, expanding operations to Chincoteague and Elizabeth City, North Carolina, and the U-boat sinkings subsequently stopped.

Today the port service oversees the comings and goings of 3,100 ships a year. Air Operations conducts 100,000 flight operations each year, an average of 275 flights per day.

Not all of the aircraft carriers, cruisers, destroyers, and submarines are in port at the same time; many are at sea or deployed to foreign ports. The fifteen piers and other port facilities stretch over 7 miles of wharf and pier space. Battleship gray is the color of the day—every day. The view is constantly changing as ships enter and exit the base.

Ely would hardly recognize the place.

Waterside tours of the naval station are available on the *Miss Hampton II,* 764 Settlers Landing Road, Hampton, (888) 757–BOAT, or from naval personnel at the Information Center at 9079 Hampton Boulevard. Call (757) 444–7955 or go to www.norfolkvisitor.com/norfolknavy/ for details.

## Dinner and a Movie
### Portsmouth

Dinner and a movie is a regular date in the United States, but in Portsmouth, you can do both without leaving your seat.

The 1945 Commodore Theatre on High Street, an art deco landmark, has been lovingly restored with a few quirky additions—like a restaurant kitchen. The new owners upgraded the tatty old screen to a modern 42-foot model with a state-of-the-art THX sound system. Fred and

Caroline Schoenfeld ripped out those squiggly old theater seats and added tiers of tables and comfy armchairs. A lamp, telephone, and menus grace each table. The phones are for checking in with the parents or the babysitter and for ordering your meal from the Commodore's kitchen.

Sure, there's popcorn, soda, and candy just like the old days, but the Commodore bakes its own bread, makes its own pizza, and serves its own to-die-for charcoal-grilled chicken salad plus a full selection of desserts. As Ogden Nash wrote of courtship, "Candy is dandy but liquor is quicker," so the Commodore also has a bar. Make a call to order a glass of wine or a beer to accompany your meal and sweeten your sweetheart. Instead of the pressure of making small talk with your date, you can let Brad Pitt do the talking. She'll love you forever.

The Commodore is at 421 High Street in Portsmouth. Phone (757) 393–6962 or visit www.commodoretheatre.com.

Dinner and a movie takes on a whole new meaning at the Commodore.

## A Penny for Your Yachts

Portsmouth

Hampton Roads is about as big in the maritime world as a port can be. You know you're at the center when you see milepost 0 on buoy 36 on the Intracoastal Waterway. It's home base.

Not only does Hampton Roads contain the world's largest military station and the nation's largest naval shipyard, it's also has one of the top one hundred marinas in the world. For whatever floats your boat, Portsmouth is the place to be.

The Tidewater Yacht Agency is a boatyard for the biggest toys for the biggest boys. It contains a sixty-ton boat hoist to move your yacht and an 80-foot enclosed wet slip for in-water repairs.

Nearby, the Texaco Starport is the largest on the East Coast, with gas to go and 325 deepwater slips accommodating boats up to 100 feet. No need to do without the necessities ashore either. There are cable and telephone hookups, fax and express mail service, a swimming pool, catering, and luxurious bath and laundry facilities. Since you can't sail into town for a dinner and a movie, there's also limousine and water-taxi service, or the more plebeian rental cars.

Portsmouth seduced these high rollers of the high seas by levying the lowest boat tax allowed by law—a penny. Some jurisdictions tax you up to $4.00 for every $100.00 of value on your boat, so many jumped ship to come to this Wal-Mart of the water. Portsmouth is a regular port of call for more than 12,000 pleasure boaters every year, and many make it their permanent home. For millionaires on a mission to stay that way, it's a penny for your yachts.

## Stumped for a Gift?

Pungoteague

If you're stumped on what to get the man who has everything, why not take his favorite tree and turn it into an objet d'art?

Artist Robert J. Lentz knows his way around wood. A woodcrafter since childhood, he spent thirty years with the U.S. Forest Service. His calling has been to take doomed or dead trees and find the art in them. Lentz insists that the worst-looking woods transform into the best-looking art.

One piece, called *Colonial Spirit,* on display in Lentz's home gallery, came from a maple tree killed by Hurricane Floyd in 1999. It had stood for centuries at the College of William and Mary in Williamsburg.

Lentz can take a favorite fruit, nut, or deciduous shade tree and make it into a keepsake. Send him a piece of the trunk (measuring at least 6 by 8 inches) and a description of your relationship with the tree. A few months later, he'll send you back a bowl, sculpture, or free-form object to treasure. The cost, if you're stumped, ranges from $75 to $2,000.

You can contact Robert Lentz at 13477 Evans Farm Lane, Pungoteague. Call (757) 442–4295 or e-mail him at rlentz1@ verizon.net.

*Arborial art at its best.*

## P. D. Gwaltney Jr. and His Pet Ham

Smithfield

I've been known to keep food in my refrigerator for way too long, but I can't beat the record set by meat packer P. D. Gwaltney Jr. He kept a pet ham for life. The ham actually outlasted him and is still on display today at the Isle of Wight Museum in Smithfield.

This perpetual pork is a salty, solid testimonial for the Smithfield method of curing hams. Although it's still a company secret, the process includes a combination of seasoning, salting, and smoking the meat to prevent spoilage and give it a great taste.

Cured in 1902, Gwaltney's ham was stored for two decades in the rafters of one of his packing houses. Whether it shivered in the cold or sweated in the summer heat is anybody's guess, but by the time he took it down, it had become a lower-fat ham. It lost 65 percent of its body weight over the years.

Gwaltney had grown fond of his ham, so he stored it in an iron safe. It was aired out daily, and admirers were allowed to take a peek at the pet pork, which was insured against fire and theft.

P. D. Gwaltney Jr. pals around with pork.

The pet ham traveled with Gwaltney everywhere he went. He carried it to state fairs, food fairs, and exhibitions. Always worried that someone would have a hankerin' for his ham, Gwaltney had a brass collar fitted around the shank, so it could be fastened to the floor when necessary. The ham had become quite famous; it was even featured in *Ripley's Believe It or Not* in 1932.

Although P. D. Gwaltney Jr. has passed away, his ham lives on. It celebrated its 100th birthday in 2002, while the town celebrated its 250th, and can be seen at the Isle of Wight Museum, 103 Main Street, Smithfield. Call (757) 357–7459.

## Do the Dismal!

Suffolk

Dreary, dark, and dank enough to earn the name Great Dismal Swamp, this expansive wetlands on the Virginia–North Carolina border was the key to transportation during America's early years. It's now a place to vacation.

When president George Washington wanted to connect Tidewater Virginia with the ports of North Carolina, he had the brainy idea of digging a canal through the swamp. Virginia governor Patrick Henry agreed, although neither of them did any digging. The Dismal Swamp Canal company, created in 1784, hired slaves from nearby plantations to do the dirty work. Although the digging began in 1783, the first boat didn't pass through the swamp until 1805. It took twelve years to complete the 22-mile course.

Called George Washington's Ditch, the canal is still open today as a part of the Atlantic Intracoastal Waterway from Norfolk to Miami. It's the oldest continually operating man-made canal in the United States. The locks located in Deep Creek, Virginia, and South Mills, North Carolina, open four times a day, at 8:30 and 11:00 A.M. and 1:30 and 3:30

P.M. A steady stream of yachts pass through. Visitors to the swamp who are yachtless use the refuge roads for hiking, biking, bird-watching, mosquito slapping, and snake spotting. The Washington Ditch Road is recommended for biking.

The ditch is included on the National Register of Historic Places and is a National Civil Engineering Landmark. It was sold to the federal government in 1929 for $500,000. I think they bought some swampland in Florida too.

## Birthplace of Mr. Peanut
Suffolk

Replete with monocle, tuxedo, top hat, and cane, you'd think he'd be a New Yorker, but Mr. Peanut is Tidewater born and bred. He was the brainchild of fourteen-year-old Anthony Gentile, who entered the goober in a mascot contest sponsored by Planters Peanuts in 1916.

The founder of Planters, Amedeo Obici, was a marketing genius. Born in Italy in 1877, Obici ran a fruit stand in Scranton, Pennsylvania. Intrigued by peanuts, he began selling them, and his success led to new roasting processes. He founded the Planters Nut and Chocolate Co. in 1906, and later relocated to Suffolk, Virginia, where the best peanuts in the world are grown.

Obici's marketing savvy focused on repeat business and including peanuts in new confections. In addition to the contest to find a mascot for his company, Obici also ran ads in the *Saturday Evening Post* promoting the five-cent lunch: peanuts and Coca-Cola. His salesmen promoted their product in peanut-shaped automobiles. Obici also opened his own retail stores and kept his employees employed during the Depression. Upon his death, he left his fortune to the building of a hospital in memory of his wife, Louise.

Planters was bought by Standard Brands in 1961. Nabisco merged with Standard Brands in 1981, and today the brand is owned by Kraft foods, a Philip Morris Company. One goober survived all the changes—long live Mr. Peanut!

Virginia plans to honor its first nut with a commemorative license plate, monocle and all. Now, that's nutty!

## Pork, Peanut, and Pine Festival

Surry

Harvest festivals are a dime a dozen, but it's not often you get to celebrate the pig, the peanut, and the pine tree in one place. Every summer, thousands gather at Chippokes Plantation to celebrate the fruits of the farm.

One of the oldest continuously farmed plantations in the United States, Chippokes is still an expansive 1,400 acres of prime Tidewater country. It still produces cotton, corn, peanuts, and soybeans. In the good old days, it also produced tobacco. No more.

Nearly 20,000 folks gather each July for the peanut picking or the ever-exciting farm equipment demonstrations. Hundreds swarm around to see how home remedies cured or killed their ancestors in the days before drugs. And the craft festival on the mansion grounds always features a pig replica or two.

There's plenty of food to eat, of course, focusing on prime products. Taste the pork chops, pork barbecue, or roasted salted peanuts by the bag. Chippokes is also the site of the Farm and Forestry Museum, with a sawmill, a forestry interpretive trail, and milestones in agriculture and forestry. Special exhibits and demonstrations like "Keeping House on the Farm," horse and mule field day, corn-shucking parties, scarecrow-making classes, or the tantalizing steam and gas engine show draw visitors from around the country. The park is closed for deer hunts in late November.

Chippokes Plantation State Park is located off Route 10 on Route 634 (Alliance Road) on the southern shore of the James River, east of Surry. Phone (757) 294–3625.

This is the piggy that didn't go to market.

## A Cavalier Attitude
Virginia Beach

In the summer of 1927, media, moguls, and socialites descended on Virginia Beach. They came to witness and wonder at a newfangled, fireproof high-rise hotel where amenities were everything and everywhere.

A $2 million hotel was notable in those days, as were the four water lines in every room. At the Cavalier Hotel, there was hot and cold running water, saltwater, and a marvel called "ice water." In the days before refrigeration, it was a marvel indeed.

The elegant tiled indoor pool was filled with seawater, and guests wanted for nothing. There were 435 staffers to accommodate the 367 guests who lived like kings. The hotel, known as the Aristocrat of the Virginia Seashore, was set on 250 acres with an eighteen-hole golf course, sunken gardens, horseback riding, hunting, and a private beach.

The Cavalier featured things we now take for granted, like a barbershop and beauty shop, drugstore, gift shop, doctor, and commercial photographer. The hotel even had an on-site stockbroker with a ticker tape connected directly to the New York Stock Exchange. Trains brought guests from the Midwest and the Northeast right to the hotel's front door.

*Greatness is always in style.*

In the 1950s evenings glittered at the private and exclusive Cavalier Beach Club, with performers like Benny Goodman, Glenn Miller, Tommy Dorsey, Frank Sinatra, Guy Lombardo, Bing Crosby, and all the other big names. Nonmembers could only listen to the sounds of the glitterati at play from farther down the beach.

The guest list has always been a who's who in American glamour. F. Scott Fitzgerald, Rudy Vallee, Jean Harlow, Elizabeth Taylor, Bob Hope, and Judy Garland all summered in Cavalier style. Presidents from Calvin Coolidge to George Bush (the first) have visited the place.

Carlos Wilson, a longtime employee at the Cavalier Hotel, served as a personal steward to many visiting celebrities and politicians. He remembers Richard Nixon well. The president would go into the men's club and request that a fire be lit in the fireplace. Nixon would spend hours in the Hunt Room staring into the flames of the huge fireplace. Although that's not a day at the beach for most visitors, it seemed to suit the thirty-seventh president just fine.

The Cavalier Hotel is on the beach at 42nd Street. Phone (800) 446–8196 or visit www.cavalierhotel.com.

## A New Ager Before His Time

Virginia Beach

On the highest point along Virginia Beach, an old rambling house spreads the spirit of Edgar Cayce. This unassuming man, born in Kentucky in 1877, had a number of attributes: He was a good husband, father, photographer, bowler, gardener, and fisherman. Aside from that, Cayce could also foretell the future, diagnose illness, and commune with the angels.

While most folk go to sleep and have ordinary dreams, Cayce went into dreamy trances to diagnose illnesses or explain ancient civilizations. He claimed to have had seventeen different incarnations, ranging from an Egyptian priest to a Persian ruler. In his most recent lifetime, Cayce made more than 14,000 different predictions, including the date of the beginning of the Aquarian Age. He said 1998. When asked when humans would be liberated from a world of war, crime, and cruelty, he responded: "When someone wants to know when will we have the New Age, tell them, 'When we have helped to create it.'"

Devotees of Cayce, who died in 1945, continue advancing Homo sapiens toward Homo spiritualis at the Association for Research and Enlightenment (ARE), located at the site of Cayce's home/hospital. Guests and members attend classes and workshops on extrasensory perception, training in psychic development, alternative realities, reincarnation, hypnosis, breathwork, and meditation. Cayce was an early wellness advocate and an exponent of a clean colon. Colon hydrotherapy classes include fifty-five hours of thorough training. That's a long time to spend on the lower digestive tract!

For those who want more traditional body work, ARE has a health services center that offers spa packages. Beyond the familiar spa services like facials, massages, steam baths, and paraffin baths for hands and feet, visitors can experience castor oil pack treatments, craniosacral therapy, or an Epsom salts bath. The colon hydrotherapy takes an hour and costs $65 or more—it's a procedure that gives clean a whole new meaning.

The Association for Research and Enlightenment and Rejuvenation Center Massage and Day Spa is located at 215 67th Street at Atlantic Avenue in Virginia Beach. Phone (757) 437–7202 or (800) 333–4499.

## Elvis at the Beach

Virginia Beach

There are plenty of sand castles every summer in Virginia Beach. And in late June, there's a king for each and every one of them. Welcome to the Viva Elvis Festival!

Although Elvis Vernon Presley has nary a connection to Virginia's largest city, he's everywhere, in every imaginable shape and size. Nowhere is that more apparent than in the Elvis Parade. Hundreds of 'em hit the boardwalk with swagger and smirk. There are fat Elvises in sequined jumpsuits and young ones with sideburns wider than their hips. There are baby Elvises, African-American Elvises, and Elvises that look more like Elvis than Presley himself.

There's no escaping reasonable and unreasonable facsimiles of the King of Rock and Roll, his quirks, or his musical legacy. Peanut butter and banana sandwiches are for sale. Three concert stages feature free concerts by a horde of impersonators. For those who can't sing but look the part, there's a lip sync contest. Even cousin Jerry Presley shows up to sing, with backup by Elvis's own group, the Jordanaires.

Let the good times roll.

251

And just when you think it's safe to lie down and catch a little peace and quiet, who falls out of the sky but more Elvises? The pièce de résistance is the Skydiving "Kings" in Elvis attire, who take their sequins from the sun to the sand. Guess they "can't help falling in love" with Virginia Beach. Visit www.vbfun.com/events for more information on the festival.

## Mount Trashmore
Virginia Beach

Talk about turning trash into treasure—Virginia Beach has done it quite literally at Mount Trashmore Park.

Trash has to go somewhere, and on the flat land of the Tidewater, a pile of trash 60 feet high and 800 feet long is a whale of an eyesore. So city fathers recycled the old pile into a city park.

The trash was covered with dirt and grass and turned into a 165-acre environmentally friendly park complex. Mount Trashmore contains a skateboard park, a playground, fitness trails, water-wise gardens, and many more recreational amenities. Easy to spot, it towers high above the Virginia Beach shoreline at 300 Edwin Drive. And although it's built of trash covered with grass, there's no litter anywhere. It's one of the cleanest parks around. Phone (757) 473–5237.

## Don't Hate Me Because I'm Beautiful!

Virginia Beach

Being your own woman isn't always a good thing. It certainly wasn't in early Virginia. Grace Sherwood was bright and beautiful and a free spirit. She was also known to speak her mind, which led to a great deal of neighborhood bickering and backbiting.

Whether her neighbors acted out of envy or spite, we'll never know, but they began to tell tales about her witchy behavior. In their stories, Grace was empowered to change the weather, kill livestock, and ruin her neighbors' gardens. Then the courts got involved.

In 1706 Grace was charged with suspicion of witchcraft. The local court and the attorney general in Williamsburg did the smart thing and refused to rule. Instead, they decided to let nature take its course: Grace would be tried by water. Colonials believed that nature's purest element would not accept evil, so in their peculiar logic they believed that the innocent would drown and witches would float. Case solved.

Grace was taken from the jail to the Lynnhaven River for her "trial." It was a sensational event, drawing crowds of spectators. Grace stayed her outspoken self, screaming threats at the crowd.

Grace Sherwood, wife and mother of three, was "cross-tied," her left thumb bound to her right big toe and her right thumb to her left big toe. Bent and crossed over herself, she was tossed into the river. Against all odds, Grace pulled a Houdini—she freed herself and swam to shore. She was alive but had convicted herself as a witch.

Something else had changed too. The blue sky had turned to black. Thunder rolled and lightning flashed toward the ground. The crowds ran for home, but everyone was soaked and many were washed into ditches by the surprise cloudburst.

Grace went back to jail and waited eight years before her accusers dropped the charges. She finally was able to go home, the Pungo area at Virginia Beach, and she lived to the ripe old age of eighty.

To see the site of Grace's dunking (or "ducking" as it was called in those days), take Witch Duck Road to the portion of Lynnhaven River renamed Witch Duck Bay in her honor.

## Just Ducky
Virginia Beach

Herb Videll carves ducks from peach pits. He's become so good at it that people send him peach pits from around the country. Videll started with a class at the Atlantic Wildfowl Heritage Museum in Virginia Beach, and he now comes back every week to whittle with the tourists.

The little museum occupies the oldest standing cottage on the oceanfront. The wife of its builder didn't like either the size of the house or the sound of the surf, so they sold it to the de Witt family in 1909. The de Witts must have liked it just fine, because it was home to them and their ten children until the city bought it in 1988.

Today it's operated by the Back Bay Wildfowl Guild as a museum. It celebrates the migratory birds that pass by this Atlantic Flyway town, as well as hunters, decoys, and boats. Beyond the decoy carvers, old photographs, paintings, and displays, there are interactive exhibits. One quacks, honks, and tweets, and you match the sound to the bird. The "paint a duck" computer lets you color a bird in whatever hues suit your fancy. Or you can always learn to whittle like Herb Videll.

The Atlantic Wildfowl Heritage Museum is at 1113 Atlantic Avenue in Virginia Beach. Phone (757) 437–8432.

## Neptune Rises from the Cement!

Virginia Beach

You'd expect it from Virginia's biggest city. Everything about this beach town is bigger, better, and brasher than anywhere else along the ocean-front. For example, their boardwalk is made of concrete to hurricane-proof everyone's fun in the sun. Lined with high-rise hotels and luxury condominiums, Virginia Beach is such an attraction that even the whales stop by for the winter. Actually, the whales are attracted by the seafood buffet provided by the fertile waters exiting the Chesapeake Bay, but the city capitalizes on the behemoths by offering winter whale-watching January through March.

An Olympian lifeguard on duty.

The sea is the city's center, so when the King Neptune Festival folks decided on a permanent icon in a city park, the sea regent came to town in a big way. Unveiled during the thirty-first annual festival in October 2005, the 24-foot, twelve-ton sculpture includes King Neptune himself, a 17-foot dolphin, an 11-foot loggerhead turtle, an 8-foot octopus, and other denizens of the deep.

Although the festival staff cast a wide net for an artist, the winner proved to be almost local. Sculptor Paul DiPasquale, who also created the charming and controversial statue of tennis great Arthur Ashe to join a string of Confederate heroes on Richmond's Monument Avenue, designed King Neptune, which was cast in China (the country, not the porcelain). It required eighty tons of clay, twenty-five tons of plaster, one ton of glue, and 7,500 grinding and sanding disks.

Arising from the sand and cement, not too far from the sea, the statue is the second largest in Virginia, dwarfed only by Iwo Jima in Arlington. Neptune reigns over all the events at his own public park at the Boardwalk and 31st Street, including the King Neptune Festival (www.neptunefestival.com) in the fall. About 400,000 folks crowd around the regent for the event. It's apparent the crown still draws a big crowd!

## Floundering Around
Wachapreague

The Flounder Capital of the World is found on the Atlantic side of the eastern shore, with the barely pronounceable name of Wachapreague. If you can't contain your excitement over the epicenter of this flatfish with both eyes on the same side of its head, this is the place to flounder around.

The old Victorian town sports a duck pond and town park, a host of barrier islands, and two restaurants serving seafood, of course. There are five lodging options with fishy connections. Consider the Captain's Corner motel, Fisherman's Lodge and Campground, or the Wachapreague Hotel and Marina.

What the town has in abundance are marinas and charter fishing boats. There are five different marinas and two dozen vessels in the charter fleet. Motor out with the *Crack of Dawn, James Gang, Lucky Dawg,* or *Smiling Jack.* The fishing is fine.

There are plenty of choices in Wachapreague, except when it comes to social life. It's a choice of church or chum. You'd better know your way around a rod and reel if you want to participate in the town's events. There's the Spring Flounder Tournament, the Ladies Tuna Tournament, and the regular fish fries. Go fish. Call (757) 787–2460 or visit www.esvatourism.org.

## Working for Peanuts

Waverly

Peanuts aren't nuts at all. They're legumes. So if your mom tells you to eat your vegetables, pull out a bag of peanuts. Chances are, they may have been grown in rural Virginia.

The tiny town of Waverly (about one hour southeast of Richmond) celebrates the lowly legume with the First Peanut Museum in the U.S.A.

Better known for its prison and landfill, Waverly wasn't content with a simple road marker honoring the first peanut vendor in the country. In 1842 it was Matthew Harris who made history by carting a wagon full of Waverly peanuts off to nearby Petersburg to sell on the street corners. Customers had an appetite for them, and the rest is major-league history. Can you imagine baseball without peanuts?

The Waverly Women's Club, a busy bunch for a town with only one stoplight, runs the First Peanut Museum. It's a compact space that offers exhibits on the history of the peanut and explains all the agricultural equipment associated with digging them from the dirt. There are old photos, antique planters and cultivators, needles for sewing peanut bags, and peanut scoopers. Most people think peanuts grow on trees; the museum clears up that misconception mighty fast. There's also peanut art bedecking the simple white structure, a peanut sleigh with peanut reindeer, and a not-to-be missed Mr. Peanut constructed from masking tape.

Located in a converted coal shack behind the Miles B. Carpenter Folk Art Museum off U.S. Highway 460, the peanuts-only museum brings great pride to the local folks. Some of the volunteer docents grew up on peanut farms in the area and will dish the dirt on peanut lore. To make sure everybody understands the origin of the peanut, there are peanut plants growing in the yard. And it's all free, though donations are surely welcome.

Opening day in 1990 was big doings. As one of the members of the board of directors cut the twine strung between two bags of peanuts, several hundred visitors rushed to be the first in line. Good thing it doesn't take long to tour the tiny structure. The peanuts-only museum has been a surprisingly big draw for a town with only 2,500 residents. About 6,500 visitors pay homage to the peanut annually in Waverly.

No matter how you eat peanuts—boiled, salted, in the shell, or ground and spread on bread with jelly—you'll have a new appreciation for the food after a day in Waverly. And that ain't peanuts.

The First Peanut Museum is located on US 460 west, near the intersection of Route 40, about 20 miles from Petersburg. Phone (804) 834–2969.

## Alley Oops?

Williamsburg

Whatever you do, don't call it bocce. Lawn bowling is the sport of English gentlemen. Shakespeare wrote about it, and Charles I and Henry VIII played it. The game with roots in the thirteenth century crossed the big pond with the Brits and became the sport to bet on in Jamestown, Williamsburg, Boston, and Toronto. Early Jamestown settlers bowled in the streets. As the colonies grew, so did the number of bowling greens, the grassy sites used for competitions. U.S. towns named Bowling Green are a dime a dozen. Virginia, Kentucky, and Ohio spring to mind. After a century or two of postrevolutionary anti-British sentiment, lawn bowling is back.

There's a jewel of a bowling green right behind the Williamsburg Inn. The sport returned to Colonial Williamsburg in 1954 when craftsmen and interpreters formed teams called the Blacksmiths, the Wigmakers, and the Silversmiths who played for visitors. In 1966 Colonial Williamsburg created a world-class bowling green measuring 120 feet square. The Lawn Bowling Club was formed, and today you can see players garbed in white rolling in the grass.

It's not your regular bowling alley game either. A white ball called a "jack" is rolled down a rink to start play. Players then roll four "bowls" toward the jack, and it's perfectly acceptable to knock your competitor away from a win. If you're sure you're going to lose, you can also knock the jack out of the rink. It's a technique called "burning an end," and it means you have to start all over again.

The tricky part is that unlike the bowling balls at your neighborhood alley, these "bowls" aren't completely round. It's enough to make you want to order a beer.

Guests of the Williamsburg Inn are welcome to use the bowling green. For information, call (800) 822–9127 or visit www.colonial williamsburg.com.

If you've always wanted a room with a flume, this resort's for you.

## Water, Water, Everywhere!
Williamsburg

Some hotels practice the art of perfect plumbing, protecting guests from a single stray droplet of water from a faucet. Others have a reputation of soaking their customers, but few make the practice so public! Great Wolf Lodge, a new addition to old Williamsburg, purposely pumps more than a million gallons of water hourly on its guests. And they're gleeful about it.

The resort's owners spent $62 million to make the interior as leaky as possible—at least in the 55,000-square-foot indoor water park operating eleven and a half hours daily. Kept at a balmy 84 degrees year-round, the wet spot is bigger than a football field. It includes two tube slides twisting both inside and outside the hotel for 687 feet before dropping sliders into a pool below. There's also a three-story waterslide called Totem Towers and the River Canyon Run, which requires a four-person raft. And, there's Crooked Creek, a 90,000-gallon Lazy River, a wave pool, a canoe and paddle shop, and two hot springs, plus a $1 million tree-house water fort.

Of course, the water flows outside, too, to the Raccoon Lagoon, for those who like a little sun on their noses. When the kids are wrinkled up like little prunes, they can retire to their KidKabin Suite, a log cabin fort inside their room, which protects pint-sized privacy from the prying eyes of parents.

If you're not sure a water-filled hotel will float, rest assured the 301 suites at Great Wolf Lodge filled up right after the grand opening in 2005. The resort is located at 549 East Rochambeau Drive in Williamsburg. Call (800) 551–9653 or visit on the Web at www.greatwolf lodge.com. Occupancy is running nearly full at a great rate. Now, who told these people their idea was all wet?

# SOUTHWESTERN VIRGINIA AND THE BLUE RIDGE HIGHLANDS

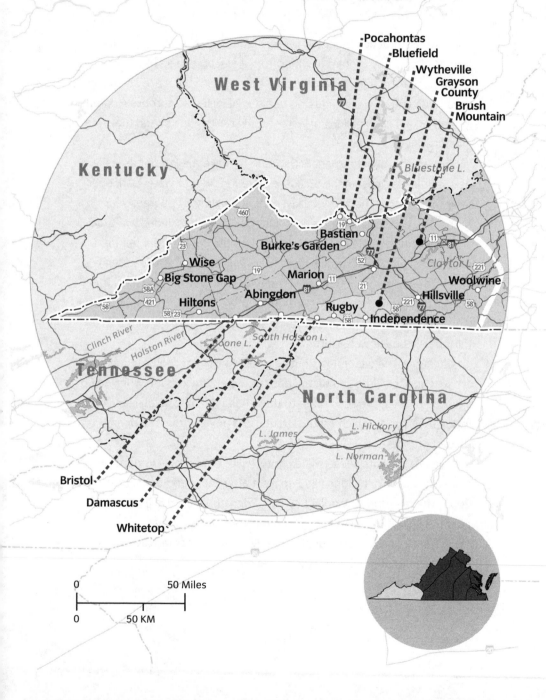

West Virginia

Kentucky

Pocahontas
Bluefield
Wytheville
Grayson County
Brush Mountain

Bluestone L.

Bastian
Burke's Garden

Claytor L.

Wise
Big Stone Gap
Marion
Woolwine
Hillsville
Abingdon
Hiltons
Rugby
Independence

Clinch River
Holston River
South Holston L.

Tennessee

North Carolina

L. Hickory

L. James

L. Norman

Bristol
Damascus
Whitetop

0        50 Miles

0        50 KM

# SOUTHWESTERN VIRGINIA

## and the Blue Ridge Highlands

## The Barter Theatre

Abingdon

Imagine trying to buy your way into a Broadway show with a pound of butter or a bunch of beets. You'd be out on the Great White Way faster than the usher could say "No way."

But a theater in Abingdon got its start with just such a ticket policy. When actor Robert Porterfield found himself in the real-life role of starving artist in New York during the depths of the Great Depression, it was more than depressing, it was life threatening. Porterfield came home to Abingdon with twenty-two of his theater pals and decided to work for food. His theater would barter entertainment for groceries.

When it opened on June 10, 1933, the Barter Theatre was a hit, and the starving stopped. In its first season, the theater only took in $4.35 in cash, but the twenty-two actors gained a collective 300 pounds. Porterfield took his trading talent to playwrights like Noel Coward, Tennessee Williams, Thornton Wilder, and George Bernard Shaw, offering them a Virginia ham for a play. Only one refused. Shaw, a vegetarian, traded his talent for spinach.

The Barter begot talent. Actors who have performed at this small-town theater include Gregory Peck, Patricia Neal, Ernest Borgnine, and Kevin Spacey. Even though you can't trade food for a ticket today, you can still see a great show at the Barter, located on Main Street in Abingdon. Call (540) 628–3991 or visit www.bartertheatre.com.

A chicken! A chicken! My ticket for a chicken.

# BUGS AND BATS AND BEETLES

Although eons of time have eroded the scope and size of the Appalachian Mountain Range, which was once Himalayan in scale, the weathering created caves, rivers, streams, and bogs that contain biological treasures.

The Nature Conservancy has designated the southern Appalachians, and much of Virginia's Blue Ridge, one of the nation's six hot spots of biodiversity. So if you've got a hankering to see *Clemmys muhlenbergii* (an orange-trimmed bog turtle), loggerhead shrike, cave beetles, yellowfin madtom, fanshell mussels, or a gray or Virginia big-eared bat, this is the spot. In fact, there are more than 400 rare plants and animals to see, of which 22 are listed as endangered.

You might not want to go wandering about the 2,200-acre Clinch Valley Bioreserve unescorted. It's wild, unforgiving country, combed with caves, water, and wildlife. You could end up eating like *Survivor* contestants without the chance for winning the million dollars. Guided hike and bike trips are offered in Washington County through Adventure Damascus Tours in Damascus (phone 888–595–BIKE or visit their Web site, www.adventuredamascus.com) and through the Nature Conservancy (www.tnc.org).

## Hotel Guests, Hotel Ghosts
Abingdon

Once a finishing school and then a college for refined young women, the Martha Washington Inn in Abingdon continues to be a class act. The fine hotel is doubly rated as a four-star and a four-diamond hotel—a rare pedigree indeed.

Built as a private home in 1832 for Gen. Francis Preston, his wife, and their nine children, the three-story brick mansion had more than sixty rooms. Bought from the Preston estate, the home and grounds became a college in 1858. During its seventy years of operation, the Civil War, a typhoid epidemic, and the Great Depression all left their mark on Abingdon's grande dame. You might even say that the building is haunted by its past.

But the guests don't seem to mind the ghosts. In fact, the pricey Camberly Suite is no less popular because it's the scene of a bloodstain that simply won't go away. As in *Macbeth,* it was a damned spot that just wouldn't shout out. When a young Confederate soldier was sent to give important intelligence to General Lee, he just couldn't leave town without saying goodbye to his sweetheart. He was shot to death at her feet. Today the stain is covered by carpet.

If you hear the soft sounds of a violin playing in the night, it's not from the banquet hall downstairs. The melodies emanate from a century ago, when a Martha Washington student tenderly cared for a grievously wounded Union captain. Her ministries were for naught; Capt. John Stoves did not recover. As he lay near death, he called out to the girl, "Play something, Beth. I'm going." Beth told his doctor, "He has been pardoned, sir, by an officer higher than General Lee."

A short time after, during an epidemic of typhoid fever, Beth too passed away. Both she and her Union captain were buried at Abingdon's Green Springs Cemetery. Guests still hear Beth's haunting violin melodies on the third floor.

And if you're having a nightcap on the long veranda, you just might see a horse on the hotel grounds. One night in December 1864, a Union soldier wounded by a Confederate bullet was carried inside the Martha Washington College for care, but he died before midnight. His horse roamed the campus grounds, waiting for his master to return. On moonless nights, guests still see the loyal steed standing in wait for his master.

Camberley's Martha Washington Inn is located at 150 West Main Street in Abingdon. Phone (276) 628–3161 or visit www.martha washingtoninn.com.

## Wolf Creek Indian Village
Bastian

You won't see any of the original residents at the Wolf Creek Indian Village when you visit. The population of this 1215 settlement has been gone a very long time. When it was first discovered in the 1930s, local farmer Brown Johnson kept the site secret. During his spring plowing, he unearthed artifacts and human bones. As a gesture of respect to the earlier residents, he covered his find and let the land go back to pasture.

With flinty concentration, Eddie Atwood makes arrowheads.

Four decades later, highway construction crews rediscovered the bones and much more. Hundreds of years ago, Wolf Creek was the site of a thriving settlement with more than one hundred residents who lived in wigwams within double palisade walls. Archaeologists uncovered evidence of life along Wolf Creek, finding fire pits, ceremonial areas, and gardens. Bland County residents have reconstructed a replica of the village, showcasing skills from generations of early American Indians.

Wolf Creek Indian Village is open daily. Local guides demonstrate activities such as gardening and cooking, tanning hides, basket weaving, making pottery, and creating tools from stone. Local resident Eddie Atwood makes the projectile points we know as arrowheads. A native of Wytheville, Atwood revels in his Cherokee and European ancestry. During the day, Atwood is pure Native American.

You can reach the village via exit 58 off Interstate 77 at 6394 North Scenic Highway in Bastian. Call (276) 688–3438 or log on to www.indian ville.org.

## Long Playing: Townsfolk Turn Best-selling Novel by Native Son into an Industry
Big Stone Gap

Since 1964 the residents of Big Stone Gap have volunteered to act out the tale of the coal boom in southwest Virginia. The town's resident novelist, John Fox, based his best-selling novel *The Trail of the Lonesome Pine* on real townspeople and real events, treating them with only a light dusting of poetic license.

Staging a play began as a way for the community to get involved in the arts. Lonesome Pine Arts and Crafts Inc. opened shop in the nineteenth-century Jerome Duff house, which was promptly renamed

after *Lonesome Pine* heroine June Tolliver. The house, which doubles as a museum and gift shop, stands right next door to the outdoor amphitheater where the play is presented in the summer. The author's home is also open for tours. Fox was not only local; he was well-known in a big way, publishing 500 short stories and 14 novels.

Landing the role of June in the town drama is a feather in any girl's cap. Like a beauty contest winner, the role is a coup for life. Playing June calls for a Pygmalion transformation from mountain girl to sophisticated young lady. There's nothing wrong with spending three evenings a week with the town's handsomest young man either. The play's protagonist, Jack Hale, is an engineer from the "outside world," and the two are thrown together amid the tumult of transformation brought on by the discovery of iron and coal in Virginia's Blue Ridge Mountains. Unlike most modern stories, it's a modest one, rated for family viewing. And unlike most love stories, it has a happy ending.

*The Trail of the Lonesome Pine* turns out most happily for Big Stone Gap, drawing 5,000 to 7,000 visitors annually. It's been named the Official State Outdoor Drama of Virginia, exposing everybody in town to the arts in one way or another.

*The Trail of the Lonesome Pine* is presented at the June Tolliver Playhouse on Thursday, Friday, and Saturday nights in July and August. Call (800) 362–0149 or (276) 523–1235 for details.

## The Lemonade Lassies
Bluefield

It's not so hot in Bluefield. In fact, the town that straddles the Virginia–West Virginia border is known as Nature's Air-Conditioned City. Perched at 2,612 feet above sea level, Bluefield is a cool and breezy change of altitude from sweltering southern summers.

Chambers of commerce are known for accentuating the positive, and in 1939 Bluefield's chamber manager, Eddie Steel, came up with a cool campaign. He proposed that the chamber serve free lemonade to anyone and everyone on the city streets whenever the temperature hit 90 degrees. It was a great idea, but it wasn't put into practice until August 1941. That's the first time it got warm enough to call out the "lemonade lassies," the citrus-serving brigade.

There was a long dry spell that lasted from 1960 to 1977. But nature has a way of balancing its own quirks. In 1988 there were hardly enough lemons to go around. The chamber served lemonade seventeen times—the Bluefield record. So if you happen to hit Bluefield when they're having a hot time in the old town, cool off with a free lemonade.

## Marryin' Towns
Bluefield

Mrs. Emma Yost never forgot the day that two towns along the Virginia–West Virginia border tied the knot. Her wedding to L. W. Yost was part and parcel of the festivities.

On July 12, 1924, the town of Graham, Virginia, changed its name to Bluefield. To enliven the town's name-changing ceremony, officials enlisted a local bride and groom to tie the knot. So Emma was whisked to the fairgrounds on a sultry July day in the back of a limousine. The governor of West Virginia stood by the groom and the Virginia governor by the bride as vows were exchanged.

Both marriages were successful. Emma and L. W. Yost celebrated their fiftieth wedding anniversary in 1974. Bluefield, Virginia, and Bluefield, West Virginia, share more than a name—they share a cooperative chamber of commerce, tourism efforts, and much more. Who said marriages just don't last anymore?

## Big Bang in Bristol

Bristol

Straddling the Virginia-Tennessee line, Bristol was formed as a railroad town. Not too much happened in Bristol (with the exception of the birth of Tennessee Ernie Ford) until 1927, when the Big Bang gave birth to country music.

Big Bang was the name Johnny Cash gave to the first recording sessions that took country music off the mountains and out to the masses. Record producer Ralph Peer rented out an old hat factory, hung some quilts on the walls to help with the acoustics, and put out a call for talent. It flowed out of the mountains like water after a heavy rain. He auditioned folks like J. P. Nextor, Norman Edmonds, and Charles McReynolds and his Bull Mountain Moonshiners. A. P., Sara, and Maybelle Carter came down from Maces and wowed the producer with "Bury Me Under the Weeping Willow" and "Little Log Cabin."

It was hotter than Hades in Bristol that August when Peer was making his recordings. It's amazing the wax masters made it to New York without melting. Peer called the sound he was recording country music. So did America. Officially designated the birthplace of country music, Bristol sent musicians to the National Folklife Festival in Washington, D.C., in 2003, the seventy-sixth anniversary of the Big Bang. There were fireworks as well as fiddling.

You'll be able to visit the Birthplace of Country Music Alliance Museum at its permanent location in 2009 at 520 Cumberland Street. Phone (276) 645–0035 or log on to www.birthplaceofcountrymusic.org.

## Was It Something He Ate?

Bristol

At Virginia's Bristol Burger Bar on Piedmont Avenue, the food is filling, and everyone seems to enjoy their burgers in spite of the Hank Williams incident.

Williams stopped in for a bite at the Burger Bar on his way to a concert in Canton, Ohio, on New Year's Eve, 1952. There may be no connection whatsoever, but Williams was found dead in the backseat of his Cadillac the next day. The songwriter who gave us "Your Cheatin' Heart," "Cold Cold Heart," and "I'll Never Get Out of This World Alive" was only twenty-nine years old.

A half century later, people are still humming Hank Williams songs and chowing down at the Burger Bar. Both are legendary.

A bar at the border—the Tennessee border, that is.

## Audie Murphy Monument
Brush Mountain

Although he survived countless encounters with Nazi soldiers in World War II, hero Audie Murphy did not survive Brush Mountain. The most decorated soldier of World War II and a popular Hollywood actor, Murphy died in an airplane crash in fog and rain on the mountain's slopes on May 28, 1971. Ironically, Murphy was on a business trip in connection with *A Time for Dying,* a movie about Jesse James that would prove to be his final film. The local post of the Veterans of Foreign Wars built a monument in his honor.

It's not easy to pay homage to Murphy. It's a 17-mile drive northeast from Blacksburg and a 1.5-mile hike along a short section of the Appalachian Trail to an elevation of 3,100 feet, but it is worth the trip.

Murphy's story parallels the American Dream. The son of a Texas sharecropper, Murphy joined the infantry and entered World War II at the age of eighteen. His heroism helped to stop the Nazi advance into France. For his efforts, Murphy received twenty-four medals from the United States, including the Congressional Medal of Honor, plus three medals from France and one from Belgium. After the war Murphy wrote a memoir, *To Hell and Back,* and starred in forty Hollywood films.

The monument is located in Jefferson National Forest, Blacksburg Ranger District (540–552–4641). To honor Audie, drive 13 miles on Route 624 from Blacksburg. Just past Route 650, turn right onto a gravel fire station road (FSP 188.1). Turn right at the top of Brush Mountain and proceed 3 miles to the trailhead.

# THE VARMINT OF BURKE'S GARDEN

A monster ran amuck in Burke's Garden in 1952. The peaceful agricultural community was terrorized by an unidentified serial killer. More than 400 registered sheep perished, and farmers suffered losses exceeding $32,000. Whatever was on the killing spree had to be stopped. No one was able to identify the killer, and he became known as "the varmint."

The Board of Supervisors of Tazewell County took action by contacting two of America's best-known big-game hunters, Arizona's Clell and Dale Lee. Their dogs were famous for tracking anything on four legs. Dale Lee was hunting jaguars in Venezuela, but Clell Lee answered the call.

When he arrived in Bluefield, Lee was underwhelmed by the cool reception. Local farmers Bowen Meeks and Joe Moss greeted him very formally and with little warmth. Mrs. Meeks was hospitable, however, and invited Lee to stay at her home.

Lee was shown a block of ice with an animal pawprint in it. He told Meeks and Moss that the enemy was a coyote. They were flabbergasted—none had been seen in Tazewell County in a lifetime.

Accompanied by local sheep owners, game wardens, hunters, and the sheriff, Lee and his dogs headed out for the hunt. The dogs followed the scent and ran the varmint for about five hours before dark descended.

Lee ordered everybody back at dawn, but the sheriff explained that nobody in Tazewell County hunted on Sunday. "Neither do I, usually, but we have a fresh scent," said Lee. "There is no necessity for my imposing on your hospitality and expense longer than necessary."

In the morning, the hunters learned that the varmint had struck again, killing two more sheep. Lee stationed hunters near the site of the kill, an old cemetery, and set his dogs on the scent. After a few hours, shots were fired, and the hounds stopped baying. The varmint had been caught.

It was a coyote and one to be reckoned with—measuring nearly 4½ feet long and weighing 35 pounds. His fangs were an inch long.

The formerly calm, cool Virginians were jubilant. There were autographs and photos, and Lee estimated that he received about eighty invitations to dinner.

When one resident asked if he was related to the Lees of Virginia, Clell responded, "Possibly," but asked what difference it would make. He was to find out.

Lee was ready to claim the $2,500 bounty and leave, but the sheriff reminded him that it was Sunday and there would be no check cut on the Lord's Day.

Clell was enticed to stay on a while, and a dinner dance was held in his honor. One dignitary provided Lee with a family tree showing the westerner his direct bloodline to Gen. Robert E. Lee.

When Lee went back to the courthouse to pick up his check, the town was full of visitors—nearly 7,500 of them. The coyote had been hung from a tree, and people were lining up to see it and to meet the long-lost Lee. Some had driven hundreds of miles.

The hunter was not the only Lee in the pack. Light Horse Harry Lee, hero of the Revolution, had been known for his hunting dogs and his Morgan horses, which the family had continued to breed for more than a century. The dogs that had gotten the varmint were Lee descendants as well.

As one Tazewell County resident explained, "Blood talks."

## You Could Call It Bilt-less

Burke's Garden

Hidden in the Blue Ridge Mountains of southwest Virginia is one of the most unusual geological formations in the United States. A bowl-shaped valley sits within Beartown Mountain at 3,100 feet above sea level. While exploring Virginia's western frontier in the 1740s, surveyor James Burke accidentally discovered the valley. Burke reported to his party that he had discovered the Garden of Eden. Skeptical, his men wanted to see it for themselves. They followed Burke back to the valley, which was full of game grazing on the bluegrass. When a snowstorm hit, they buried the remnants of their meal, including potato peels, and left in a hurry. They returned in the spring and discovered that a lush potato garden had sprung up at the site. The party laughed and joked about its being "Burke's Garden."

Settlers fell in love with the fertile valley, and many farming families remain some six generations later. One name you won't see in Burke's Garden is George Washington Vanderbilt. This megawealthy timber and railroad baron was accustomed to having what he wanted, and he wanted a dream castle in the mountains. He sent his minions out to scout for the perfect setting, and one of them came back recommending Burke's Garden. Vanderbilt was as skeptical as Burke's men had been, so the millionaire went to see it for himself in 1880. He called together a number of the locals to broker a big real estate deal, but the yokels trumped the millionaire. Not one of them would sell a single acre.

Vanderbilt left town to inspect his second choice, Asheville, North Carolina, where he built the largest private home in America—Biltmore.

Burke's Garden is located in Virginia's southwest Blue Ridge Highlands in Tazewell County on Route 623. Call (800) 588–9401 for more information.

## Down the Trails

Damascus

Damascus is the one Virginia town built on foot traffic. At the intersection of four different trails, the town elevates its hikers to celebrity status. From Damascus, you can take to the woods by foot via the Appalachian Trail, the Virginia Creeper Trail, the Daniel Boone Trail, or the Iron Mountain Trail. (For bicyclists, there's the Transcontinental Bike Trail.)

A hiker's dream—everything from shoelaces to Band-Aids is available here.

The Appalachian Trail's blaze runs right down the middle of Main Street. Hiker dollars constitute the majority of the town's economy. On Saturdays, the population of Damascus doubles. Something's afoot when a town offers e-mail service at the town hall, mail pickup and registration at the post office, shuttle service, laundry, and a pharmacy to those who are just passing through. The Methodist church has maintained a hostel for hikers since 1976. Called simply the "Place," it's an icon of hospitality—the place to rest, relax, and refresh among the friendly folks of Damascus.

The town celebrates its walking wanderers every May the weekend after Mother's Day during Appalachian Trail Days. Through-hikers (those who are walking the 2,200-plus miles from Maine to Georgia) and weekend walkers are welcomed. You may find that you have to take on a trail name (just for the day, of course). You might cause strange looks if you call yourself Joe among people named Dawn-walker, Moonstone, Copperhead, and Eagleman.

Appalachian Trail Days begins with a hikers' parade. Bagpipes lead the marchers through town to the gazebo in the Damascus Town Park where the music begins. Everybody gets into the act, from the Senior Citizen Band to the homeowners who hold garage sales. Although it normally has a population of fewer than 1,000, Damascus hosts between 25,000 and 30,000 visitors during AT Days. There's a Twinkie-eating contest, a hiker talent show, a pet show, and hikes, of course. There are also slide show narratives about hikes in exotic locations like Canada, California's Pacific coast, Nepal, and beyond. And don't miss the whittling workshop sponsored by the Whittling Club. There's a display of their whittled wonders in the back room of the public library.

For more information, call (276) 475–3831 or log on to www .damascus.org.

## Be in Three Places at Once

Grayson County

You don't need to be an elk or a mountain goat to climb Virginia's tallest peaks, which are both located in Grayson County. Mother Nature and time have eased your climb to Mount Rogers, at 5,729 feet above sea level. You can hike up from Elk Creek Garden off the Appalachian Trail in less than three hours at a snail's pace and back down in two (thanks to gravity). There's no view from the top of this peak; instead you'll find yourself in a thick spruce forest more reminiscent of Maine than Virginia. Be sure to wear a sweater. The temperature during your climb will drop at least 20 degrees Fahrenheit.

The peak of White Top Mountain at 5,520 feet is even easier to reach. You can drive there along U.S. Highway 58, the highest road in the commonwealth. At the top you get a view of three states, and if you ask the locals, they'll show you the spot where you can put one foot in Tennessee and the other in North Carolina, while keeping your hands in Virginia. It's like geographical Twister.

# FIDDLIN' AROUND GRAYSON COUNTY

When you're in southwest Virginia and you see somebody carrying a four-stringed instrument with a bow, don't you dare call it a violin! It's a fiddle.

Those strings are as often plucked, picked, and strummed as they are drawn with a bow. And the musical instrument beloved by Mozart and Haydn aren't hidin' in these woods. In these parts, fiddlers are on top of the food chain, musically speaking, and there are several fiddlers' conventions in Grayson County annually.

More than just a chance to gather and hear some of the good old-timey music and bluegrass varieties, these conventions are serious competitions. Folks come in from around the country to try to win the crown. And they're not just fiddlin' around.

In March, the Fairview Ruritans hold court off Route 89 south of Galax. There are evening competitions in bluegrass and old-timey music as well as individual competitions. In April, everyone and their Aunt May meet at Grayson County High School in Independence for the Mountain Music Rendezvous.

On the third Saturday in June, there's the Wayne C. Henderson music festival and guitar competition at Grayson Highland State Park. And during the last weekend in June, folks gather at the ball field at Elk Creek School on Route 658 off U.S. Highway 21 just north of Independence for two nights of serious competition at the

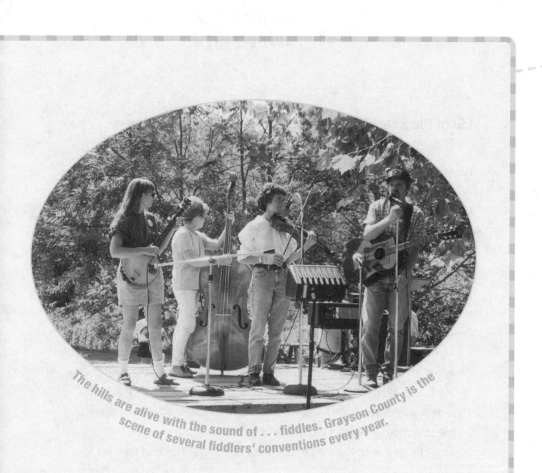

The hills are alive with the sound of . . . fiddles. Grayson County is the scene of several fiddlers' conventions every year.

Grayson County Fiddler's Convention. Camping is permitted for a fee, and it becomes mountain music's answer to Woodstock, with pickin' all night long.

In August, the Fries Town Park becomes a country campground for two days and nights as the tiny town gets into the act with . . . you guessed it, a fiddle competition. For more information on the fiddlers, contact Grayson County Tourism at (276) 773–2471 or visit www.graysoncountyva.com.

## I Shot the Sheriff (and the Judge, the Lawyer, a Witness . . . )
Hillsville

I'm sure Bob Marley never came close to the Carroll County Courthouse on North Main Street in Hillsville, but the words of his hit song "I Shot the Sheriff" ring just as true as if the reggae hero had tromped into town on March 13, 1912.

In this remote southwestern Virginia town, Floyd Allen and his family preferred mountain justice to any court in the land. When his nephews got into a fistfight outside church, they were indicted for interfering with public worship. Carroll County deputies Pink Samuels and Peter Easter were sent to fetch the Allen boys back for trial.

As they passed Sidna Allen's store, Floyd Allen confronted the deputies and demanded that his nephews be untied. The deputies refused, and Allen threatened them with a pistol, knocking Samuels in the head. Although Uncle Floyd cooled down enough to take the boys to the courthouse, he had already let his temper get the best of him. He was charged with the illegal rescue of prisoners. The trial was set for March 13.

Both Floyd and his brother Sidna had their share of scrapes with the law, for shooting and counterfeiting and the like, but this time Floyd had boasted that he would die and go to hell before spending a minute in jail.

The courthouse was packed when the jury convicted Floyd. The judge directed the sheriff to take the prisoner. Floyd simply said, "Gentlemen, I just ain't goin'," and the shooting broke out.

Floyd, his son Claude, and his brother Sidna were armed. When it was over, the judge, the sheriff, the commonwealth's attorney, and a witness for Allen lay dead. Every high court official of Carroll County had been killed.

As the Allens escaped, the surviving assistant clerk of the court sent a telegram to the governor of Virginia. Mountain people are known to be frugal, so the clerk sent the important telegram collect. It read: "Send troops to the County of Carroll at once. Mob violence, the court, commonwealth's attorney, sheriff and some jurors and others shot on conviction of Floyd Allen for a felony. Sheriff and commonwealth's attorney dead. Court serious. Look after this now."

In time, all involved surrendered or were captured. Floyd and Claude Allen were convicted and sentenced to die by electrocution on March 28, 1913. The bullet holes are still visible in the courthouse steps, and Sidna Allen's Victorian home still stands. It's 6 miles south of Hillsville on U.S. Highway 52 in Fancy Gap. Tours are offered from April through October. Phone (276) 728–2594.

## Folded into the Carter Family

Hiltons

Under the barn roof, you have your choice of old school bus seats or plain old benches. It's Saturday night at the Fold, and it's time for a little music and a lot of dancing. For $5.00, you can join the neighbors for a little clogging, buck dancing, and flatfooting. Founded by the children of Maybelle Carter to keep traditional mountain music alive, guest artists line up for the privilege of playing on a stage once graced by the legends themselves—Janette and Joe Carter, Johnny and June Carter Cash, and other country music greats.

The fiddlin' fun begins at 7:30 P.M., and everybody dances, from preschoolers to octogenarians, and everybody knows everybody else. If you don't, you will by the time you're done dancing.

Traditional mountain music is celebrated here.

The Carter musical dynasty began with A. P., Sara, and Maybelle Carter at the Bristol recording sessions of country music in 1927. They went on to write more than 300 songs. Maybelle and her three daughters, Helen, June, and Anita, performed as Mother Maybelle and the Carter Sisters at the Grand Ole Opry, where young June met and later married Johnny Cash.

The Carter Family Museum and cabin is open before performances for a small admission charge, and you can pick through the old photographs, instruments, awards, recordings, and personal memorabilia of this founding family of country music. It was Mother Maybelle's guitar that led the parade to the opening of the new Country Music Hall of Fame in Nashville in 2001.

The Carter Family Fold and Memorial Music Center is on A. P. Carter Highway (Route 614) in Hiltons. Phone (276) 386–6054 or go to www.carterfamilyfold.org for details.

## Race You to the Outhouse

Independence

Most folks race to the outhouse. In Independence, they race with the outhouse. Independence hosts the state's one and only "Grand Privy Race." It's held annually during the Mountain Foliage Festival in October. Some tourists come to see the foliage, but they're missing the point. Just as New York has the Macy's Thanksgiving Day Parade signaling the start of the holiday shopping season, Independence has the parade of the privies, announcing the beginning of the foliage season.

The portable potties line up at 11:00 A.M. for a double elimination race down Davis Street. Charities and organizations flush with volunteers find a rare backyard building or build their own to compete for cash prizes. The privy can be pushed or pulled—no gas power permitted—and the winning team takes home $300.

Although privy time is usually private time, the Grand Privy Race draws more than just flies. There are vendors from North Carolina, Tennessee, and Virginia, good old-timey music and clogging, and lots of food to fuel the racers.

The race has been such a success that a companion event has been added. The toilet paper toss—the perfect accompaniment—features seven different categories in which to compete with cash prizes in each. Longest toss wins the prize. Throw me a roll, would you?

The Grand Privy Race is held the second Sunday in October on Davis Street in Independence. It's located 26 miles from I–77, at the intersection of US 21 and 58. Phone (540) 773–3711 for more information.

## Home of Mountain Dew
Marion

Now one of the top ten best-selling soft drinks in the world, Mountain Dew almost didn't. When its inventor, William H. Jones, tried to take it to market, it almost didn't happen. Bill Jones had a flair for selling fruit-flavored syrups for soda, especially on a golf course or at a happy hour. The affable Mr. Jones went to work for Clay Church, the president of the Dr. Pepper Bottling Company of Marion's new venture, the Tip Corporation. Tip's intent was to sell a grape soda to compete with Grapette, a popular brand at the time. Jones sold syrup like there was no tomorrow, but the little company failed.

Undeterred, the effervescent Bill Jones poured his efforts into a new idea. He suggested a lithiated lemon concentrate to Pepsi bottler Ollie Hartman of Knoxville, Tennessee. Around these mountains, whiskey was known as White Lightning, and carbonated mixers were called Mountain Dew. As luck would have it, Ollie Hartman held the trademark on the name.

Jones, Hartman, and the Minges brothers, who were also in the bottling business, partnered up. They each invested $1,500 to resurrect the Tip Corporation and manufacture Mountain Dew to compete with Golden Girl Cola, North Carolina's most famous blonde beverage.

Although Mountain Dew was tasty and quite popular regionally, it couldn't compete with the big manufacturers' advertising budgets and franchise agreements. It was tough going, but Jones hung on through the hard times. As he told his wife, "Alice, we don't have to keep up with the Joneses—we are the Joneses."

Jones tinkered with the recipe, adding caffeine and enough orange juice to get it out of the lemon-lime classifications. According to his daughter, Mary Linda, Jones wanted his drink to give people an afternoon pickup. Early mixtures had so much caffeine that it crystallized

in the bottle and looked like slivers of glass. He tinkered and tested some more.

Jones tested the formula at the old Pepsi plant on Main Street, mixing one batch of the carbonated water at high speed and another at low speed. It took fifteen tests, but taste-testers finally gave the Mountain Dew formula the nod. By March of 1964, Tip was producing the concentrate for ten million cases.

In August of 1964, Pepsi-Cola acquired the rights to Mountain Dew. Sixty thousand shares of Pepsi common stock were traded for 940 shares in the Tip Corporation. Jones not only enjoyed stock dividends, he was paid a salary by Pepsi and continued to tool around town in a Cadillac with vanity plates that read MT DEW.

Mountain Dew was reformulated in the 1960s to be the magic elixir of bubbles, lemon, lime, orange, sugar, and caffeine that we know today. Most people who Do the Dew have never heard of White Lightning or Marion. Learn more at www.mountaindew.com.

## Editing a Small-Town Paper

Marion

How did Sherwood Anderson, one of the most important writers of the twentieth century, end up in a small town in southwest Virginia? By choice, of course. The author of the wildly popular *Winesburg, Ohio* had sold tens of thousands of copies of the book and had become a celebrated figure in American literature when he decided he was tired of city life. Anderson settled in Grayson County in a home called Ripshin. Although he loved the country life, the author soon got bored, so he bought the *Smyth County News* and the *Marion Democrat* in 1927.

For the next two years, Anderson dove into his new role as editor, writing about moonshiners, local politics, fisticuffs in local bars, school

plays, and crop yields. Anderson created a fictional reporter, Buck Fever, and on slow news days, Buck's observations became a popular addition to the paper.

Anderson married local girl Eleanor Copenhaver, and his son Robert took over the newspapers. The world-famous author took to the road again, focusing on travel writing and fiction. When he died in 1941 in the Panama Canal Zone, his wife brought his body back to Marion. Anderson is buried in Round Hill Cemetery.

Son Robert wrote in his eulogy: "Sherwood Anderson had come to love this mountain country and its people. He wrote about the turn of a road, a field beyond. An old farmer came into the shop. 'Say, that's my field you wrote about,' he said. 'I never realized it was beautiful until I read your piece.'"

A good writer is still important in Marion, which honors Anderson's memory with an annual short story contest. Write on!

## Clean Coal (?) Mine
Pocahontas

The term "clean coal" might seem like an oxymoron, but the Pocahontas Coal Company made a fortune marketing the stuff for seventy-three years. The company's mother lode of "black gold" burned cleaner than the competitions and became the standard because of its smokeless purity. The U.S. Navy chose Pocahontas coal to steam us to victory in two world wars. Housewives preferred it, too.

Dug deep into the mountains of southwestern Virginia and south-eastern West Virginia, the mines of the Pocahontas Coalfield produced forty-four million tons of coal, which could fill a trainful of coal cars 6,000 miles long.

When the mine opened in 1882, coal came out of the mountain the hard way. Miners with picks and shovels went underground, bringing it out by the bucketful. The Pocahontas had a 13-foot coal seam, a discovery that brought more than fame to the mountain. It also brought new residents, African Americans and Hungarians who settled and stayed and became part of the Appalachian culture.

More than a million visitors have walked into the mine, now designated a National Historic Landmark. It's still cold and dark and a little spooky. It makes you grateful for the dawn of the information age. Spending a day behind a computer feels like child's play compared to a day in the mines.

Although the coal burned clean, it was dirty work. Visitors to the mine can tour the 1896 bathhouse where miners left the day's dust behind before they headed home. It's now the Coal Heritage Museum.

The mine is open seven days a week April through October. Pocahontas was a company town, so it's not hard to find the mine on Route 659 in Tazewell County. Log on to www.wvweb.com/www/pocahontas_mine or call (276) 945–2134 or (800) 588–9401.

## Pickin' with the Postman
Rugby

For his day job Wayne Henderson delivers the mail along 80 miles of rural mountain roads. By night he makes guitars, mandolins, fiddles, and dobros for the likes of the Smithsonian, Eric Clapton, Doc Watson, and other music magicians.

From the garage workshop adjacent to his house, Henderson both repairs and builds some of the best guitars in the world. He began whittling as a boy, and when he took the veneer off his mother's dresser drawer, his father sent him to a nearby fiddle maker for some old-

fashioned apprenticing. Henderson became good enough at his craft to be courted by George Gruhn, known for his Nashville guitars. He would spend time in Nashville and then return to Rugby.

Now he has a customer backlog years long. They're all begging the master to finish the mail run and repair their old instruments or build brand-new ones from scratch. Dozens of dismembered instruments lie about the workshop awaiting the master's touch. Henderson opens the shop around 6:00 P.M. and works with a few assistants and a lot of groupies who come to pick with the pro, especially on Wednesday nights.

Henderson not only makes guitars, he loves to play them. He's won scores of ribbons from the Galax Fiddler's Convention and has toured around the world. When Henderson picks up an instrument, the room goes silent, and only the guitar sings.

If you'd like to see the master yourself, take Route 16 from Marion through Troutdale. Turn right on US 58 and left at the Methodist Church. Henderson's shop is on the right. Phone (276) 579–4531.

## This Is One Foul-Smelling Festival
Whitetop

It's a stinkin' good time when the ramps come up. The ramp, a poor cousin of the lily, is a wild leek that grows at high altitudes in Appalachia. This green harbinger of spring was one of the first fresh foods for mountain folks after a hard winter.

Those brave enough to have eaten a ramp describe the taste as pungent—it's like eating a clove of garlic and an onion at the same time. It's easy to identify the ramp eaters—you can smell 'em before you see 'em. Ramps have real staying power; the smell will ooze out of your pores for days.

Virginians, known to celebrate almost anything, hold an annual festival honoring the humble ramp at the Mount Rogers Fire Hall in Whitetop. To find enough of the odiferous bulbs, a caravan of volunteers combs the woods. At the festival (its logo features a skunk) they're available cooked or raw. Even the fried potatoes that come with your barbecue chicken dinner have ramps in them.

The daylong festival includes a craft show and plenty of foot-stomping music. There's bluegrass, old-timey tunes, and gospel, but the festival highlight is the ramp-eating contest at 4:00 P.M. In 2005 Jody Davis took the coveted title of ramp champ with fifty in three minutes.

Bet you can't eat just one.

Five-time ramp champ Stanley Maloskey, who once downed sixty-nine ramps in three minutes, holds the adult record. "You have to have a taste for them to keep 'em down," he says. The prize is $100 and a bottle of mouthwash.

The Whitetop Mountain Ramp Festival is held the third Sunday in May at Mount Rogers Fire Hall on US 58 in Whitetop. Call the Grayson County Tourist Information Center in Independence at (276) 388–3422 or visit www.graysoncountyva.com for more information.

## Who Are the Melungeons?

Wise

Southwestern Virginia is home to a group of people with a fascinating ancestral history that is just coming to light. The Melungeons are believed to be descendants of the Turkish and Portuguese sailors who explored American shores in the sixteenth century. Some of these sailors were believed to be shipwreck victims, others stayed by choice, intermarrying with Native Americans, Africans, and later with Northern Europeans. Being of mixed ancestry was suspect in early American history, so these people moved deeper into the frontier to find peace and freedom from persecution. They found a safe haven in the southern Appalachian Mountains of Virginia.

Believe it or not, some of their descendants still speak with an Elizabethan accent, some 400 years after the Virgin Queen's reign. Some Melungeons trace their ancestry back to Roanoke Island, North Carolina, where Sir Francis Drake was reported to have left several hundred Turkish and Moorish sailors.

Other Melungeons don't discuss their ancestry at all. Because the race listed on your birth certificate could lead to either opportunity or persecution in Virginia as late as the 1940s, many Melungeon families

kept their heritage to themselves. Their surnames are common to Appalachia as well as Northern Europe: Collins, Bigson, Mullins, Moore, Hall, Bennett, Bell, Osborne, Seton, Bolling, and others.

It wasn't until after Alex Haley's *Roots* made geneology a pastime for ordinary folks that the Melungeons began reclaiming their heritage. There have been three "unions" of Melungeons in Wise, drawing as many as 2,000 people, with more planned for the future. The gatherings include genealogy seminars, panel discussions, Melungeon medical histories, and storytelling. A DNA study will help resolve the question, comparing the DNA of 175 samples of Virginia Melungeons with the rest of the world populations. Conducted by the University of Virginia in Wise, the results will be released to the Melungeon Heritage Association (www.melungeon.org).

## The Bridges of Patrick County
Woolwine

Once upon a time, Virginia had hundreds of covered bridges. Skilled craftsmen used lumber and pegs to handcraft these beautiful and functional structures. They were quite an improvement from the early fords, which were simply narrow and shallow places to cross. The bridges were a marvel in the seventeenth and eighteenth centuries, but they were prone to destruction by fire and flood. After the American Industrial Revolution, stronger fireproof steel-truss bridges came into use, and nobody wasted much energy on the old-fashioned covered bridges.

Predictably, the wooden structures fell to ruin, and today there are only eight left in the entire state. Twenty-five percent of the remaining covered bridges are off Route 8 in Patrick County near Woolwine. Before you get too excited, that's only two bridges, but if you're a nostalgia fan, Patrick County is the place to see 'em.

The 1821 Bob White Bridge crosses the Smith River. It's 80 feet long and is an example of a Burr arch bridge, designed by Theodore Burr, who patented his invention in 1817. Even he would be amazed to see it still standing. Even though it carried traffic for fifty years, it's just for pedestrians now, so you can walk back and forth at will. Take Route 618 1 mile to Route 869. Go south about a tenth of a mile to the bridge.

Jacks Creek Bridge doesn't cross Jacks Creek at all. It too crosses the Smith River. Built in 1914, the covered bridge is 48 feet long. A modern bridge replaced it, but the county maintains it just for nostalgia's sake. From Woolwine, take Route 8 south for 2 miles, then take Route 615 west about two tenths of a mile.

## America's First Woman President
Wytheville

The woman who earned the title of America's First Woman President was Edith Bolling Wilson. The daughter of a judge, Edith was accustomed to having things her way. She was born on October 15, 1872, in the town of Wytheville. On that day her father, Judge William Holcombe Bolling, sent word to the courthouse across the street that court would be delayed until the baby was born.

Edith grew up in the house on Main Street where her father maintained his law offices on the ground floor. She attended Saint John's Episcopal Church, with its Tiffany windows, right down the street. She would later commission a window for the church in memory of her parents.

In 1915 Bolling married President Woodrow Wilson and assumed the duties of First Lady. When Wilson suffered a stroke and complete physical collapse in 1918, Edith took charge. No one was admitted to see the president except doctors and nurses. It was she who decided what

matters would be brought to his attention, earning her the title of America's First Woman President.

Take the self-guided walking tour of Wytheville for more Edith tidbits. Call (877) 347–8307 or log on to www.visitwytheville.com.

## The World's Best Chili Dog
Wytheville

For more than eighty years, people have been piling into Skeeters in Wytheville. The restaurant opens at 8:00 A.M. for breakfast and stays open for lunch and early supper; the doors are locked promptly at 5:30 P.M. in the winter. Extended summer hours add thirty minutes at the end of the day.

The draw isn't the drinks; the place doesn't serve any alcohol. And the only entertainment is the kind you provide yourself—like watching the traffic, humming to yourself, or reading the newspaper. Skeeters isn't Vegas.

Located in the middle of Main Street, Skeeters has the reputation of serving the world's best chili dogs. It says so in huge painted letters on the brick exterior.

People drive for miles to get one. And they'll tell the waitress how many years it's been since they've had a chili dog and how many times they've thought about it in between. (Chili dog eaters can get down-right boring at times.)

The waitress can't quite understand what all the fuss is about. "There's nothin' really special about 'em," she says. Even the chili is just the frozen kind, but people just love 'em.

Call Skeeters at (276) 228–2611.

## To the Point
Wytheville

John Campbell Findlay had a big idea. In the 1950s this Wytheville entrepreneur recommended that all the shops on US 21 draw in new customers by thinking big. If everyone put up an oversize object symbolic of what was sold inside, Wytheville would have a lively commercial district. Being a leader has its risks as well as its rewards, so Findlay set about putting his money where his mouth was. As he was the owner of an office supply store, he constructed a 30-foot pencil and attached it to his building.

It sure was the talk of the town, but that's about all it was, just talk. None of the other businesses followed suit.

Those big naysayers should have listened to Findlay. His office supply store with the big pencil, now run by his daughter, still does big business.

Eventually, US 21 was bypassed by Interstates 81 and 77, and traffic now whizzes past Wytheville at 80 miles per hour. About 60,000 vehicles travel the interstates daily. What draws visitors into town these days would make big-thinking John Campbell Findlay smile: A huge, bright rainbow-colored hot-air balloon hovers over town. Actually the old water tower, the colorful oversize symbol of festivals and fun, was the brainchild of the town council. Maybe the spirit of Findlay helped launch the balloon skyward. In any case, it's been a big success, drawing up to 250,000 visitors a year. Phone the Wytheville Convention and Visitors Bureau at (877) 347–8307 or go to www.visitwytheville.com.

Even dolls need to nap.

# INDEX

# INDEX

# INDEX

# INDEX

# INDEX

# INDEX

# INDEX

# INDEX

# INDEX

# Photo Credits

All photos by Sharon Cavileer, except the following: p. 30, © Cynthia Tunstall; p. 60, Sam Dunaway; p. 69, Stacy Ann Logsdon; p.73, Jeannette Muller; p. 76, photo by Les Schofer, courtesy of The Corporation for Jefferson's Poplar Forest; p. 81, courtesy of Lynchburg Visitors Center; p. 82, courtesy of Hill City Master Gardner Association; p. 84, courtesy of Lynchburg Visitors Center; p. 98, Pampkin Historical Park; p. 117, Jennifer Miller; p. 125, Hebrew Cemetery fence, courtesy of Richmond Convention and Visitors Bureau; p. 157, Roanoke Star, photo courtesy of the Roanoke Valley CVB; p. 163, metal foundry puppet, courtesy of Stauton CVB; p. 170, Museum of the Shenandoah Valley, photo by Ron Blunt; p. 183, Hope & Glory Inn, courtesy of Slay Public Relations; p. 183, The Tides Inn; p. 218, Virginia's Eastern Shore Tourist Commission; p. 223, Blackbeard Festival, courtesy of Hampton Conventions & Tourism; p. 225, Little England Chapel, courtesy of Hampton Conventions & Tourism; p. 227, Emancipation Oak, courtesy of Hampton Conventions & Tourism; p. 230, Jamestown-Yorktown Foundation; pp. 235, 236, courtesy MacArthur Memorial Archives, Norfolk, VA; p. 240, Commodore Theater, courtesy of Portsmouth CVB; p.241, photo by Robert Lentz; p. 243, Isle of Wight County Museum; pp. 248, 251, City of Virginia Beach and Virginia Beach Department of Convention & Visitor Development; p. 255, photo by Mark Atkinson; p. 260, courtesy of Great Wolf Resort; pp. 272, 284, Birthplace of Country Music Alliance; pp. 281, 291, Grayson County Tourism; p. 311, Peter D'Alessandro.

## About the Author

**Sharon Cavileer** is a freelance writer, photographer, and public relations counselor who specializes in features and travel. Descended from generations of Virginians, Sharon has been writing about the entertaining pursuits of state residents and uncovering obscure nuggets of state history for more than twenty years.